M000274492

GETTYSBURG
IN COLOR
Volume 2:
The Wheatfield to Falling Waters

PATRICK BRENNAN
DYLAN BRENNAN

SB
Savas Beatie
California

© 2023 by Patrick Brennan and Dylan Brennan

All rights reserved. No part of this publication may be reproduced, stored in a retrieval system, or transmitted, in any form or by any means, electronic, mechanical, photocopying, recording, or otherwise, without the prior written permission of the publisher.

Library of Congress Cataloging-in-Publication Data

Names: Brennan, Patrick, 1952- author. | Brennan, Dylan, 1995- author. Title: Gettysburg in color / Patrick Brennan, Dylan Brennan. Description: El Dorado Hills, CA : Savas Beatie, [2022] | Includes index. | Summary: "The Brennan's compiled over three hundred photographs, lithographs, etching, and drawings that portray in documentary form the campaign and battle of Gettysburg. Using the latest technologies, the authors then painstakingly colorized each image. Adding the work of modern artists to flesh out the story plus battle maps using Google Earth as the base, the Brennan's have fashioned an entirely new way to experience the greatest battle in American history"– Provided by publisher.

Identifiers: LCCN 2022019544 | ISBN 9781611216097 (v.1; hardcover) | ISBN 9781611216585 (v.2 ; hardcover) | ISBN 9781611216103 (v.1 ; ebook) | ISBN 9781611216592 (v.2 ; ebook)

Subjects: LCSH: Gettysburg, Battle of, Gettysburg, Pa., 1863. | War photography. | Photography—Retouching. | United States—History—Civil War, 1861–1865—Art and the War.

Classification: LCC E475.53 .B844 2022 | DDC 973.7/3490222--dc23/eng/20220525

LC record available at https://lccn.loc.gov/2022019544?

Published by
Savas Beatie LLC
989 Governor Drive, Suite 102
El Dorado Hills, CA 95762
916-941-6896 / sales@savasbeatie.com

05 04 03 02 01 5 4 3 2 1
First edition

Savas Beatie titles are available at special discounts for bulk purchases in the United States by corporations, institutions, and other organizations.
For more details, contact Special Sales, P.O. Box 4527, El Dorado Hills, CA 95762, or please e-mail us at sales@savasbeatie.com, or visit our website at www.savasbeatie.com for additional information.

CONTENTS

DEDICATION

For Mom, my favorite motivator

and

John S. Peterson
In life, one of life's aces

Dylan & Patrick Brennan
AUGUST 2022

FOREWORD

The past is a strange country, and even though the American Civil War is not so far in the past as Julius Caesar or Christopher Columbus, the past often speaks strangely in our ears, and looks strangely in its images. Until the 19th century, looking at the past was largely a matter of the imagination. We had no choice but to rely on the brushes, pens, and pencils of artists to recreate the faces of Washington or George III or the death of Wolfe at Quebec, and even when those artists were working directly from life, their art was still a membrane separating us from the figures and events of the past.

The introduction of photography, however, brushed this membrane aside. We had known since the 17th century that certain chemicals—silver chloride especially—turned dark under exposure to sunlight. But it was not until the 19th century that Joseph Nicéphore Niépce, using a pinhole card to focus sunlight on an inked plate, created the first "photograph." Niépce's partner and successor, Louis Daguerre, developed a process in 1837 for treating silver-plated copper sheets with iodine vapor to make them sensitive to light, then "developing" the images on the sheets with warm mercury vapor to create a sharply defined *daguerreotype*. Within twenty years, photography had made strides even beyond the daguerreotype, and photographers were capturing images of conflict in the Sikh War (1848), the second Burma War (1852), and the Crimean War (1853–56).

The American Civil War occurred at just the peak moment for photography to wrest control of the image-making of war and personalities from the hands of the artists. By 1855, there were 66 photographic galleries in Great Britain; two years later, there were 147, with 42 alone on London's Regent Street. In the United States, the rage for photography was, if anything, even greater, with more than 3,000 photographers active in the republic, and 77 photographic galleries just in New York City. The great appeal of photography lay in what seemed to be its power to communicate truth, unreliant on an artist's skills (or lack thereof) or a patron's influence over the outcome. Photography offered detail, depth, objectivity.

The Civil War beckoned to photographers through an American population that craved exactly that kind of realism as a reassurance for the treasure and blood it was committing to the war. Mathew Brady, Alexander Gardner, Timothy O'Sullivan and a host of others carted their awkward tripod cameras and their portable darkrooms for developing images on glass plates to camps, battlefields all over the theatres of war, and even at sea. They captured the faces and uniforms of generals and privates, of the dead and the wounded, of the widows and orphans, of railroads and ironclads, and even of Abraham Lincoln's death bed. The photographs of the Civil War were to the generation of the Civil War a reassurance of fact; to us, they are a window in time, the rare occasion when we are permitted a direct and unmediated glimpse of the past.

Or *almost* unmediated. The photographers had scenes they wanted us to see, and they arranged those scenes so that we would see them as they saw them. And the scenes were strange enough on their own terms. A photograph of George Gordon Meade, the victorious Union commander at Gettysburg, poses him with a stiffness and formality that appear unnatural to our candid and relaxed gaze. Alexander Gardner captured the windrows of unburied dead on the Gettysburg battlefield with a solemnity and remoteness of feeling that could hardly have been shared by the burial details that are usually shoved beyond the margins of the camera's eye. Above all, the technology of photography in the Civil War had no way of capturing color. Vivid reds became dark blacks; variable shades of gray became an unvarying off-white. Skin tones descended into tubercular blandness. The past remained strange for us to look at. A gauze curtain still separated us from *them* and *then*.

The work of Patrick and Dylan Brennan, through the use of computerized color restoration, has

removed at least one element of that strangeness in Civil War photography. They have given us back the color of the landscape, the blues and reds and browns and grays of the soldiers and the civilians, the hue of living eyes and faces. We can look at Meade or the soldiers or the piled corpses and move one step closer to seeing them as they were seen, and not merely as they were captured by chemicals. The gauze curtain has been pulled back.

What connects us to our past connects us to life. And even if images are only part of that connection, they still invite us to remember Gettysburg, one of the greatest and most terrible moments in our past. Through the images this book reproduces, we take one closer step in the imagination to understanding what it was to live in that moment.

— Dr. Allen C. Guelzo, author of
Gettysburg: The Last Invasion

(National Park Service, Gettysburg National Military Park, Museum Collection, hereafter GNMP, Photo by John Kamerer)

CHAPTER 1

❧ THE WHEATFIELD ❧

WITH ZOOK'S UNIONISTS PRESSING his South Carolinians south along the wooded spine of Stony Hill, Joseph Kershaw galloped away to find reinforcements. At the same time, Brigadier General Paul Semmes led his brigade from Maj. Gen. Lafayette McLaws's division toward the western belt of Rose Woods. Kershaw begged him for support, and the highly regarded, 48-year-old Semmes immediately ordered his 50th Georgia forward. Kershaw then rode to find his wayward 15th South Carolina. He ordered them to come up on Brig. Gen. George T. Anderson's left to help close the now dangerous gap between the latter's position in Rose Woods and Kershaw's boys on Stony Hill. Then he thundered back to the desperate fighting.

The evening approached 7:00 p.m. The sun blazed hot on the western horizon over South Mountain. However, few of the sun's rays penetrated the shadows on Stony Hill. Forbidding darkness and thick gun smoke choked the soldiers battling in the timber. Zook's New Yorkers pressed south through the gloom and hammered at Kershaw's two regiments on the hill, while Zook's rightmost regiment—the 140th Pennsylvania—advanced in the open field west of the woods and fired through the smoke at the flickering muskets of the 2nd South Carolina.

Meantime, Patrick Kelly finally righted the Irish Brigade and pushed them through the trampled wheat into the gap between Zook and Cross. Curling around

An antebellum plantation owner, banker, and militia officer, Brig. Gen. Paul Semmes began the war as the colonel of the 2nd Georgia. By April of 1862, Semmes commanded a brigade that he led through all the major battles in the East. With some reputation as an exaggerator when claiming battlefield laurels, Semmes still compiled an estimable record as a brigade commander of 1,335 Georgians across four regiments. *(The Photographic History of the Civil War, hereafter PHOTCW)*

1

Born in western Ireland, Col. Patrick Kelly and his wife emigrated to New York City when he was twenty-eight years old. A pre-war merchant with militia experience, Kelly spent time in the 69th New York and the 16th U.S. Infantry before landing in the Irish Brigade with the 88th New York. Capable and courageous, Kelly replaced Brig. Gen. Thomas Meagher in command of the undersized brigade—523 men in five regiments—six weeks before Gettysburg. *(United States Army Heritage and Education Center, hereafter USAHEC)*

Pennsylvania bred with a seminary education, Col. John Brooke followed an embarrassing episode at First Bull Run by raising his own regiment—the 53rd Pennsylvania—and assuming the colonelcy. With no previous military training, Brooke proved to be an excellent and gritty officer who temporarily led his brigade at Antietam. He rose to permanent brigade command two months before Gettysburg, five regiments of 851 battle-tested veterans. *(USAHEC)*

Zook's left, two regiments of Kelly's right wing—the 28th Massachusetts and the 116th Pennsylvania—volleyed at the boys of the 7th South Carolina manning Stony Hill's southern crest. They followed the volley by clambering up the heights and crashing into the Carolinians. Meanwhile Kelly's left wing faced Anderson's Georgians in Rose Woods and unleashed an ineffectual volley with their .69 caliber buck-and-ball muskets. The Confederate response devastated the New York Gaels.

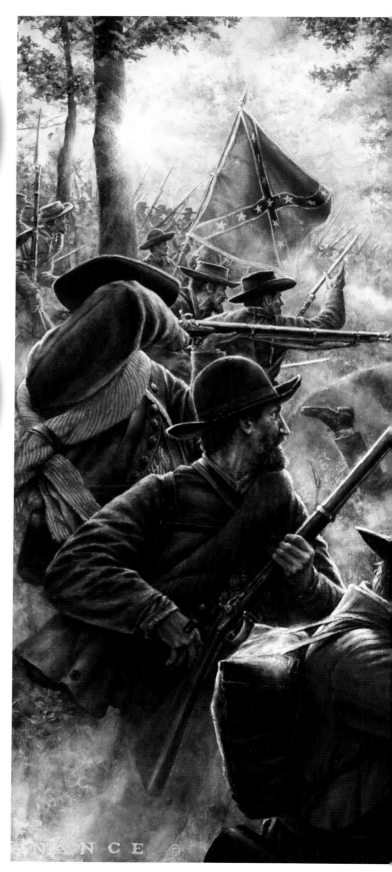

1. The 28th Massachusetts leads the right wing of the Irish Brigade up Stony Hill and into a brutal collision with the 7th South Carolina. *("A Savage Encounter" by Dan Nance)*

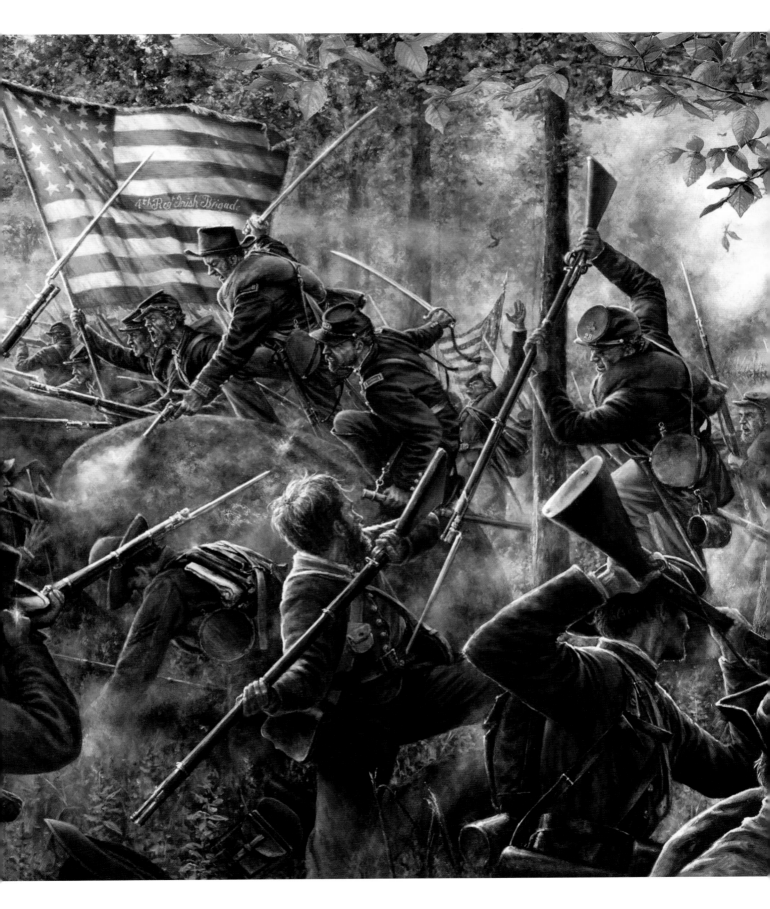

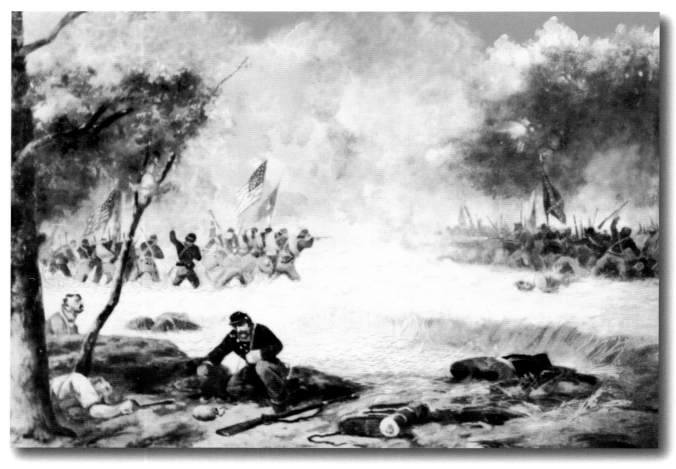

2. Brooke's brigade (left) sweeps across the Wheatfield and crashes into Anderson's survivors manning the stone wall (right). The impetuous Unionists crush the Confederate line and chase the stunned Rebels through Rose Woods (upper right). *(GNMP)*

As the fighting raged on Stony Hill, more Bluecoats entered the action. Representing the last of Brig. Gen. John Caldwell's division, Colonel John Brooke led his brigade across the Wheatfield and into the inferno. His infantry swept south past the Irish Brigade and drove the left wing of Anderson's Georgians further into Rose Woods, shattering the tenuous connection between Kershaw and Anderson. Brooke's boys netted dozens of Georgia Rebels in the sweep, but as they pushed over Rose Run and through the smoke-shrouded timber, they lost contact with their division-mates who had not joined their advance. Instead, their thrust stalled near the western edge of the woods where Paul Semmes's three Georgia regiments blunted their petering attack with a withering volley. As the two sides traded fire, Joseph Kershaw reached a rough decision. Isolated and assailed on three sides, his boys on Stony Hill were trapped in a meat-grinding pincer. With no support in sight, he

reluctantly pulled his battered Carolinians off the hill to a stone wall near the Rose farm 250 yards away. The Federals rushed forward into a vacuum, and the Stars and Stripes again crowned the modest eminence.

Elation swept through the Northern ranks. They had bloodily won back de Trobriand's original position.

Their joy proved fleeting.

Still occupying the field west of Stony Hill, the Northerners from Zook's 140th Pennsylvania saw them first, a sight so terrifying that half the regiment immediately broke for the rear. Joseph Kershaw's hobbled Carolinians probably recognized them soon thereafter. When the squeal of the Rebel Yell crescendoed, everyone—especially the Yankees—knew someone was playing a new card. Advancing from the west rolled William Wofford's Georgians, a solid wall of Southern steel heading straight for Zook and Kelly's exhausted troops on Stony Hill. Shouts arose among

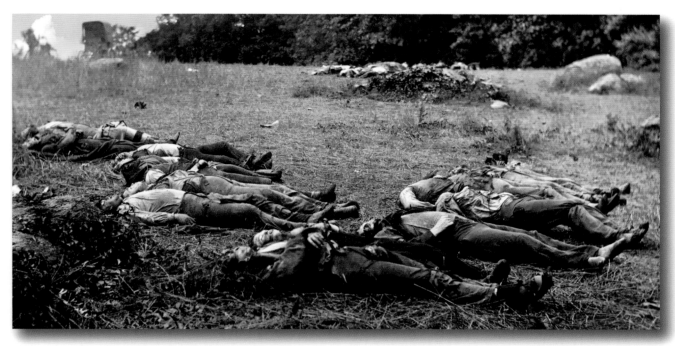

3. Looking north, Confederate dead mark the site of the firefight between Semmes and Brooke. Rose Woods looms in the background. *(Library of Congress, hereafter LOC)*

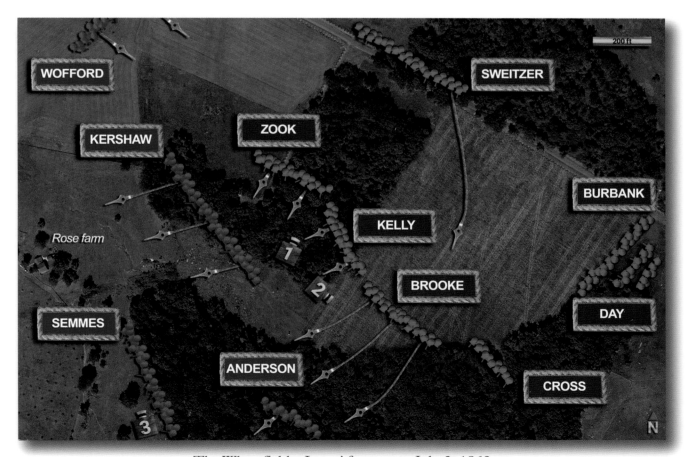

The Wheatfield—Late Afternoon—July 2, 1863
39° 47'49.25 N 77° 14'36.09 W. Google Earth Pro. 9/6/2013. 8/25/2022.

Kershaw's Palmettos that help had arrived, and those South Carolinians who had bitterly abandoned their position just minutes before rose up to go at it again. A mounted officer, possibly William Wofford himself, rode up to the 2nd South Carolina and asked them to join his Georgians in the attack. He swung his hat, they cheered to the heavens, and, suddenly, everything seemed possible.

⇜THE PEACH ORCHARD⇝

Dan Sickles watched the beginning of Brig. Gen. Charles Graham's disintegration from a vantage point near the Trostle farm. In the center of the storm, he confronted Colonel Henry Madill of the ravaged 141st Pennsylvania, one of the regiments hammered out of the Peach Orchard by Barksdale's troops. Sickles wanted to know if the officer could hold on, but the dazed and confused Madill had no idea where his men had gone.

With Confederate shells spinning through the air, Sickles and a few of his staffers rode east toward the Trostle farm buildings to avoid the barrage. They were too late. A projectile clipped the general's right knee and broke his leg. At first Sickles seemed unaware he had been hit. Soon, however, he was reeling from loss of blood and shock, and he transferred command of the III Corps—or what was left of it—to David Birney. Someone gave him some brandy, and someone else gave him a cigar. He sat up on his stretcher so that his men could see he wasn't dead, but he begged his people not to let him be captured. They bore him to an ambulance where he departed the field, his leg to be amputated, his Gettysburg battle ended.

Meanwhile Lt. Col. Freeman McGilvery labored mightily to get his guns off the field and redeployed for further action. At the Trostle farm, a gated lane that passed through a stone wall acted as a funnel for the mass of soldiers trying to reach the safety of Cemetery Ridge.

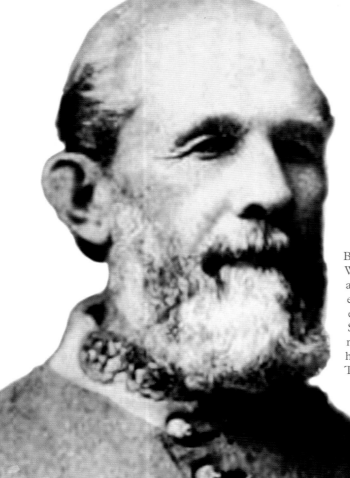

Born and raised in the mountains of Georgia, Brig. Gen. William Wofford experienced much success in his antebellum pursuits. A plantation owner, lawyer, newspaper editor, and state legislator, Wofford's only military experience was a captaincy during the Mexican War. With Sumter, he became colonel of the 18th Georgia and marched to glory in John Bell Hood's Texas Brigade, which he commanded in the bloodbath at Sharpsburg. Transferring to Thomas Cobb's outfit, Wofford took brigade command when Cobb was killed at Fredericksburg. The aggressive Wofford did very well in his new role at Chancellorsville, and he guided 1,632 Georgians in six regiments onto the field at Gettysburg. *(USAHEC)*

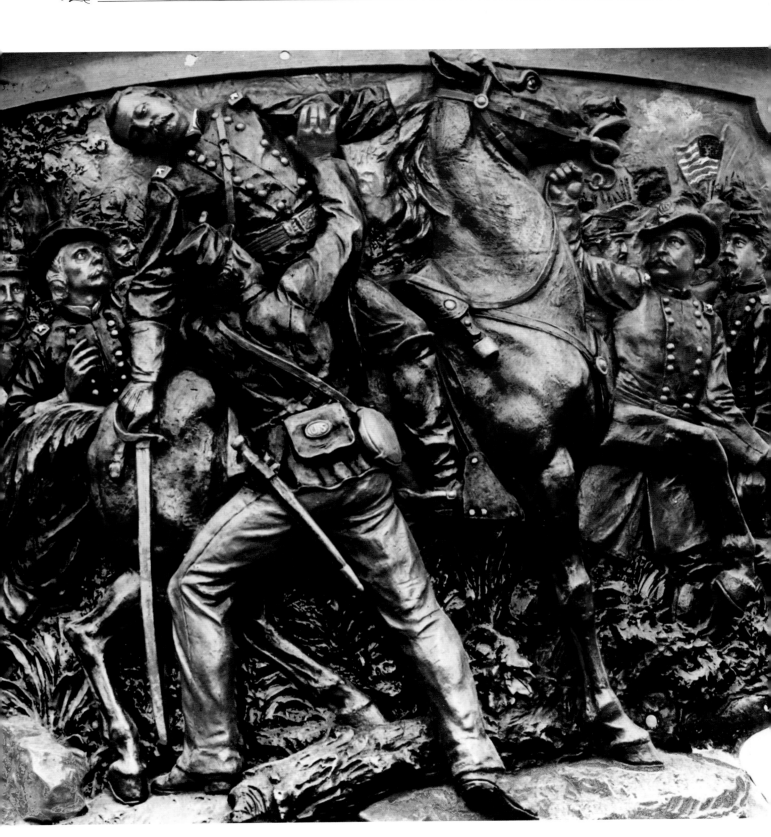

4. With his grand plan collapsing in a welter of blood and chaos, Dan Sickles's battle of Gettysburg ends near the Trostle barn when a Confederate shell mangles his right knee. *(New York State Archives)*

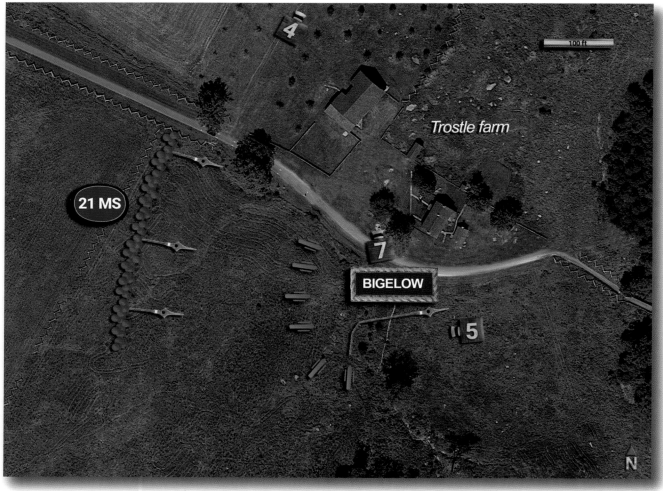

The Trostle Farm—Late Afternoon—July 2, 1863
39° 48'05.46 N 77° 14'33.84 W. Google Earth Pro. 9/6/2013. 8/25/2022.

Most of McGilvery's exhausted gun crews negotiated the gate and headed to a shelf 300 yards to the east of Plum Run. However, McGilvery needed time to organize the new line. When the last of his crews arrived at the gate—Captain John Bigelow and his 9th Massachusetts Battery—McGilvery ordered him to drop trail and fight off the Rebel pursuit. Bigelow arrayed his guns in an arc facing west and south, just before the 21st Mississippi materialized across the front. For the next few minutes, Bigelow and his people held off the Mississippians with sheer will and double loads of canister. Eventually, they would be driven away, losing four of their six guns, many of their men, and most of their horses. The flag of the 21st Mississippi may have waved from the top of one of their caissons, but Bigelow's boys had bought McGilvery his precious time.

Opposite above:
5. With the 21st Mississippi bearing down on his western front (center and left distance) near the Trostle barn (right), John Bigelow directs his battery to buy time for Freeman McGilvery. One of Bigelow's batteries (center foreground) escapes by crashing through the stone wall on the property's eastern border. *(USAHEC)*

Opposite below:
6. Looking southwest, Union stragglers wade Plum Run on their way to Cemetery Ridge as Bigelow's cannoneers (center left distance) hold off the 21st Mississippi (right distance) between the Trostle house (left) and the Trostle barn (right). (Map on p. 27.). *(LOC)*

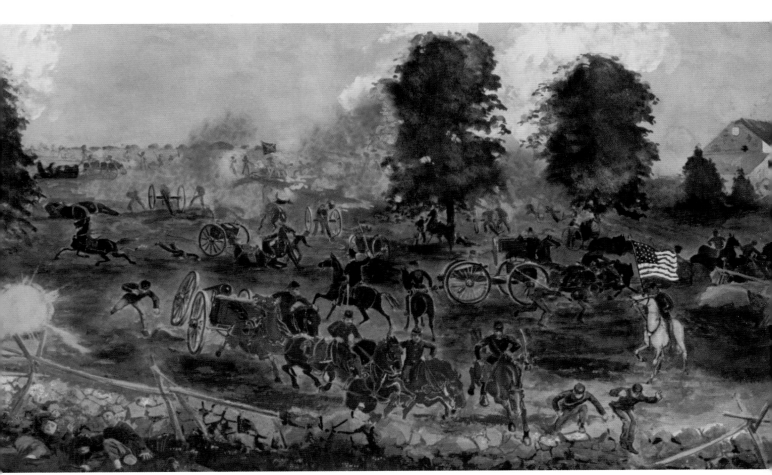

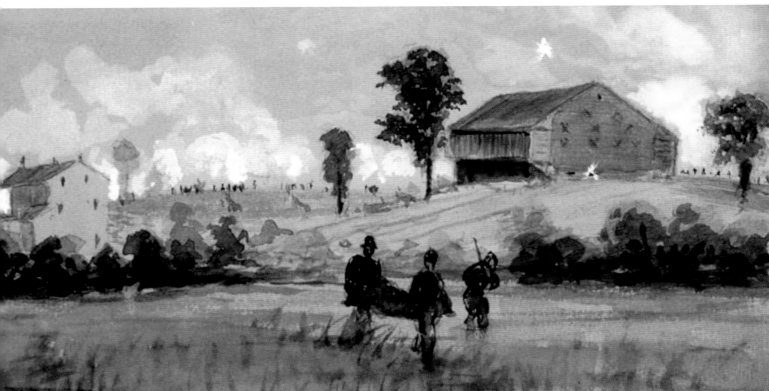

Capt. John Bigelow, Massachusetts Light Artillery:
9th Battery *(David H. Jones Collection)*

7. Dead artillery horses cover the ground near the Trostle barn a few days after the battle. *(LOC)*

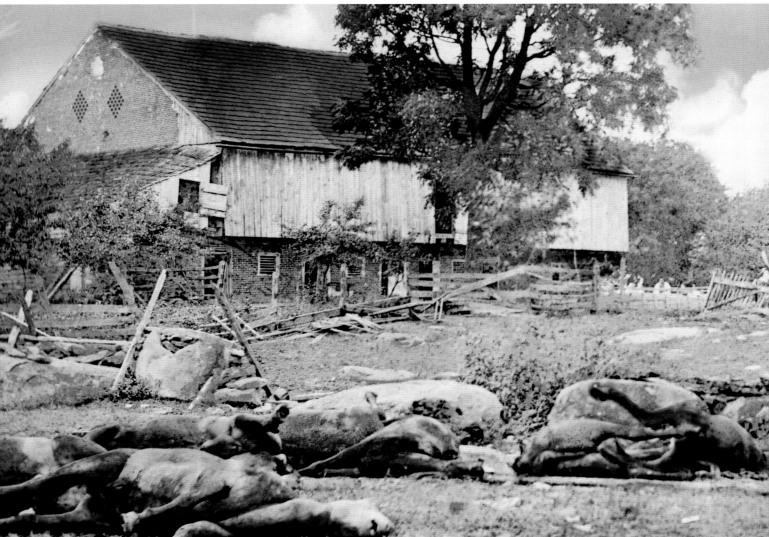

⊱ LITTLE ROUND TOP ⊰

In the growing shadows and darkening skies, the Unionists on Little Round Top marveled at the view. Trees partially blocked their sightlines, but the men could tell Caldwell's advance had enjoyed much success. Six Federal brigades now surrounded the Wheatfield. Zook and Kelly manned Stony Hill. Brooke lined the western edge of Rose Woods, and Cross's brigade deployed south of the infamous stone wall. V Corps commander George Sykes had ridden up Little Round Top and watched as Stephen Weed's brigade from Brigadier General Romeyn Ayres's division arrived on the heights to join their comrades from the 140th New York in extending the Union line across the crest and down the north slope. Sykes informed Ayres to send his remaining two brigades to beef up Caldwell's division near the Wheatfield. These ten regiments of United States Regular troops crossed the Plum Run valley and began to form along the field's eastern boundary, their collective right near the Wheatfield Road. Artillery deployed to support their right and cover the Plum Run valley.

Among Little Round Top's innumerable boulders and crevasses, Federal patrols began to corral clots of Rebels who chose not to retreat. From their perch along

The highly-regarded Brig. Gen. Stephen Weed, a New York graduate of West Point, spent most of the war as a V Corps artillerist. A month before Gettysburg, Weed left the regular army and became a brigadier of volunteers. Gettysburg would be the first time he commanded infantry in battle, four regiments of 1,504 men. *(LOC)*

the hill's crest, Union artillery continued to punish the Rebels in Round Top's woods and atop Houck's Ridge. Those same Confederates maintained a stinging return fire on both the Yankee bastion and the left flank of the Regulars as they crossed Plum Run and ascended the ridge to the Wheatfield. Dozens of Rebel bullets hit their marks. General Stephen Weed sat in his saddle near Hazlett's battery when a bullet severed his spine and left him paralyzed. He called for Hazlett, an army friend from the antebellum days, and offered his comrade some dying thoughts. But, when he beckoned Hazlett closer to reveal a private matter, a Rebel Minié ball crashed through Hazlett's head, killing him almost instantly.

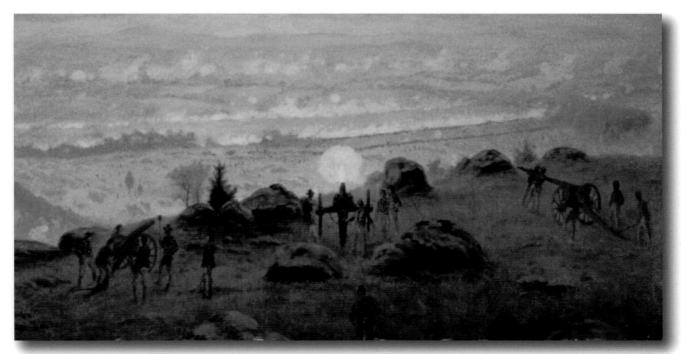

Atop Little Round Top, Hazlett's Battery fires at the Confederates west of the Wheatfield (center distance). The battle for Little Round Top is over, but the area remains a dangerous place as sharpshooters ply their trade. *(LOC)*

ᴥ THE WHEATFIELD ᴥ

John Caldwell had shot his bolt. All four of his Federal brigades now actively engaged the enemy, and if he wanted to press the matter, he would need to look elsewhere for more troops. He found Jacob Sweitzer and his three regiments positioned on the Wheatfield Road along the southern border of Trostle Woods. Completely unaware of the mortal danger posed by Wofford's assault, Sweitzer led his boys in the footsteps of Brooke's advance. However, as Sweitzer approached the Wheatfield's now infamous stone wall, Wofford's rolling Rebel tide bore down hard on Kelly's and Zook's boys. Some of those Unionists recall being ordered to withdraw while others simply saw the writing on the wall. The Northerners unloosed some half-hearted volleys then poured off the hill and into the Wheatfield to escape the Rebel juggernaut.

Meanwhile Semmes and Anderson's Georgians turned on Brooke's isolated line in Rose Woods. In the claustrophobic chaos, Semmes caught a bullet to his leg that proved mortal, but his men raked the enemy front as Anderson hammered Brooke's left flank. The pressure cracked the line, forcing the routed Bluecoats through the woods, across Plum Run, and into the Wheatfield. With two brigades of screeching Georgians in hot pursuit, Brooke's boys ran with a purpose, joining Zook's and Kelly's soldiers in a race to safety. This time, nobody rallied at the Wheatfield Road or in Trostle Woods. This time, they kept running.

Sweitzer heard the noise emanating from Stony Hill but thought nothing of it. Suddenly, to the west, hundreds of Bluecoats came tumbling off the hill and roaring out of the woods. Rebel bullets then began to slam into his men's backs, and one of his color guard asked the colonel if they weren't facing the wrong way. Sweitzer repositioned two of his regiments to face the threat, but more and more Georgians leaked out of the hill's timber and exchanged shots with the suddenly lonely Yanks. The firing became general, and the

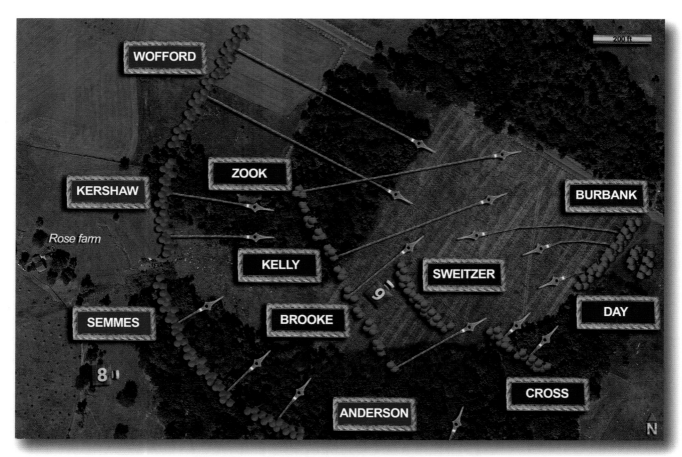

The Wheatfield—Early Evening—July 2, 1863
39° 47'49.25 N 77° 14'36.09 W. Google Earth Pro. 9/6/2013. 8/25/2022.

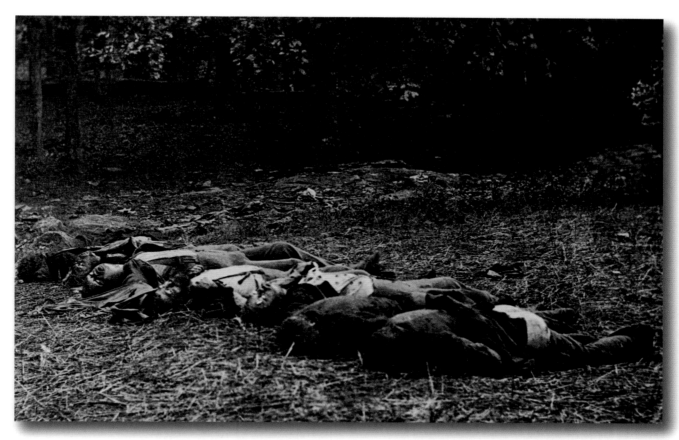

8. Looking east into the trees, dead Confederates line the border of Rose Woods very near where Semmes and Anderson routed Brooke's isolated brigade. *(LOC)*

fighting grew savage as the Yanks tried to hold back the Rebs. The 4th Michigan's leader, Colonel Harrison Jeffords, led a hand-to-hand effort against some Georgians from Cobb's Legion in a brutal effort to recover the Michigan regiment's fallen colors. A bayonet thrust cost him his life, and the flag disappeared in the chaos.

Sweitzer meantime recognized the folly of remaining where he was. He ordered his boys out of their murderous predicament.

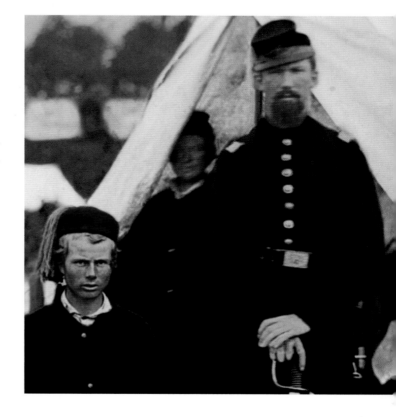

Col. Harrison Jeffords (right) led his 4th Michigan in the swirling action of the Wheatfield against Lt. Col. Luther Glenn and the Georgians of the Cobb Legion. *(LOC)*

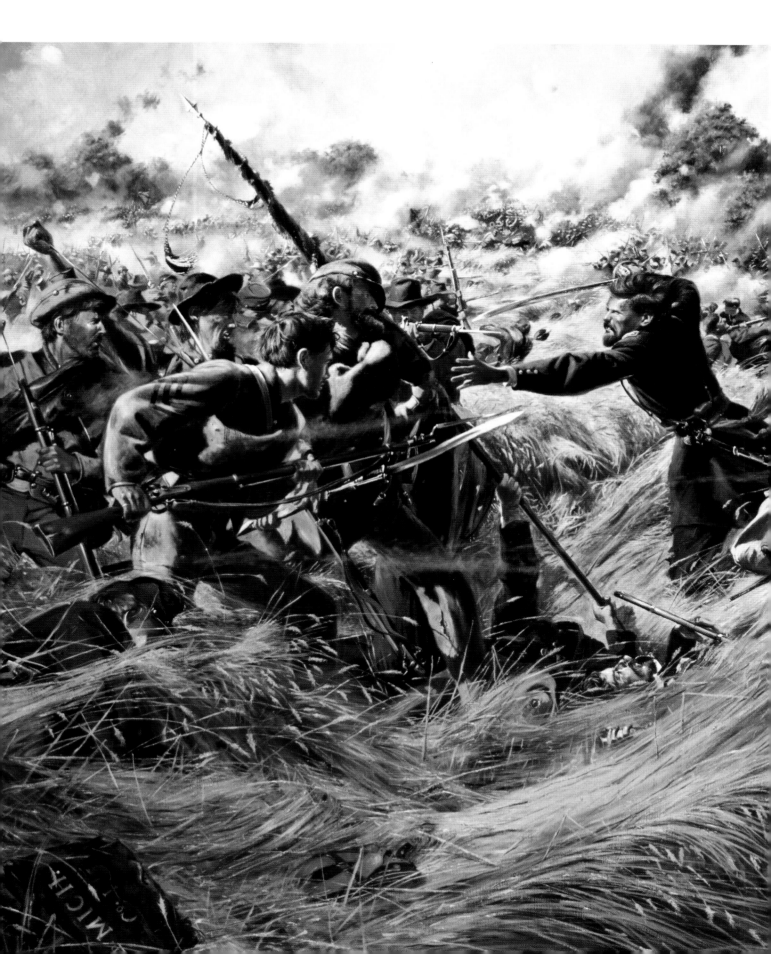

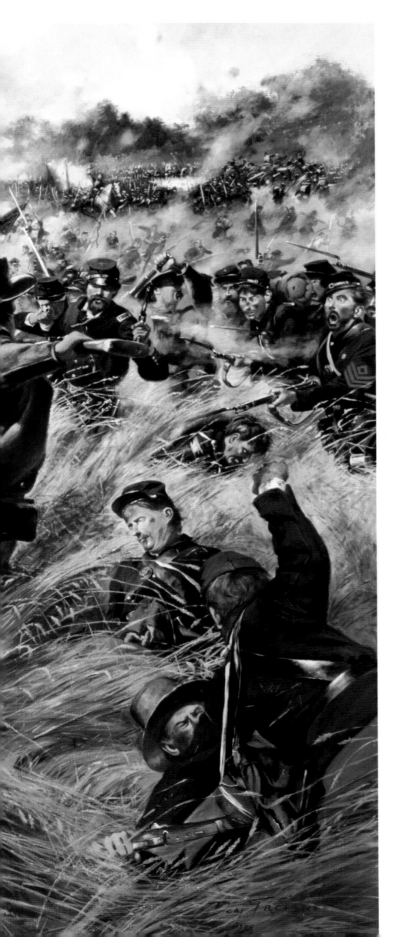

9. As Harrison Jeffords battles to save the 4th Michigan's flag, Confederate infantrymen coil before bayoneting the colonel, making him the only officer to die by that method during the entire war. *("Saving the Flag" by Don Troiani)*

⇜THE EMMITSBURG ROAD⇝

William Barksdale was down to three regiments. His 21st Mississippi had broken from the brigade formation and helped destroy the enemy Peach Orchard formation. They now pursued the Yankees toward McGilvery's reformed artillery line east of Plum Run, but Barksdale's remaining hard chargers didn't mind the reduction a bit. After crushing the Unionists at the Sherfy farm, they wheeled to the north to do their own pursuing of Graham's scattered command and attack Andrew Humphreys's next grouping, Colonel William Brewster's New York Excelsior Brigade.

At the same time, around 6:00 p.m., the first two brigades of Richard Anderson's division jumped off Seminary Ridge to join the battle. Brigadier General Cadmus Wilcox—whose men had dueled with Berdan's sharpshooters seven hours previously—led four of his Alabama regiments directly east toward Brigadier General Joseph Carr's Union brigade at the Emmitsburg Road. Wilcox's fifth regiment—the 8th Alabama—had become separated from the brigade in the pre-assault maneuvers and desperately tried to catch up. Colonel David Lang brought out his undersized Florida brigade—barely the size of a pre-war regiment—to extend Wilcox's line to the north. Eighteen Yankee cannon flayed the tight Rebel lines, but Wilcox's men pushed through Henry Spangler's farm buildings and dueled with enemy skirmishers and sharpshooters lining the many field fences. The Yankees soon gave up the fight and ran east to rejoin their comrades who had been withholding their fire to avoid shooting their own men. Topography then favored the Southerners as Wilcox's advance suddenly disappeared into a depression about 100 yards from the road. Everything went quiet.

Joseph Carr's five regiments nervously awaited Wilcox and Lang's reappearance. On the brigade left, the 12th New Hampshire had advanced west of the nearby Klingle house and could see Barksdale's chopping attacks to their south. The threat of being cut

Connecticut-born but Brooklyn-bred, Col. William Brewster was a pre-war revenue agent with no military training who quickly rose to command the 73rd New York in Dan Sickles's Excelsior Brigade. However, from October of 1861 on, Brewster seemed to be consistently absent from the unit. Then, when he finally did return to the front after Chancellorsville, his seniority gave him brigade command. At Gettysburg, the inexperienced officer led six regiments of 1,837 New Yorkers. *(LOC)*

A New York tobacco dealer with militia experience, Brig. Gen. Joseph Carr raised the 2nd New York after the guns of Sumter and ascended to brigade command during the Peninsula Campaign. He gave gritty performances at 2nd Bull Run and Chancellorsville, but he was suffering the effects of malaria as he led his five regiments of 1,718 Unionists onto the field. *(LOC)*

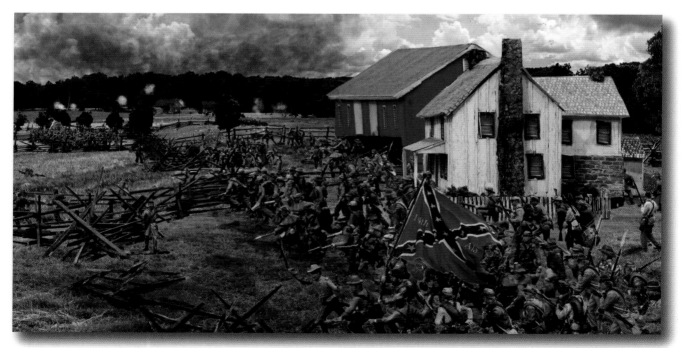

10. Brig. Gen. Cadmus Wilcox's brigade rushes into battle, the first organization from A.P. Hill's Corps to join Longstreet's operation. Here three Alabama regiments push past the Henry Spangler farm as they race east toward Humphreys's division on the Emmitsburg Road. *("Wilcox Crosses the Spangler Farm" by Dennis Morris, The Gettysburg Diographs)*

An amiable yet precise officer whose independent actions helped save Lee at Chancellorsville, Brig. Gen. Cadmus Wilcox had spent his entire life in the army. A West Point graduate from North Carolina and Mexican War veteran, the cerebral Wilcox taught tactics at the Point and studied in Europe, writing a book on tactics and translating a similar Austrian work to English. After Sumter, Wilcox took command of the 9th Alabama and quickly rose to brigadier. Despite a solid resume, the gentlemanly Wilcox never received the promotions he thought he deserved, and on occasion he threatened resignation from the army. Still, he helmed five regiments of 1,726 Alabamans at Gettysburg. *(LOC)*

A twenty-five-year-old Georgian working as a surveyor in Florida when Sumter fell, Col. David Lang began the war as a private in the 1st Florida. His antebellum education at the Georgia Military Institute no doubt aided his eventual rise through the ranks to colonelcy of the 8th Florida, and he led that unit particularly well at Fredericksburg where a head wound almost cost him his life. He returned to the regiment after Chancellorsville then took over the brigade when sickness prostrated Brig. Gen. Edward Perry. Gettysburg would be his first battle in command of three regiments of 742 Floridians. *(USAHEC)*

off played on the men's minds, but they knew the real danger lay in that swale just to the west. Also, south of the Hampshiremen, Lieutenant Francis Seely and his gunners from Battery K of the 4th United States Artillery prepped for the coming contest. They had deployed between Brewster's and Carr's brigades and now piled ammo next to their six pieces to assure maximum speed when the crisis came.

Suddenly, the Alabamans seemed to rise out of the ground screeching the Rebel yell, and the Union line erupted. The 12th New Hampshire swept their compact front with repeated volleys and plugged the Rebel momentum. Seely pumped scathing rounds of case shot that shredded the Alabaman southern flank and drove the faint of heart back to the swale. The slaughter was awful, morphing Wilcox's regiments into a howling mob, but on they came, loading and firing with a terrifyingly inevitable force. In a final heave, they

reached the roadway some thirty feet from the Yankees, where the blue and gray lines descended into a violent cyclone.

On Carr's north flank near the Codori-Hummelbaugh farm lane, the 1st Massachusetts gamely stifled Lang's Floridians. From his isolated perch north near the Codori farm, Young Gulian Weir confirmed Winfield Scott Hancock's management genius as his fortuitously placed cannon raked the Florida northern flank. On the southern flank, however, Rebel pressure threatened to crack their enemy yet again. Another crisis threatened the Yanks, another opportunity beckoned the Rebels.

Birney was desperately trying to develop a new line that would connect Humphreys's survivors with the V Corps units on Little Round Top. He ordered Humphreys to refuse the left of Brewster's all-New York Excelsior Brigade to face Barksdale's attack. Humphreys redeployed Brewster's five units—including the Zouaves

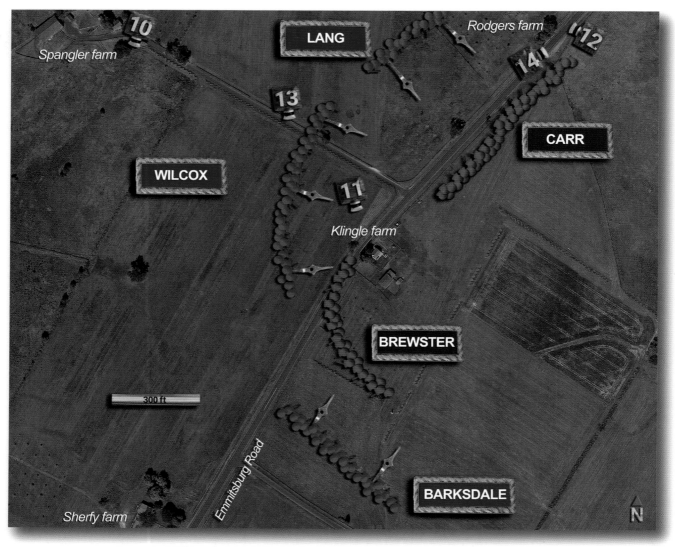

Emmitsburg Road—Early Evening—July 2, 1863
39° 48'23.63 N 77° 14'40.73 W. Google Earth Pro. 9/6/2013. 8/25/2022.

of the 73rd New York who had survived the cauldron of the Peach Orchard—to face south, creating yet another Federal salient on the Emmitsburg Road. Brewster barely got his people into position along the Trostle farm lane—joined there by some of Graham's survivors—when Barksdale's boys pounced.

Separated by the narrow lane, the two sides blazed away. But, with Wilcox firing from the west and Barksdale attacking from the south, the Confederates gouged the salient, causing two New York regiments to abandon the angle. The Rebs had blown a hole between Brewster and Carr, uncovering the units on both sides of the rupture. The rest of Brewster's front line evaporated, but his sole reserve, the 120th New York, advanced into the gray flood to somehow—if only for a moment—stem the tide.

∾◦∾

They called him "Hancock the Superb" with good reason. Always with the pressed white shirts, the almost urbane manners, the voluble cursing, the finely cut figure in the saddle. At his core, however, he could general like few others, and Gettysburg would be his finest hour. In the opening moments of the crisis, he bounded about the battlefield envisioning the battle flow, evaluating critical locations, and deploying artillery and troops to counter the threats in sometimes mystifying

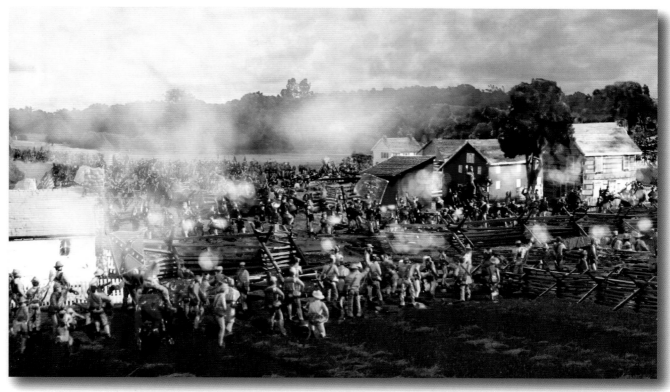

11. The 14th and 10th Alabama of Wilcox's brigade hit the left flank of Carr's near the Klingle house.
(Detail of "Wilcox's Brigade Attacks" by Dennis Morris, The Gettysburg Diographs)

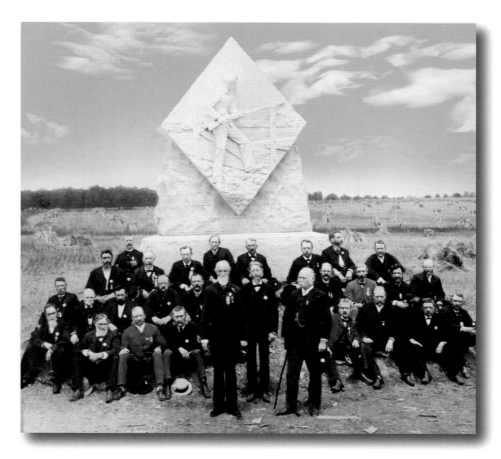

12. Viewed from the east, the surviving members of the 1st Massachusetts Infantry gather at their monument north of the Rodgers house and west of the Emmitsburg Road. Lang's Floridians departed the Spangler Woods tree line on Seminary Ridge (left), crossed the intervening fields, and struck Carr's right flank in this area.
(William Tipton Sample Photograph Album, William L. Clements Library, University of Michigan)

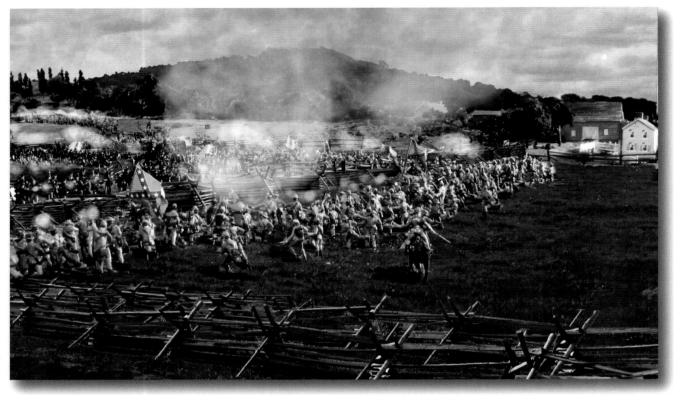

13. As Wilcox presses Carr's front (foreground), Barksdale (center) attacks from the south (right) and demolishes the Excelsior Brigade manning Humphreys's salient. Meanwhile, in the left distance, the 21st Mississippi destroys Bigelow's battery at the Trostle farm. *(Detail of "Wilcox's Brigade Attacks" by Dennis Morris, The Gettysburg Diographs)*

ways. When Hancock personally assigned their location, the men of Thomas's battery looked about their somewhat enclosed surroundings east of Plum Run and wondered why. Through division commander John Gibbon, Hancock additionally carved up Brigadier General William Harrow's brigade—then occupying the II Corps' southern flank—and assigned the various regiments new roles. The 1st Minnesota rolled south to support Thomas's guns, and the 19th Maine trotted forward to back Weir. In one memorable moment, Hancock dismounted to personally position a Maine private to anchor the regiment's left flank. Would he stay the general asked? Until Hell froze was the assurance.

Gibbon sustained further reductions when Hancock cannibalized Colonel Norman Hall's brigade and pushed the 19th Massachusetts and the 42nd New York forward to aid Humphreys. With little idea what was expected of them and no staff officer present to offer advice, the two units gingerly moved to fill the chasm north of Weir's blazing guns.

Gibbon himself had advanced Harrow's remaining two regiments some 300 yards to the Codori farm then assigned Lt. T. Fred Brown's 1st Rhode Island Battery to a point just east of the Codori buildings. Brown's guns aimed to the northwest to counter any Rebel move from that direction. Their placement raised some questions among Hancock and his subalterns, but Gibbon's decision stood. Such wisdom would soon be tested, because exiting the tree line 1,000 yards to the west came another of Richard Anderson's combat groups. Brigadier General Ambrose Wright and his Georgians emerged from the shadows and aligned themselves under a pounding Yankee artillery barrage from Cemetery Hill. With the sun nearly set, they could barely see 100 yards ahead of themselves. Dressed, they double-quicked into the gloomy darkness. Nearly twenty Federal cannon covered the fields, and every step brought the Rebels a harder pounding. After 500 yards near the Bliss farm, they picked up their comrades from the 2nd Georgia Battalion and some stray Mississippians from Brigadier General Carnot Posey's brigade. Now counting 1,400 rifles, they continued past the farm toward the Emmitsburg Road.

The day before, Meade trusted Hancock to choose the field of battle. Today, in the middle of an epic crisis, Meade will give Hancock the power to control half the battle. *(LOC)*

The end of Dan Sickles's grand experiment came quickly. As Wilcox's swarming Alabamans began to punch holes in Carr's quaking brigade, David Birney decided to cut bait. Evidently satisfied that his attempt to form a new line to Little Round Top was doomed, Birney ordered Humphreys to retreat to Cemetery Ridge. Humphreys, the 52-year-old army regular, complied, but he was not about to let his division collapse, even with Rebels pressing his front and pounding his flanks. Gallant and almost ridiculously brave under fire, he let his lieutenants know how he intended to remove his command from their dire straits. They rode off to do his bidding.

The 120th New York's fighting retreat to the Klingle house had brought them next to the 11th New Jersey as an anchor for Carr's southern flank. There the New Yorkers traded barbed fire with the 8th Alabama that was wheeling north to reconnect with Wilcox. As Humphreys's survivors began their dangerous trek east, the two Federal regiments provided a short-lived screen to slow the Rebel pursuit. Both units payed dearly for their service.

The battle noise grew so overwhelming that Humphreys's people had trouble communicating with the soldiers on the firing line. Grabbing, pointing, and pantomiming replaced the spoken word as the Unionists learned they would be abandoning the position. But this would be no "turn tail and run." Leading by example, Humphreys made his regiments retreat slowly while stopping regularly to return fire and hold the Rebels at bay. Those Unionists holding firm on Cemetery Ridge admiringly watched the display.

When Lang led his boys across the Emmitsburg Road in the wake of Humphreys's withdrawal, he paused to marvel at the sheer number of Yankee dead splayed across Carr's former position. However, there was more work to be done. Smoke and twilight dulled their view, but Barksdale's Mississippians, Wilcox's Alabamans and Lang's Floridians pushed east to inflict more punishment on the retreating Yanks.

There was a battle to be won.

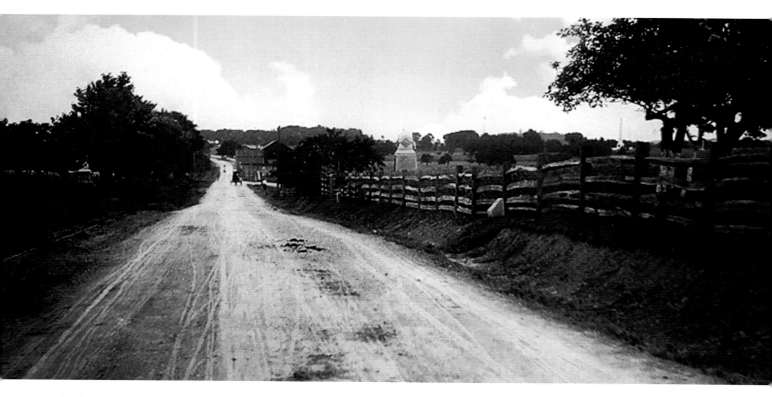

14. A turn of the 20th century image of the Emmitsburg Road looking north from the Rodgers house toward the red Codori farm (left center distance). Carr's right flank is a few dozen yards ahead, and Lang would pause here on his attack from west (left) to east (right) to marvel at the carnage. The monument to the 26th Pennsylvania—one of Carr's right flank units—sits on the east side of the road. *(Sue Boardman Collection)*

For 500 yards, Humphreys and his boys waged a chaotic, fighting retreat. Brewster's and Carr's survivors then sloshed through the boggy, bush-lined swale of Plum Run and slowly climbed the last 300 yards to the modest peak of Cemetery Ridge where their remaining officers worked to organize some semblance of order. Years later, Humphreys would regret moving so deliberately and costing the lives of so many, but for now, the general could brag that he managed to march much of his division off a battlefield where most of his comrades ran.

A single Union regiment and three batteries now coalesced to try to stem the Confederate tide, but the battle chaos made for great difficulties. Francis Seely had led his gunners on a wild withdrawal from the Emmitsburg Road front. At the same time, Hancock directed the 19th Maine forward from their position on Cemetery Ridge to a point near the Codori-Hummelbaugh lane in a search for Gulian Weir's isolated battery. To the great consternation of the infantrymen and a cursing Winfield Hancock, Seely's guns collided with the Mainers near Plum Run. Meanwhile, Weir had abandoned his position near Cordori's when he saw the distant collision and guided

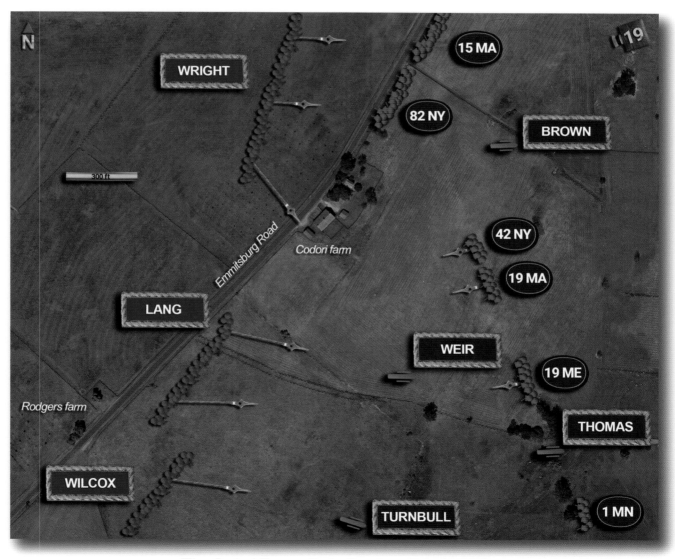

The Codori Farm—Early Evening—July 2, 1863
39° 48'33.08 N 77° 14'27.75 W. Google Earth Pro. 9/6/2013. 8/25/2022.

his guns south to support the Maine men, even as two of Seely's embarrassed gun crews stopped to add their weight to the infantry line. Four guns from Lieutenant John Turnbull's Batteries F and K of the 3rd United States Artillery also dropped trail south of the Maine formation. Turnbull's other two guns commanded by Lieutenant Manning Livingston had become separated from their comrades and deployed north near Codori's. A total of fourteen Union cannon and 430 rifles now opened on what was left of Lang's Floridians, who lowered their heads and pressed into the gale.

Great effort had won the Emmitsburg Road for the Southerners. Greater effort would be demanded to win the day.

⊱THE WHEATFIELD⊰

Caldwell stood with Ayres on the Wheatfield's eastern border discussing how the Regulars would deploy. An aide tried to interrupt the conversation by observing that Caldwell's men were giving way. Caldwell summarily dismissed the thought. A moment passed, and the aide then addressed Ayres directly, saying that no matter what anyone's contrary opinion might be, those men out in the Wheatfield were running away. Caldwell turned to see his boys streaming north through the now pulverized wheat. Quickly coming to his senses, he bolted north to try to retrieve the situation.

Before realizing the true extent of the disaster, Caldwell had directed Ayres to advance south to relieve Cross and support Brooke's people in Rose Woods. To that end, Colonel Sidney Burbank commanded his five regiments to perform a left wheel while anchored in the woods lining the Wheatfield's eastern border. The dying light and battle smoke must have hidden Wofford and Kershaw's exultant troops pouring out of the Stony Hill woods opposite. While some of the Regulars maneuvered through the timber, most of the men strode into the Wheatfield, with the right flank unit—

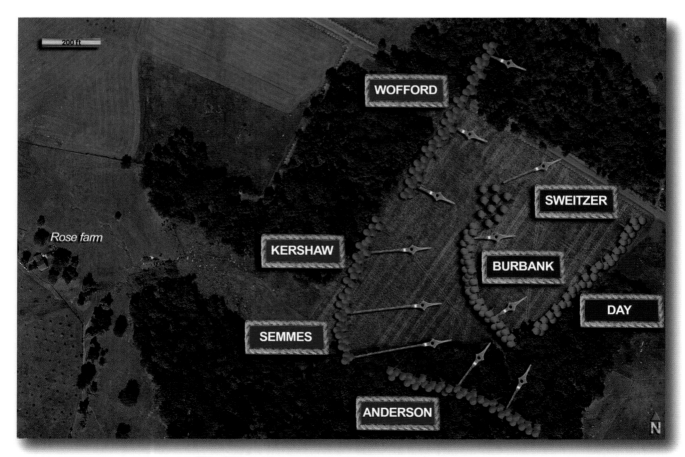

The Wheatfield—Early Evening—July 2, 1863
39° 47'49.25 N 77° 14'36.09 W. Google Earth Pro. 9/6/2013. 8/25/2022.

A New York graduate of West Point, Brig. Gen. Romeyn Ayres spent his adult life as an artillerist in the U.S. Army. With the fall of Sumter, Ayres eventually rose to command VI Corps artillery but left that post after Fredericksburg to direct an infantry brigade of Regulars. Competent and demanding, yet fun-loving and social, Ayres took over the Regular division when Meade ascended to army command three days before Gettysburg. With Stephen Weed's brigade manning Little Round Top, Ayres marched toward the Wheatfield with two brigades of 2,511 soldiers in ten regiments—the only Regular army troops in the entire army. *(LOC)*

Commander of a four-battery brigade in the Artillery Reserve, Lt. Col. Freeman McGilvery brilliantly orchestrated his long arm's response on a chaotic and rapidly changing battlefield. *(Collections of the Maine Historical Society)*

the 2nd United States—at the far edge of the wheel. Almost immediately, streams of Georgians and Carolinians pounced on their flank and curled behind them. Brutal firefights ensued as the Georgians methodically crushed each successive regiment and sent them reeling to the east. The 17th United States fought a brief rear guard action and paid a stiff price of almost 60% casualties. Ayres quickly calculated the danger of his predicament. He called Burbank back, and with the Rebels hot on their heels, Ayres's ten undersized regiments raced down the ridge to Plum Run, splashed across its marshy margins, and collected themselves 400 yards further east near Little Round Top. Nearly half of Burbank's men fell in their short

time under fire. Only a line of booming V Corps artillery near Little Round Top smothered the Rebel pursuit.

All of Sickles's revamped position had now fallen. Retaining the barest cohesion, Tilton's brigade had abandoned its line north of the Wheatfield and trudged east. Except for the spent Bluecoated stragglers from the day's battles, a gap of some 1,500 yards now yawned between Little Round Top and the II Corps on Cemetery Ridge. Longstreet had nearly wrecked three Union corps, and in the fading light, his cheering butternuts searched for more victims. Between them and victory stood two men: Freeman McGilvery and Winfield Scott Hancock.

THE PLUM RUN LINE

Freeman McGilvery certainly knew a crisis when he saw it. As the III Corps melted away, the 39-year-old former ship master realized there wasn't a moment to waste. He was determined to stop the Rebel infantry by any means, and if that meant deploying what remained of his bloodied and exhausted reserve artillery brigade—sans any infantry support—so be it. He ordered every gun crew he could get his hands on to drop trail on a shelf overlooking the eastern margin of Plum Run. By the time he finished, he had collected perhaps twenty-five guns, which included the relatively fresh 6th Maine Battery. He wouldn't have to wait long to test their mettle.

E.P. Alexander's Grayclad artillerists crowding into the Peach Orchard saw this new Yankee artillery concentration 1,000 yards to the east and began to lob projectiles at it. McGilvery answered, but greater threats grew in his immediate front. Some 300 yards west of his southern flank, the cannoneer could see the 21st Mississippi swarming past the ruins of Bigelow's battery at the Trostle farm. Once Bigelow's survivors cleared the front—including their wounded and dazed leader—the 6th Maine Battery opened on the Mississippians, followed by the rest of McGilvery's motley crews. At the south of the makeshift Union position, the Confederates pushed through the barrage and managed to overrun Lieutenant Malbourne Watson's isolated and poorly defended Battery I, 5th United States Artillery. Already, McGilvery's line was in jeopardy.

Further north, however, an even greater threat loomed. After helping to crush the enemy along the Emmitsburg Road, William Barksdale redirected his three Mississippi regiments due east nearly 700 yards across the fields north of the Trostle farm buildings—and straight at McGilvery's crews. When the

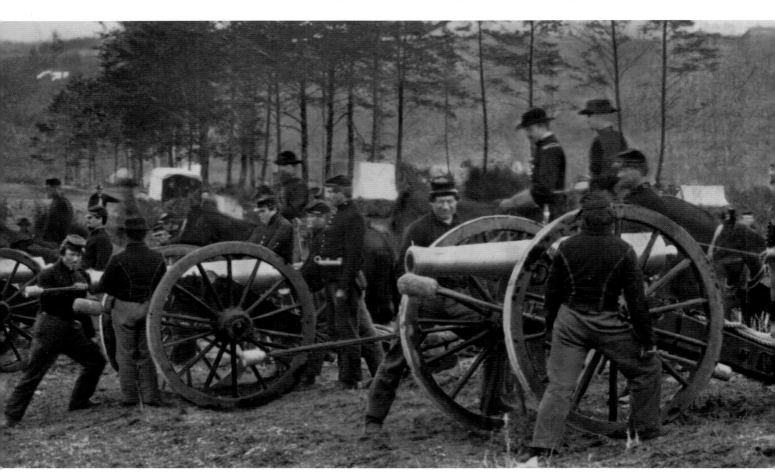

A staged shot of Federal artillery in action. It is doubtful McGilvery's Plum Run Line displayed the same sort of orderliness. *(LOC)*

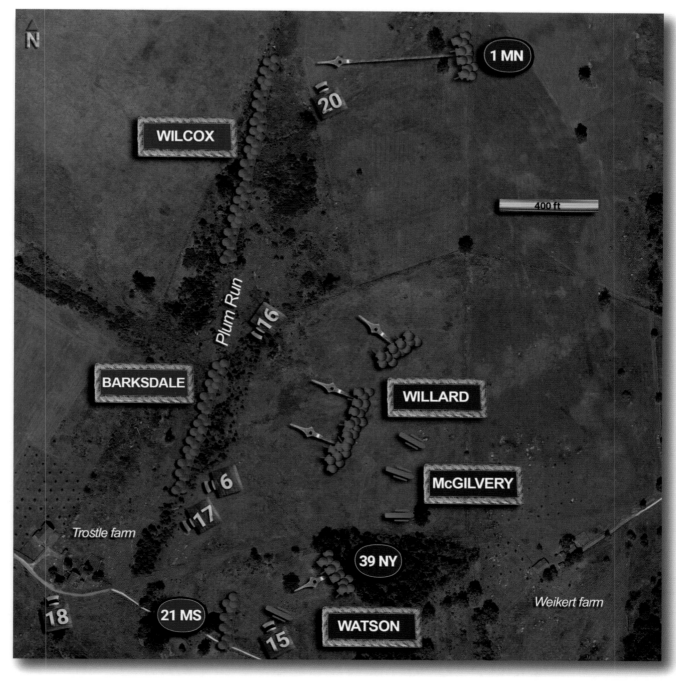

The Plum Run Line—Early Evening—July 2, 1863
39° 48'09.07 N 77° 14'20.31 W. Google Earth Pro. 9/6/2013. 8/25/2022.

disordered Mississippians poked at the shrubbery along Plum Run, the Union artillerists feverishly plastered the front. In the blinding smoke and failing daylight, one of the Federal officers surmised that the enemy slowed because they thought the woods behind the barking cannon had to be filled with infantry. Still, the Rebel riflery winnowed McGilvery's command down to four crews.

With Sickles down, George Meade made an astute decision. He ordered Winfield Scott Hancock to place John Gibbon in control of the II Corps and for Hancock to take charge of the southern half of the

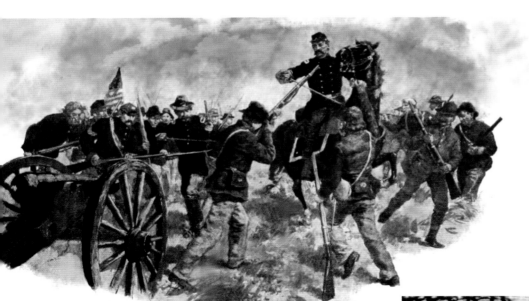

15. Captain John Fassitt of the 23rd Pennsylvania convinces the Garibaldi Guards of the 39th New York to retake Watson's guns. Fassitt helps lead the charge that wrestles the cannon away from the exhausted 21st Mississippi and solidifies McGilvery's left flank. For his quick thinking, Fassitt would be awarded the Medal of Honor. *(Deeds of Valor)*

battlefield, bringing command unity to what had become a chaotic mess. When Hancock received the command, he cursed having to give up his relatively intact II Corps to take over Sickles's ravaged troops. Off he went with a simple dictum: plug the gap between the II Corps on Cemetery Ridge and the now-secure fortress of Little Round Top. He had already used one division—Caldwell's—from his II Corps to dam the Rebel flood at the Wheatfield. He would revisit that well by calling for Colonel George Willard's brigade from Brigadier General Alexander Hays's II Corps division to support McGilvery at the Plum Run Line.

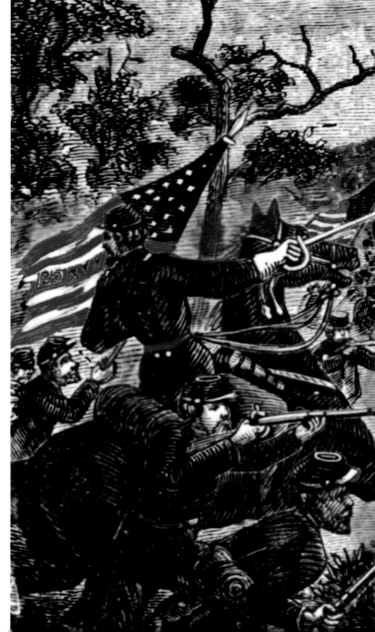

16. George Willard (left) and William Barksdale (center) drive their troops to the opposite banks of Plum Run where the Mississippian attack finally comes to a halt. Willard's attack expunged the stain of the brigade's Harpers Ferry surrender, while Barksdale's men could brag on one of the war's great charges. Neither officer, however, would survive the action. *(A Regimental History of the One Hundred and Twenty-Fifth New York State Volunteers)*

A Mexican War volunteer from New York City who stayed in the army and became a captain, Col. George Willard greeted the start of the war by raising the 2nd New York. Due to regulations, he couldn't become the unit's colonel, so he became a major in the 19th U.S. Regulars. However, in August of 1862, Willard took over the 125th New York, only to be in command when the regiment was captured en masse at Harpers Ferry during the Antietam Campaign. Willard and his boys waited for their parole, but when they resumed active campaigning, they were derisively greeted as "band box soldiers" and the "Harpers Ferry Cowards." On the march to Gettysburg, Willard ascended to brigade command of four regiments totaling 1,508 rifles, every man with a chip on his shoulder. *(A Regimental History of the One Hundred and Twenty-Fifth New York State Volunteers)*

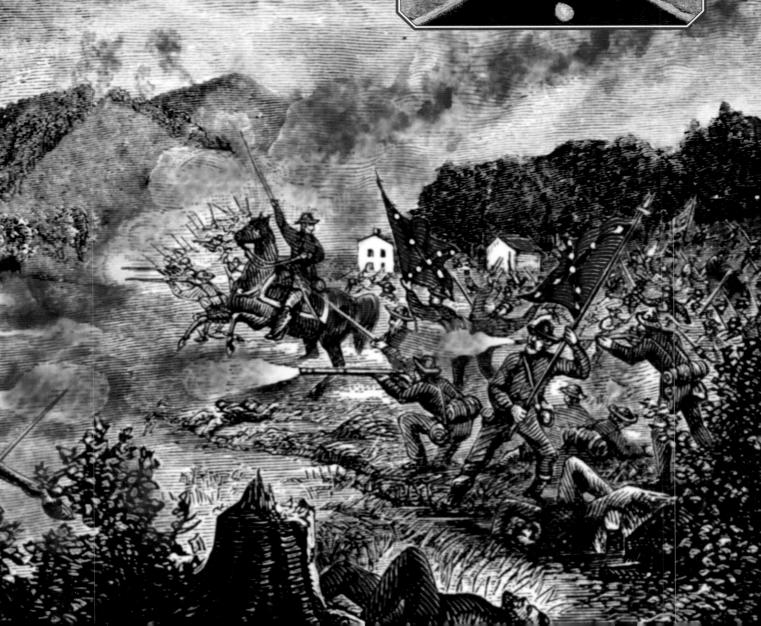

With Hays admonishing him to beat the Hell out of the enemy, Willard pulled his four regiments of New Yorkers from their position near Cemetery Hill and rushed them south along the ridge. The men had faced shame a year before during the Antietam Campaign when they were captured in toto at Harpers Ferry. Here they looked to make amends. Under Hancock's gaze, one of Willard's regiments—the so-called Garibaldi Guards of the 39th New York—chased the 21st Mississippi away from Malbourne Watson's captured guns all the way past the Trostle farm buildings. Meanwhile, Willard's remaining three regiments formed on the ridge and swept past McGilvery's relieved long arm, loading and firing as

they descended on the boulder-strewn, thicket-choked vale. The Mississippians there unloosed a single volley then fell back before the levelled Federal bayonets. The Yanks pursued past Plum Run—some of them crossing a narrow footbridge—when pressure from the Rebel artillery in the Peach Orchard to the south and Wilcox's South Carolinians to the north ended their thrust. A shell tore away part of Willard's face and head, killing him instantly, but his New Yorkers returned to the Plum Run Line with some recaptured Federal artillery and, crucially, their pride.

That the Confederates could mount and coordinate an attack was not surprising. At some point near the Trostle farm buildings, the already twice-

17. Looking southwest, a turn of the 20th century image of the approximate location where Federals find the mortally wounded William Barksdale. Plum Run flows in the foreground while the Trostle house (left) and barn (center) dominate the horizon. The small shed between the two buildings is a postwar addition. *(Richard Rollins Collection)*

wounded William Barksdale took a bullet that ripped a hole in his chest. The man who had led one of the great charges of the Civil War and practically willed his boys to glory would die in a Yankee field hospital twenty-four hours later.

Just to the south, another Federal force marched into the sector. In a response to a request from Meade for support, Henry Slocum dispatched almost two full XII Corps divisions from their positions on Culp's Hill. John Geary's got lost, but Alpheus Williams's division—led by Brigadier General Thomas Ruger—arrived after Willard's people had gone forward. The lead brigade under Brigadier General Henry Lockwood—Maryland men and New Yorkers—looped to the south of Willard's advance and pushed west toward the Trostle farm. Led by the spirited Marylanders who had never experienced

battle, the Blue column encountered no Confederates but eventually collected some of Bigelow's lost guns near a pile of dead horses in the gated lane. Ecstatic at the seeming ease with which they accomplished their assignment—no doubt heightened by the few times they got to fire their rifles—Lockwood's boys returned to find new orders awaiting them. Ruger was to march his entire division back to Culp's Hill. Immediately.

Hancock meanwhile worked his way north. He had so far choked off perhaps half of the gap, and he knew more troops were on the way, but more work needed be done. When he saw what he believed to be a retreating Federal force stumbling through Plum Run, he went to rally it. In the murky darkness, he had mistaken a Rebel battle line for his own men. A ragged volley sent him on his way, unharmed but alerted to this new crisis.

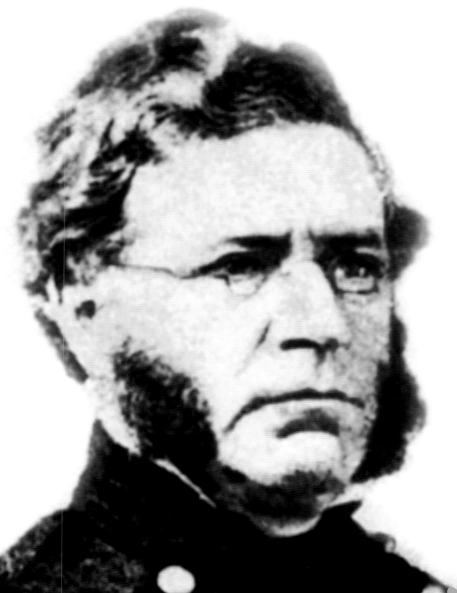

A West Point graduate from Delaware, Brig. Gen. Henry Lockwood spent most of his pre-war years teaching math at the Naval Academy. His war service proved to be equally unexciting as he commanded a brigade on the Maryland Eastern Shore where he saw no action. However, Lee's invasion triggered a call for troops, and Lockwood directed his three large regiments of 1,808 untested but spirited soldiers into Pennsylvania to join the fighting. *(PHOTCW)*

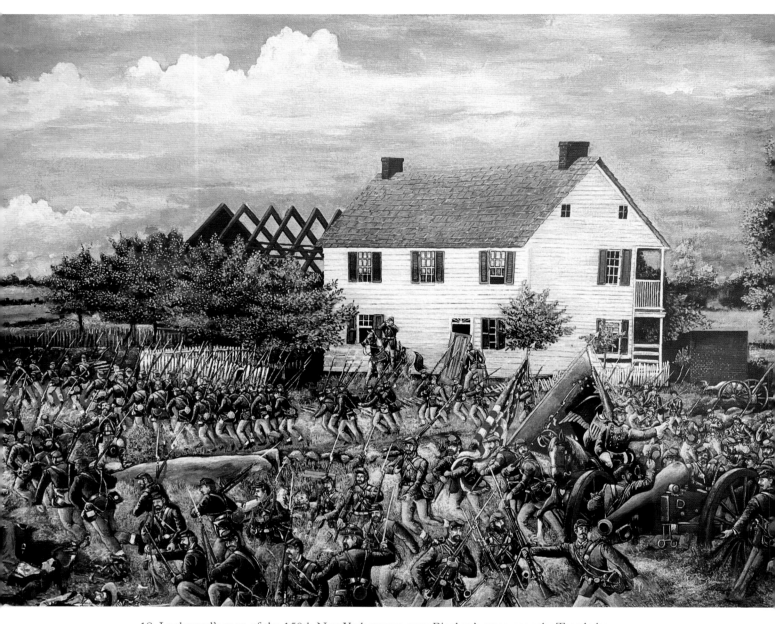

18. Lockwood's men of the 150th New York swarm over Bigelow's guns near the Trostle house.
("Go In, Dutchess County" by James Shockley)

⋙THE EMMITSBURG ROAD⋘

Along the Emmitsburg Road north of the Codori farm, 600 rifles from two Federal regiments—the 82nd New York and 15th Massachusetts—nervously gaped at Ambrose Wright's onrushing Confederates. These Unionists were one of the detachments from William Harrow's brigade; they now manned a line about 160 yards long. They recognized that the enemy line menacingly extended well past both their flanks. Still, they held their ground, balancing their weapons on the plank fence lining the roadway's eastern shoulder. When Wright's phalanx rose up out of a swale 100 yards away, the Yankees lashed the onrushing Georgians with destructive abandon. Brown's cannoneers joined in, lacing Wright's left wing and Posey's Mississippians with shot, shell, and canister. The gray wave shuddered for a moment. Then they unleashed their demonic shriek and closed with their tormentors.

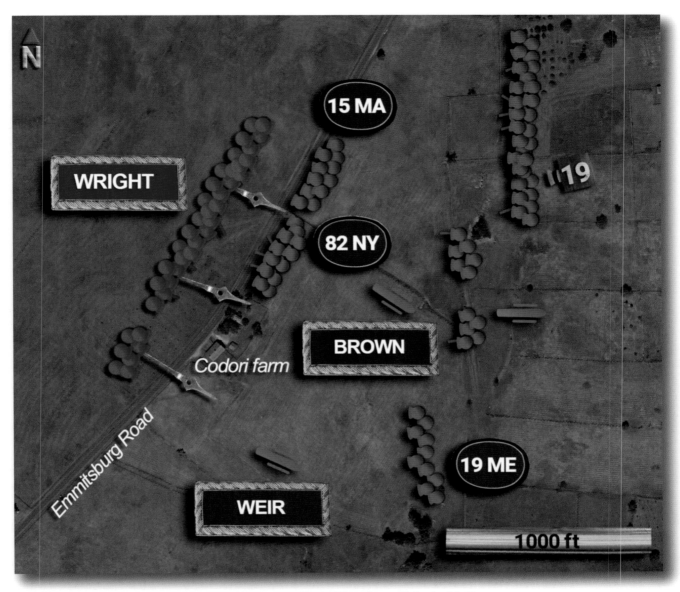

Codori Farm—Early Evening—July 2, 1863
39° 48'38.12 N 77° 14'23.42 W. Google Earth Pro. 9/6/2013. 8/25/2022.

A brutal firefight erupted across the road, ten minutes of deafening cacophony and concentrated mayhem. Part of Wright's right flank regiment—the 2nd Georgia Battalion—looked south and saw the Yankee artillery of Weir and Turnbull pounding Lang's Floridians. They angled away from Codori's and moved to capture the prizes. However, what was left of the 2nd lapped around the New York line north of the farm buildings. With Wright's screaming demons chewing up their left flank, the New Yorkers broke first, followed quickly by their Massachusetts brethren to the north. In a panic, Brown's guns limbered up and raced for the safety of Cemetery Ridge, barely ahead of the exultant Rebels.

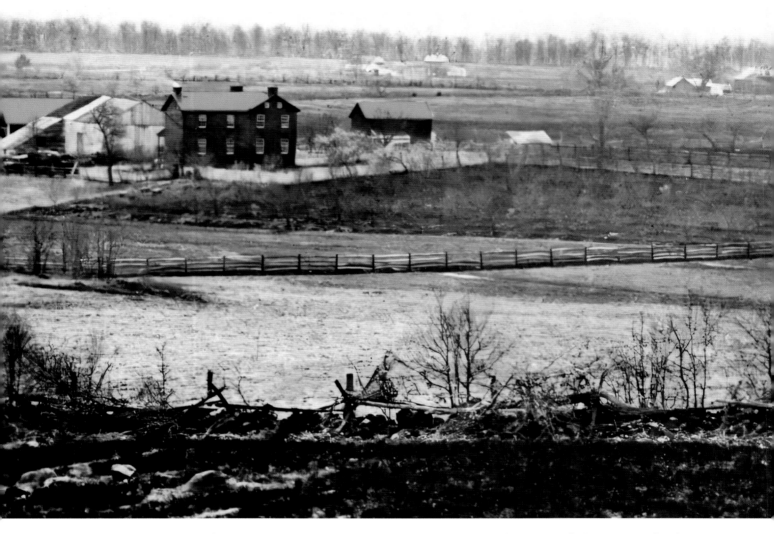

19. Looking southwest from Cemetery Ridge, Rans Wright's four regiments of 1,400 Georgians exit the woods on Seminary Ridge (right distance) and storm across the intervening fields. Waiting for them near the fence "T" (right center) along the Emmitsburg Road is the 82nd New York (left of the "T") and the 15th Massachusetts (right of the "T"), both from Brig. Gen. William Harrow's II Corps brigade.

"Rans" Wright had suffered from illness all day. At this point, no one was sure whether he continued past Codori's with his command. His subalterns however stepped forward and pointed the Georgia boys east. About a quarter mile past the hundreds of fleeing Yankees rose the crest of Cemetery Ridge. As the Confederates rolled forward, enemy musketry began to crease both flanks, and artillery continued to gouge the ranks. Brigade cohesion had taken a hard hit in the just completed firefight, but up ahead, nearly invisible in the mushrooming smoke and the settling darkness, lay victory.

THE PLUM RUN LINE

Their battle blood boiling, Wilcox's and Lang's survivors moved to reduce the last Unionist bastions west of the watercourse. Turnbull's guns had helped defend the 19th Maine's southern flank when two of Wilcox's Alabama regiments and one of Lang's Florida commands muscled through the sheets of canister and overran the guns. A fearful, hand-to-hand donnybrook erupted, and in the melee, only two of the Union cannon escaped. Maine firepower held Florida at bay, but north of the Unionists, Rans Wright's two

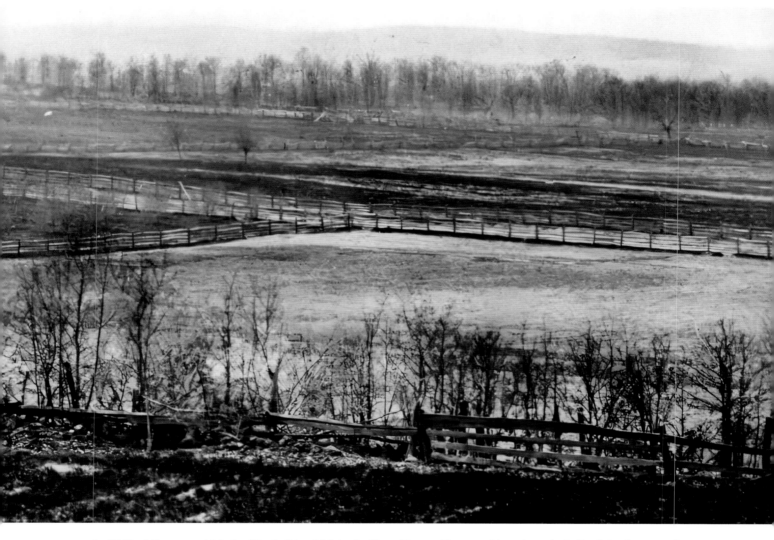

Lt. T. Fred Brown and his 1st Rhode Island Light Artillery: Battery B are positioned south (left) of the fence on the border of the dark field and the green field (center). *(Greg Ainsworth Collection)*

rightmost Georgia regiments—the 2nd Battalion and the 22nd—descended from the Codori fight to swarm consecutively over Manning Livingston's two guns then Gulian Weir's exposed battery. The two regiments Hancock had gleaned from Hall's brigade—the 19th Massachusetts and 42nd New York—managed to retreat to their original positions on Cemetery Ridge. The Rebels meanwhile captured half of Weir's six guns and dispersed the rest. With both their flanks now uncovered, the 19th Maine fell back over the run, but they immediately halted to reform then volleyed with Lang's exhausted troops.

Thomas's Battery on the ridge sprayed the Rebel front with shot and shell, but the only organized infantry in the vicinity were the eight companies of the 1st Minnesota. Hancock rode up. He profanely questioned God if these were his only men. He then pointed at a set of Confederate colors flashing across Plum Run (probably the 11th Alabama's) and ordered the Minnesotans to take them. Led by Colonel William Colvill Jr.—who had just been released from arrest—somewhere less than 300 men and officers double-timed across the intervening field then charged the tangled Rebel line. A close quarters firefight erupted

across the marshy creek banks as each side pounded volleys into the other. Wilcox's three jumbled regiments brutally ravaged the grim Union line, but the Minnesotans refused to budge. The wandering 8th Alabama arrived to add its weight to the firing line, but one of Willard's New York regiments had turned north from its pursuit of Barksdale's survivors and landed on Wilcox's southern flank. Frustrated in front and threatened on his flank, Wilcox reluctantly called off the action and ordered his men to retreat. He and his boys had advanced well beyond their supports, and these Yankees along Plum Run surely had plenty of fight left.

Meanwhile, the 1st Minnesota—all forty-seven of them still standing—staggered back to Cemetery Ridge.

Lang, Wilcox, and Barksdale would go no further.

The Plum Run Line had held.

Born poor with a penchant for hard work, Brig. Gen. Ambrose "Rans" Wright was laboring as a successful lawyer in Augusta, Georgia, when war broke out. He became colonel of the newly formed 3rd Georgia then a brigade commander just before the Seven Days where he performed with skill and competence. His colorless subsequent service had few if any peaks, but he had been a brigadier for a year as he herded his four regiments of 1,413 Georgians onto the Gettysburg battlefield. *(LOC)*

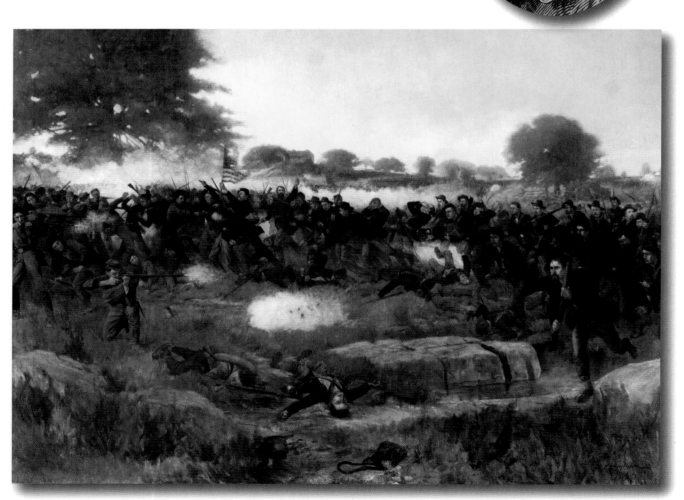

20. The 1st Minnesota slams into Wilcox's Alabamans east of Plum Run and halts the Confederate threat to the Union gap on Cemetery Ridge. The Codori farm sits on the left center horizon. *(Courtesy State of Minnesota)*

CHAPTER 2

A UNION ARTILLERIST ON Cemetery Hill loaded his piece with a shell. His comrades fired it off. It spun west for 1,200 yards and exploded over the Rebel lines south of the McMillan house on Seminary Ridge. A piece of shrapnel slammed into Dorsey Pender's left thigh as he was preparing to advance his division, and his staff placed him in an ambulance to be carried to a hospital. None of his subalterns knew what to do. With their leadership beheaded, Pender's brigades would contribute little to the day's events other than some desultory skirmishing west of Cemetery Hill.

It may have been the most important shot of the battle.

⇜LITTLE ROUND TOP⇝

From the crest of Little Round Top, the sun blazed a dull crimson, frozen just above the distant ridge of South Mountain. The sky itself grew dark, and smoke drifted luridly through the atmosphere. Soldiers filled the Valley of Death from Devil's Den to the Wheatfield Road. Some ran; some walked; some hobbled. Federal cannon on the crest maintained a slow fire, their bursting explosions blindingly illuminating the gloom before fading quickly.

To the west, exhausted Confederate officers rallied their men for one more push. After three hours, the

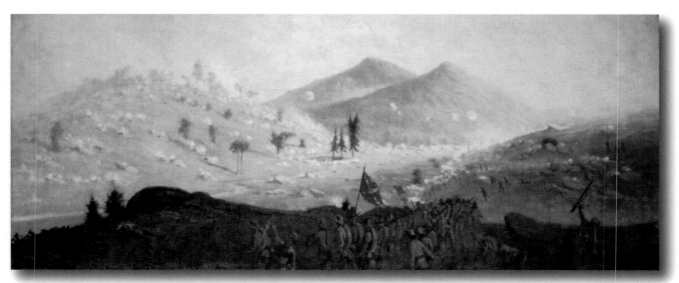

1. Wofford, Anderson, Semmes, and Kershaw's survivors descend the incline from the Wheatfield into the valley of Plum Run (center) to attack the Federal positions north of and on the crest of Little Round Top. Big Round Top looms in the distance. *(LOC)*

Wheatfield was finally theirs, but more work lay ahead. Wofford's boys cleared Trostle Woods and crept east onto the open fields of George Weikert's farm north of the Wheatfield Road. In the Wheatfield, Anderson, Semmes, and Kershaw's troops had violently expelled Ayres's Regulars and now lined the stone wall and woods delineating the field's eastern boundary. More and more crossed the wall and tumbled down the incline to Plum Run. Near the Wheatfield Road and the Weikert farm, some of Wofford's Georgians overran Lieutenant Aaron Walcott's Battery C of the 3rd Massachusetts Light Artillery and started to turn the six pieces on their former owners. Ahead of them ran the Bluecoats, and beyond them in the smoke and the shadows rose Little Round Top. Not 250 yards away, enemy cannon burst in their faces.

Just one more push …

❧

Brigadier General Samuel Crawford had led his two brigades styled the Pennsylvania Reserves—the last of the V Corps divisions to arrive on the field—onto Little Round Top's northern slope. He positioned one of his brigades to extend Weed's line to the north. Now, with Ayres's men in crisis, he sent word to George Sykes asking for instructions. Sykes replied to do as Crawford saw fit. Crawford saw fit to attack.

Crawford located Colonel William McCandless's brigade on a line extending down the lowest incline of the hill's northern slope and across the Wheatfield Road to face the onrushing Rebel mob. Off his right flank, Crawford saw the first of the VI Corps troops enter the sector, Brigadier General Frank Wheaton's brigade now commanded by Colonel David Nevin. These Pennsylvanians and New Yorkers extended the

Union line to the north, but Nevin only had three regiments to deploy. His fourth, the 98th Pennsylvania, had lost its way to the front, and no one knew where it had gone. Behind them, more VI Corps brigades piled up. Further north, Sweitzer and Tilton's survivors from the Wheatfield cauldron formed on Wheaton's right, further plugging the gap on Cemetery Ridge.

When the Regulars straggled through Crawford's lines after their whipping in the Wheatfield, Union artillery peppered the screeching Rebel pursuers. Crawford ordered his troops to deliver a volley when a Union hurrah echoed from up on the hill followed by the rush of a Union regiment down the slope. Somehow Frank Wheaton's wayward 98th Pennsylvania had found its way up Little Round Top in

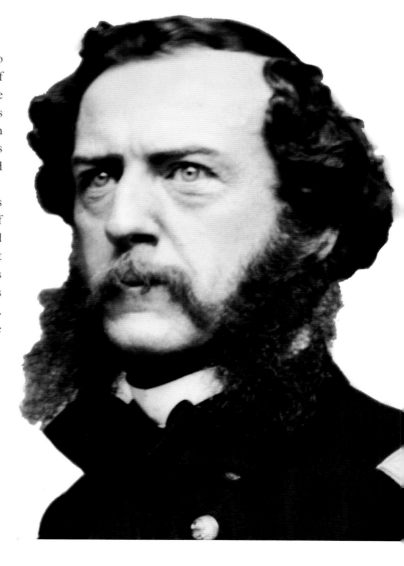

Brig. Gen. Samuel Crawford labored as an army doctor for ten years and held assignment at Fort Sumter when hostilities commenced. When the smoke cleared, he left the medical corps to become a major. Crawford took command of a brigade in April of 1862 and saw severe action at Cedar Mountain. Wounded at Antietam, the side-burned officer returned in May of 1863 to helm his home state's Pennsylvania Reserves in the Washington D.C. defenses. Lee's invasion triggered a general call-up, so Crawford marched north with his two brigades of nine regiments, a total of 2,862 Pennsylvanians ready to defend their state. *(LOC)*

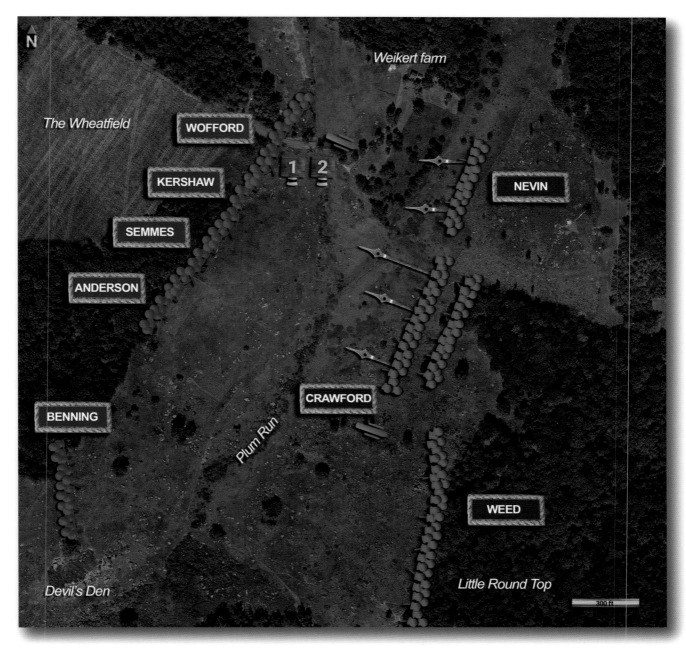

Little Round Top—Early Evening—July 2, 1863
39° 47'38.20 N 77° 14'18.73 W. Google Earth Pro. 9/6/2013. 8/25/2022.

time to see the Rebel advance across Plum Run and decided on its own to meet it. Already committed to action, Crawford called for the charge; the peculiar battle cry of the Pennsylvania Reserves split the air. Astride a beautiful mount, Crawford manhandled the tree-entangled colors from the reluctant flag-bearer (who grabbed the general's leg and ran alongside him through the charge) and led the Reserves himself, forward at the double-quick. North of the Wheatfield Road, Nevin's boys advanced across the Weikert farm and over Plum Run. Even some of the Excelsiors pushed west, much to Andrew Humphreys's dismay. The Confederates all along the line—including Wofford's Georgians opposing Wheaton—held on for what seemed to be an eternity then fell back before the mad Yankee rush.

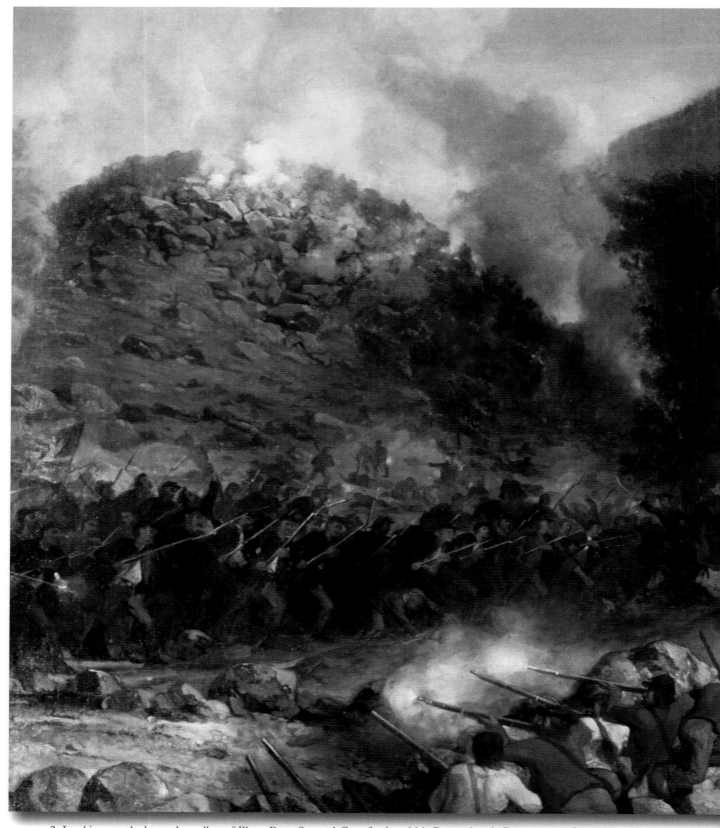

2. Looking south down the valley of Plum Run, Samuel Crawford and his Pennsylvania Reserves confront the remnants of the Confederate brigades that hammered the Federals out of the Wheatfield.

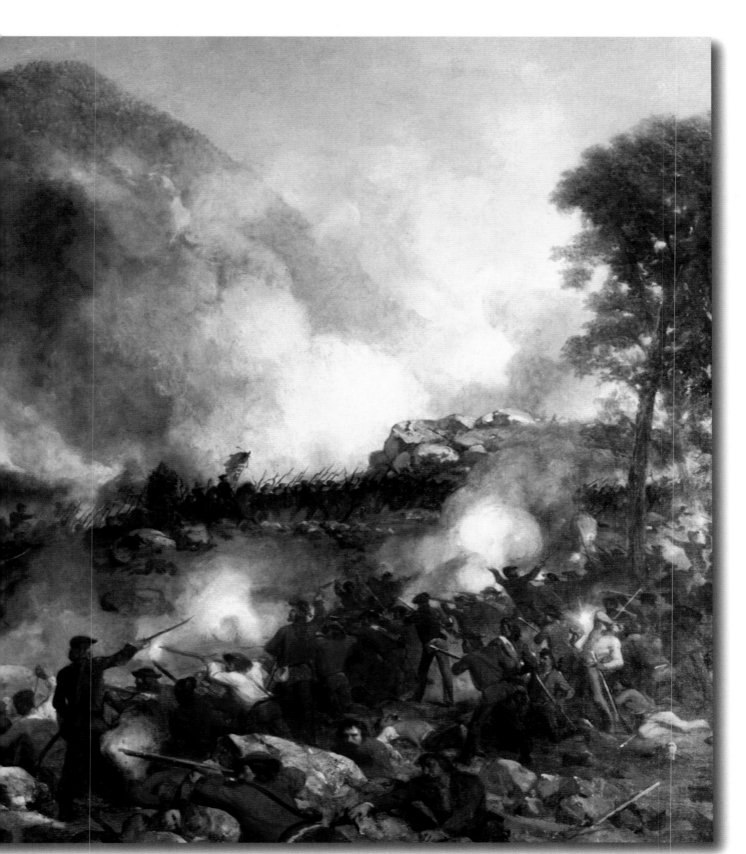

Little Round Top (left), Big Round Top (center), and the woods forming the eastern border of the Wheatfield (right) frame the action. *(Courtesy of The State Museum of Pennsylvania, Pennsylvania Historical and Museum Commission)*

Crawford's cheering Keystoners chased the Georgians and Palmettos up Houck's Ridge, although most of the Rebels recalled withdrawing on their own accord—for good reason. James Longstreet had recalled his boys before Crawford began his attack. For Longstreet, night was falling, and his troops had done all they could do. It was time to end the operation, consolidate his hard-won gains, and look to tomorrow. Just north of the Wheatfield Road, an apoplectic William Wofford ordered his angry Georgians to cede Trostle Woods to Wheaton's advancing Bluecoats without a fight. Wofford would never forgive Longstreet for that retreat order.

Briefly the Confederates disputed Crawford's advance at the stone wall along the Wheatfield's eastern border, but whether it was the Federal weight or Longstreet's orders, the Graycoats soon pulled back into the Wheatfield and sought shelter on Stony Hill and in Rose Woods. The few Yanks who ventured into the blood-soaked wheat met a flurry of Rebel musketry and quickly withdrew.

Fitful sniper fire snapped through the deepening shadows. Wounded moans and cries for help mixed with the shouts of soldiers seeking their units and officers yelling commands. Well to the north, musketry crackled, and artillery boomed. Somewhere the Battle of Gettysburg still raged. But here, as the sun slipped behind South Mountain, the fight for the Wheatfield found its merciful end.

⤳CEMETERY RIDGE⤶

George Meade departed his headquarters in the Leister house and trotted south. Word had come that Union soldiers were pouring east over Cemetery Ridge, so the general called for reinforcements from the nearby I Corps. He then headed for the center of the crisis. About a quarter mile from his headquarters, he found it. To the west, a few hundred yards away, Wright's Georgians appeared out of the gloom in full battle array, rolling up the ridge's incline straight for the clot of horsemen. Meade and his staff were the only Northerners in the area, and Meade steeled himself to fight for the ground. For a single, brilliant moment, the commanding general of the Army of the Potomac and a few members of his staff stared down hundreds of screaming Georgians racing toward the center of the Union's teetering battle line.

Norman Hall had two of his remaining regiments a little to Meade's right, manning a line south of a clump of trees. About 300 rifles in all. Their volleys blindingly exploded in the darkness and ripped into the Rebel mob. North of the copse, Brigadier General Alexander Webb's II Corps brigade of Pennsylvanians wheeled to the left and lashed Wright's northern exposure. The left half of Wright's brigade bloodily went to ground a few dozen yards west of the tree copse.

The right half of Wright's wave rolled on past Hall's flank and reached the ridge crest. The 22nd Georgia planted its flag on the heights. Victory.

A regiment of Vermonters arrived first, designated the 13th. They were battle rookies, part of the I Corps brigade of garrison troops from Washington D.C.'s defenses. Hancock pointed to the three groups of abandoned Federal artillery off in the smoke-enshrouded distance and asked if they could retake them. They cheered lustily and rushed into the breach. To the south, a rallied gang of Andrew Humphreys's boys tore at the Georgian right flank, and the screaming 19th Maine flashed their bayonets and counterattacked the Floridians near Turnbull's abandoned guns. Then more elements of Doubleday and Robinson's I Corps divisions thundered up. The panting I Corps men hustled past Meade to support the battle-crazed Vermonters. Ambrose Wright would later opine that the whole Yankee army was up on that ridge. In the enveloping darkness, it may very well have appeared so. Hemmed in on three sides in a ring of fire, Wright's boys fell back off the bloody slope.

Union pursuit from the various brigades took the Northerners all the way to the Emmitsburg Road. In the process, they recovered Turnbull's, Livingston's, and Weir's lost guns. The Yankees also collected a passel of prisoners, mostly winded Rebels who could go no further. Then, in a strange twist, dozens of supposedly deceased Federals rose from the fields, having lost their need to play dead to avoid capture. Eventually all the Northerners were recalled and returned to their posts, the battle for the ridge ended, the gap officially closed.

Their cheers split the darkness.

Meade the victor.

Hancock the superb.

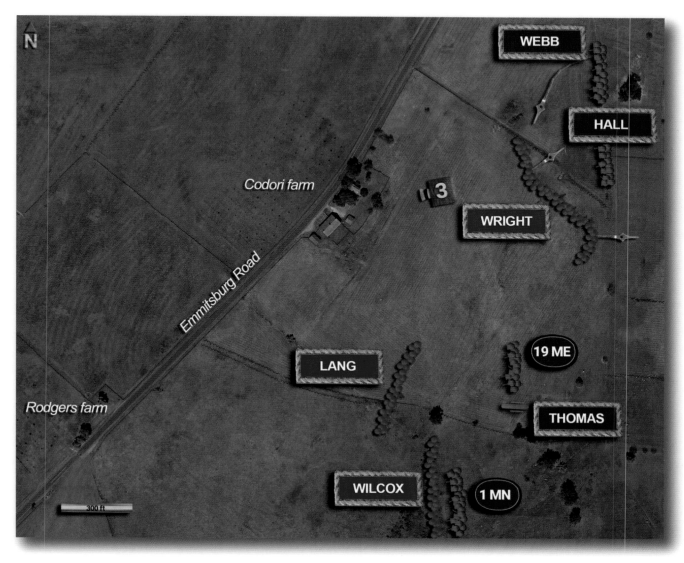

Cemetery Ridge—Early Evening—July 2, 1863
39° 48'38.12 N 77° 14'23.42 W. Google Earth Pro. 9/6/2013. 8/25/2022.

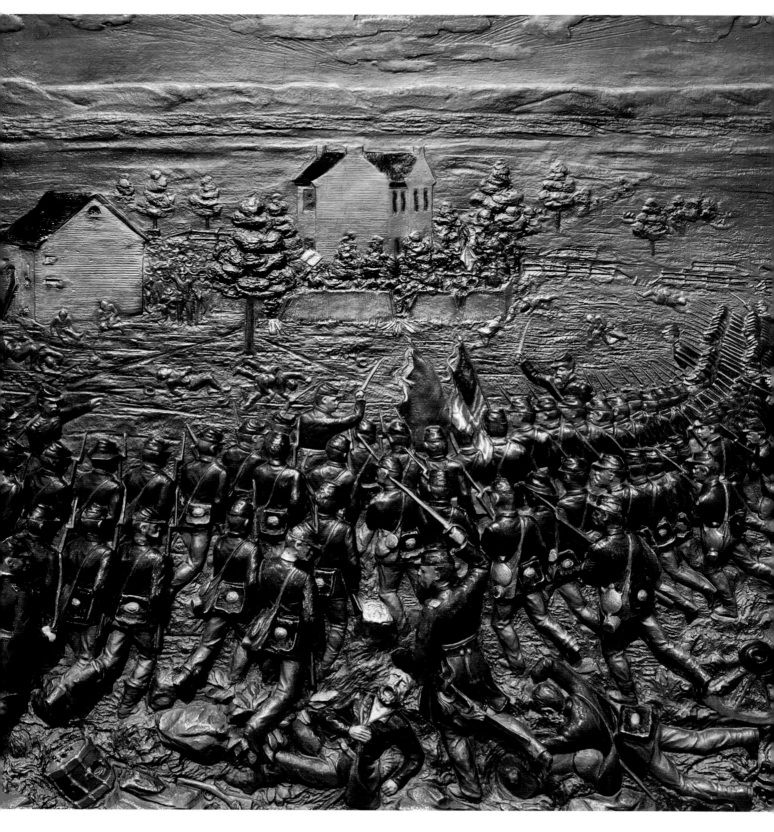

3. The men of the 13th Vermont pursue Wright's Georgians all the way to the Codori farm on the Emmitsburg Road. *(GNMP, Photo by John Kamerer)*

Vigorous, harsh, and an army lifer, Brig. Gen. George Greene could brag about being the oldest general at Gettysburg. A Rhode Islander who graduated 2nd in West Point's class of 1823, Greene left the army to take on high profile civil engineering projects all over the country. He rejoined in January of 1862 to lead the 60th New York, and by May, he commanded a brigade in John Pope's ill-fated Army of Virginia. Greene bounced between brigade and division command in the XII Corps where he always performed competently. His all-New York brigade lining Culp's Hill numbered 1,424 men in five regiments. *(LOC)*

Maj. Gen. Edward Johnson had spent much of the war recuperating from a May 1862 ankle wound at the Battle of McDowell. Virginia-born and Kentucky-bred, Johnson graduated from West Point and promptly distinguished himself in the Mexican War. Early in the Civil War, Johnson commanded a brigade-sized "army" in the Allegheny Mountains—hence the nickname "Allegheny"—but after McDowell, he repaired to Richmond, Virginia, where he scandalized society with his brutish manners and ungentlemanly amorous adventures. He rejoined the army after Chancellorsville, something of a surly outsider who engendered neither respect nor love from the 6,366 men in his four brigades. *(LOC)*

❧CULP'S HILL❧

He was something of an anomaly in the Army of the Potomac. Brigadier General George Greene had just turned 62 years old, practically an ancient in this young man's fight. He had been out of the army for twenty-five years when the war broke out. Unlike many of his fellow officers, he had taught engineering at West Point and appreciated the benefits of breastworks. On the higher northern reach of Culp's Hill, his brigade of New Yorkers had spent the day constructing a solid line of entrenchments across the military crest of the heavily forested eminence. The noise of their efforts caused no little consternation among the Southerners

waiting to assault the place. What the Rebels didn't know—and what no doubt caused an equal amount of worry for Greene—was that the lower southern stretch of the hill had been stripped of most of the defenders when the Sickles's experiment went awry. With Brigadier General Alpheus Williams's division and two of Brigadier General John Geary's three brigades gone to bolster the Union left, only the 1,400 rifles of Greene's five New York Regiments and the bloodied remains of Wadsworth's I Corps division manned Culp's impressive trench system. Facing them 1,500 yards to the northeast stood the 4,700 soldiers from Major General Edward "Allegheny" Johnson's three-brigade division.

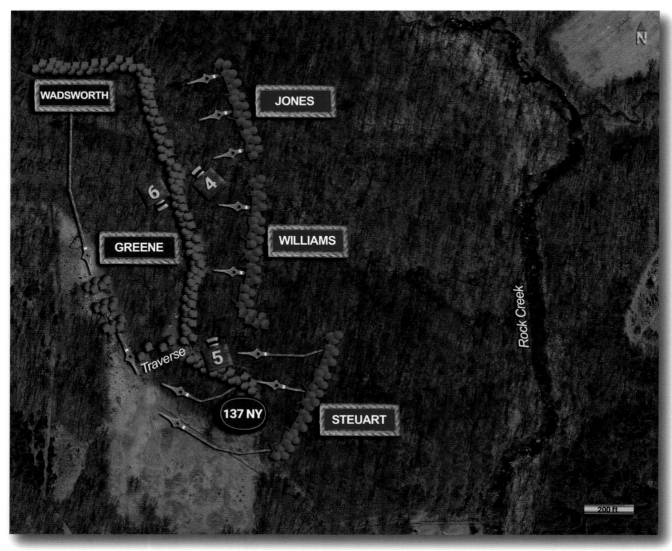

Culp's Hill—Early Evening—July 2, 1863
39° 49'03.37 N 77° 13'02.58 W. Google Earth Pro. 9/6/2013. 8/25/2022.

Richard Ewell didn't like the idea of attacking the twin hills in daylight. The failed afternoon artillery bombardment from Benner's Hill only confirmed his worst fears. Lee, however, had ordered his corps commander to launch a diversion to support Longstreet. Ewell in turn ordered Johnson to assault Culp's Hill followed in time by Jubal Early's attack on the cemetery. Ewell sent word to Pender off to the right to request cooperation with the movement, unaware that Pender was hors du combat. The clocks approached 7:00 p.m. Dusk, and darkness, a bare twenty-nine minutes away.

Johnson should have had more rifles, but a seemingly insignificant skirmish a mile east of his left flank drained some of his manpower. Early that morning along the Hanover Road, XII Corps Federals had exchanged shots with the renowned Rebels of the Stonewall Brigade, then part of Johnson's division. Eventually the Yankees withdrew as did their comrades from the V Corps, leaving the skirmishing to Brigadier General David McMurtrie Gregg's two strained brigades. Brinkerhoff Ridge, a north-south spine a little over two miles from downtown Gettysburg, anchored the Stonewalls as they dueled with dismounted units from Colonel John McIntosh's brigade advancing from the east. Little came from the fighting, and few casualties registered, but Johnson's inability to call on the Stonewall Brigade would deeply affect the next two hours.

Greene had spread out his command to occupy as much ground as possible, stretching his brigade to cover space usually allotted for a division. As darkness began to envelop the hill's wooded slopes, Greene detected Johnson's approach out to the east. His call for reinforcements would be answered by James Wadsworth with three regiments and Oliver Howard with four, but up at the crest, they were barely needed.

The woods prevented effective Union artillery fire, yet the Rebels still became disordered splashing across Rock Creek and taking fire from Greene's skirmishers. After reorganizing his boys west of the creek, Brigadier General John Jones threw his five Virginia regiments against the hill's steepest incline. A few braves made it within thirty feet of the blazing Yankee lines, but the brigade collapsed into a mob in the boulder strewn darkness and were able to inflict but few casualties on their well-protected opponents. A bayonet charge by one of Greene's New York units then gathered up 50 Rebels, two officers, and two flags. To the south against a somewhat lower elevation, Colonel Jesse Williams's five Louisiana regiments experienced much the same thing. Greene's well-conceived layout created interlocking and converging fields of fire that punished the Southern attackers. About 100 yards from the New Yorkers's entrenchments, the Louisianans ground to a bloody halt. Every subsequent effort to come to grips with the Yankees failed in similar fashion.

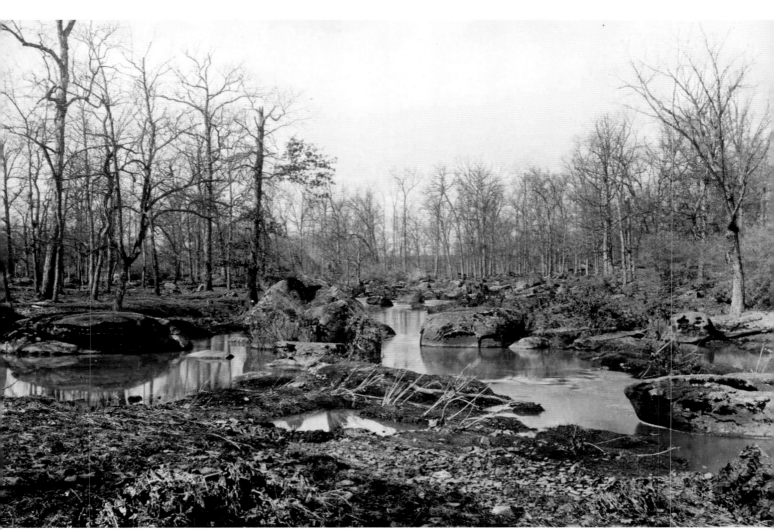

Pictured here at the turn of the 20th century, Rock Creek presented the first formidable obstacle to Allegheny Johnson's Confederate advance. The broken ground and occasionally deep depths broke up their formations as the Southerners crossed from left to right to assault the Federals on Culp's Hill. *(Sue Boardman Collection)*

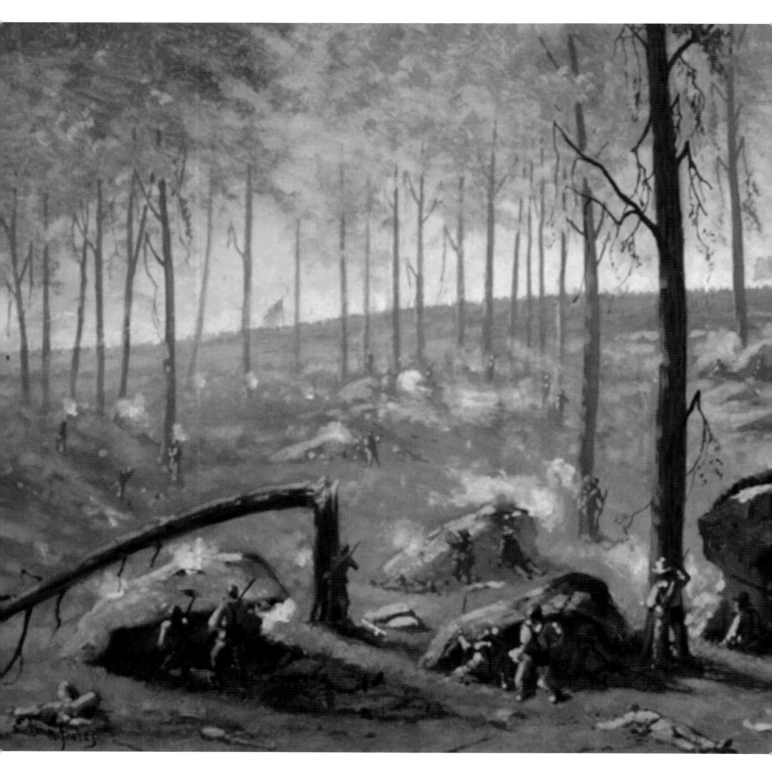

4. George Greene's blazing line at the peak of Culp's Hill (right center distance) pummels Allegheny Johnson's piecemeal attacks on the Yankee bastion. *(LOC)*

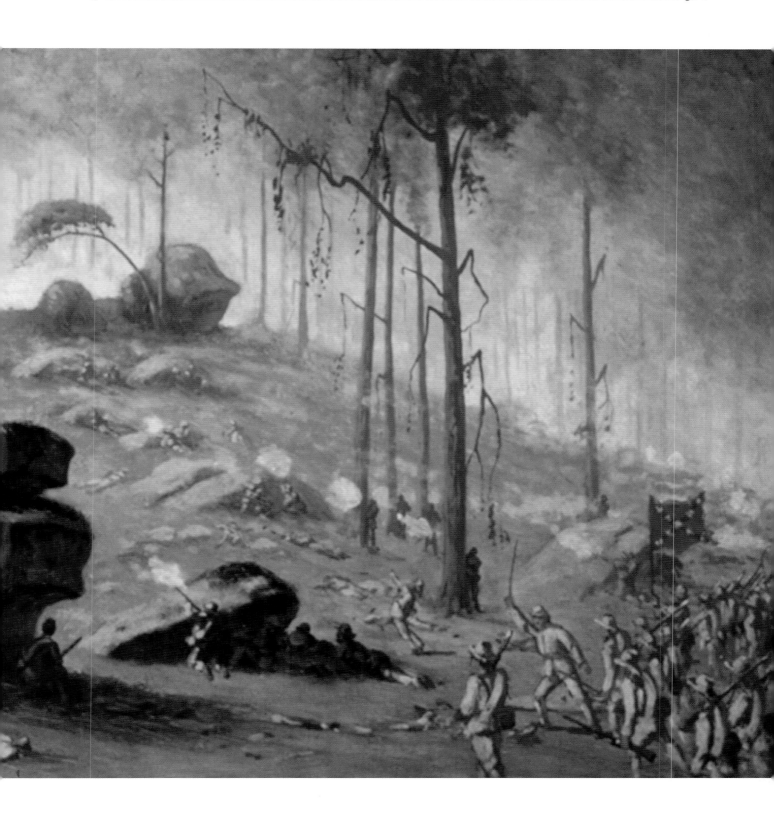

On the Confederate left flank, Brigadier General George Steuart's command got off to a poor start. His two rightmost units waded Rock Creek and advanced nearly in line with the Louisianans. His remaining four regiments however were delayed by Rock Creek's depth and fell well behind. Steuart's two orphaned regiments joined the futile effort to attack Greene's dug-in Yankees on Culp's upper heights. They unknowingly pushed into a cul-de-sac between two New York regiments and got hammered. A North Carolina unit sent to relieve them instead fired into their backs, a friendly fire incident typical of night fighting.

Steuart's remaining four regiments meanwhile emerged from the creek's vale and advanced on Culp's lower inclines. On the far left, the stunned 10th Virginia met no resistance and flooded into an abandoned trench line near the hill's base. They wheeled right and ascended the hill, first fighting off a Pennsylvania unit then scorching the right flank of the 137th New York and pushing the Yanks further north. Taking enormous casualties, the Empire Staters fell back to a fortuitously well-designed traverse—another result of Greene's forethought—and battled the breakthrough.

The 10th Virginia was joined by two more Old Dominion regiments, but Union reinforcements began to flood the zone. Two XI Corps units from von Amsberg's brigade swung around the traverse and hit the 10th Virginia's left flank. Three I Corps regiments then arrived and crowded into line along the traverse. Their rifles blasted back the Virginians,

Whispers of heavy drinking dogged Virginia native Brig. Gen. John M. Jones, a competent staff officer for Richard Ewell and Jubal Early. His West Point pedigree notwithstanding, Jones's received his first line command—a brigade of 1,453 troublesome Virginians in six regiments— just six weeks before Gettysburg. Both the men and the general they called "Rum" needed watching as Robert E. Lee cryptically remarked that Jones would resign immediately if he failed his duty. *(LOC)*

A Connecticut orphan who inherited a fortune, Brig. Gen. Alpheus Williams graduated from Yale law before settling in Detroit, Michigan, in 1836. He pursued a number of interests: Detroit's postmaster, a judge, a newspaper owner, and a bank president. He became active in a Detroit militia unit that marched to Mexico but saw no action. With the guns of Sumter, Williams became a brigadier then a division commander seven months later, seeing heavy action at Cedar Mountain, Antietam, and Chancellorsville. His 15-month tenure as a division head was the longest in the army, yet he remained a brigadier, perhaps owing to his non-West Point education, or perhaps owing to his admittedly soft-war tendencies. Extremely solicitous of his troops's well-being, Williams's men—all 5,256 of them in three brigades of fourteen regiments— loved him. *(LOC)*

allowing the fought-out New Yorkers of the 137th to pull back behind the I Corps phalanx. The Rebels retreated before the blazing Yankee bastion, and their incursion ground down to a halt.

With night fully fallen, the van of the XII Corps arrived from their relief expedition to find their entrenchments occupied by Rebels. In the darkness their officers had no desire to try to retake them and instead camped where they could for the remainder of the night. After roundabouting through the darkened fields and forests, a perplexed Colonel George Cobham finally halted his brigade on the Baltimore Pike near the traverse. Colonel Silas Colgrove's brigade returned to their unoccupied earthworks on a detached rise a few hundred yards south of Culp's Hill, while Colonel Archibald McDougall and General Henry Lockwood camped their commands west of Colgrove. Colonel Charles Candy guided his exhausted regiments up the Spangler farm lane to Greene's relief on Culp's upper hill. By the time they all came to rest, the men of the XII Corps had completely surrounded the Confederate breakthrough.

However, for corps commander Alpheus Williams, taking back the lower hill would have to wait for tomorrow.

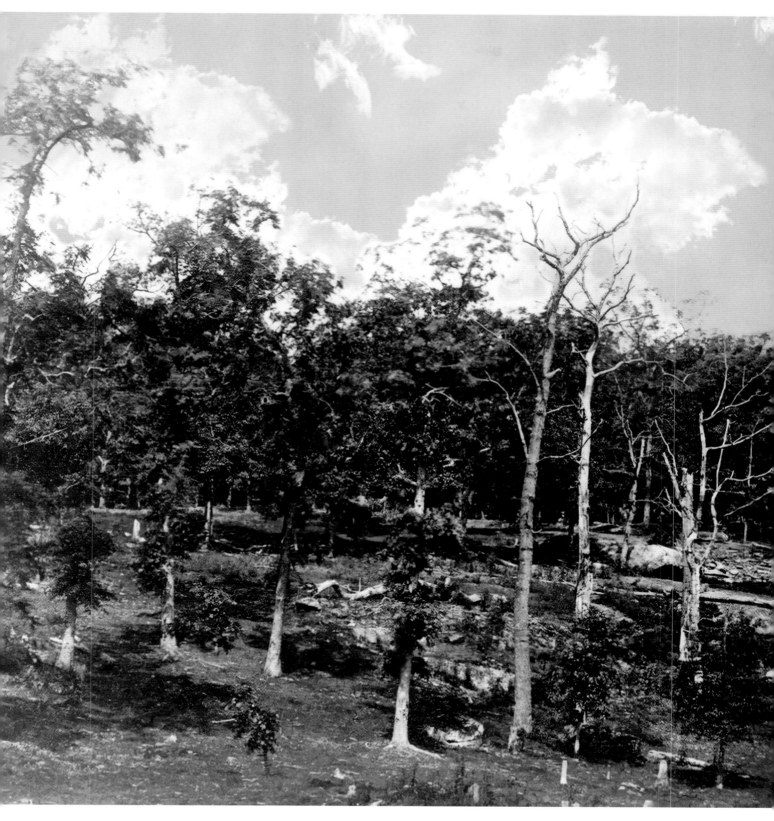

5. Looking northwest from Greene's entrenchments on Lower Culp's Hill, the Federal works on the upper hill are barely visible along the distant tree line. Taken four years after the battle, this desolate area marks the approximate location of Maryland Steuart's friendly fire incident. *(LOC)*

6. Greene's powerful works near the peak of Culp's Hill a few weeks after the battle. *(LOC)*

⭒CEMETERY HILL⭒

Oliver Howard had spent the previous twenty-four hours preparing his defenses as best he could. As with all things XI Corps, doubts remained. Schurz's and Steinwehr's XI Corps divisions buttressed twenty-five cannon covering the western slopes of Cemetery Hill. Their positions seemed fairly secure. More concerning was the infantry defending East Cemetery Hill. In light of Francis Barlow's wounding and evident capture, Adelbert Ames now commanded Howard's third division, troops who had been soundly thrashed by Early's Rebels north of Gettysburg the day before. They manned a stone wall at the northeastern base of the hill that ran along a track called Brickyard Lane. On the left of the line closest to town, Colonel Andrew Harris led Ames's former brigade, about 750 rifles. One Ohio unit and part of another refused the left flank of the line to face directly north as they took advantage of the hill's rise. Still, the center of the formation remained undermanned, while Colonel Leopold von Gilsa's bloodied 700 infantrymen

7. A postwar view looking north from Stevens's Battery, Gettysburg (center distance) rises over the intervening fields. Brickyard Lane and the XI Corps line at the base of East Cemetery Hill are barely visible in the trees near the left border. Hays's brigade exited the town proper and performed a tight right wheel to hit the Federal lines. Avery's force jumped off further to the east (right) and executed a much wider right wheel, exposing its left flank to Stevens's gunners. *(LOC with thanks to Greg Ainsworth)*

extended the line to the right. The 33rd Massachusetts from Colonel Orland Smith's brigade in Steinwehr's division arrived to anchor the right flank. Other than these 490 fresh rifles, Ames counted around 1,450 soldiers in his battered command. He had little trust they could stand another day in battle.

It was almost dark, and as the musketry swelled on Culp's Hill, Jubal Early ordered his division forward. His men had spent the day baking under the sun and hidden in Gettysburg's side streets almost directly north of Ames's angled formation. Two brigades comprised the Rebel front: Harry Hays's Louisianans on the right and Colonel Isaac Avery's three North Carolina regiments on the left. The Confederates dressed ranks, then started to execute a right wheel to attack Ames's men lining Brickyard Lane head on. Almost immediately, Stevens's Battery on its perfectly situated knoll between the twin hills raked the Rebel formation, dropping Avery with a mortal wound and pushing his troops to the north. Right after,

Wainwright's twenty-two guns along the hill's eastern crest roared into action. At a range of 800 yards and closing, the sheets of canister ripped into the Confederate infantry. But, as they always seemed to do, on they came.

Meantime, Robert Rodes directed his division west out of Gettysburg then south and east toward Cemetery Hill. He was busy trying to align his five brigades for action when the fighting to the east detonated. In the darkness and attendant confusion, he simply wasn't ready to support Early's attack.

Oddly, Oliver Howard later admitted that it wasn't until this point that he realized a battle had been joined on his front. Back on Cemetery Ridge, however, Winfield Hancock heard the noise rising from the twin hills. On his own stead, he ordered Colonel Samuel Carroll to rush his brigade from Hays's II Corps division to the sound of the fight. Carroll's Indianans, West Virginians, and Ohioans pounded north into the twilight.

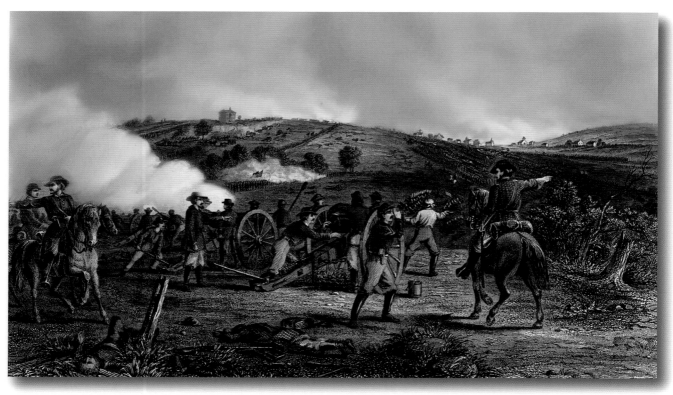

8. Capt. Greenleaf Stevens and his 5th Maine Artillery: Battery B man the knoll between Cemetery Hill (center distance) and Culp's Hill (off-frame to the right). Stevens was wounded earlier in the day, and Lt. Edward Whittier commands the guns that shredded Early's attack. *(LOC)*

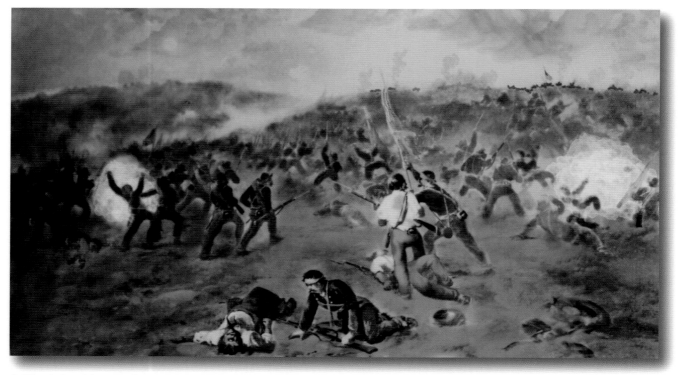

9. Hays's Louisianans (foreground and right middle distance) ignore the Federal artillery barrage from Stevens Knoll (far left distance) and East Cemetery Hill (right distance) to overrun the Union salient and begin their ascent of the heights. *(GNMP)*

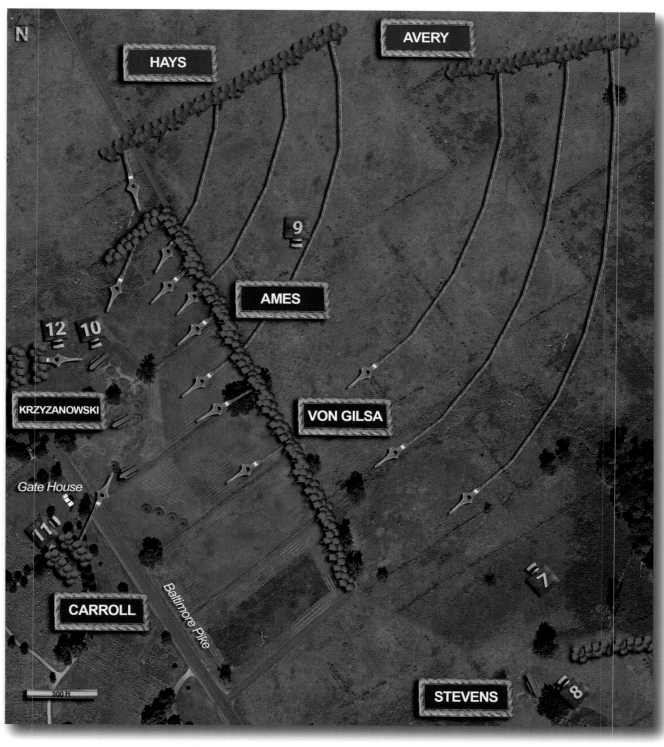

Cemetery Hill—Early Evening—July 2, 1863
39° 49'15.05 N 77° 13'38.06 W. Google Earth Pro. 9/6/2013. 8/25/2022.

In the opposite direction amidst the billowing smoke of artillery explosions and crashing waves of volleyed musketry roared Early's demons. The Louisianans had the shortest distance to cover and hit first, crushing the two Ohio units holding Ames's left flank and pouring over the undermanned wall in fierce close combat. Harris's Unionists broke up the hill and scattered past Captain Michael Wiedrich's Battery I of the 1st New York Light Artillery on the crest, but the German artillerists refused to give in. As the Louisianans stormed up the hill, a wild melee broke out among the guns with some of Harris's Buckeyes returning to join the fight. Hays sent back for reinforcements, but John Gordon claimed he had no orders to move his brigade. The crazed Louisianans fought on alone. Col. Wladimir Krzyzanowski on the other hand reacted quickly and led the 119th New York across the Baltimore Pike and into the fray.

Further down Brickyard Lane, the 33rd Massachusetts and Stevens's gunners smashed the Carolinians on the outer edge of the wheel and drove them back. The New Yorkers in the center of von Gilsa's brigade also held for a moment, but Avery's

boys quickly ripped through the tremulous Germans and rolled up the hill. In their sights stood Captain Bruce Ricketts and the 1st Pennsylvania Light Artillery, which chief artillerist Henry Hunt had designated the key to the entire position. Like Wiedrich's people, Ricketts's artillerists had no intention of giving up their weapons. Another wild donnybrook exploded with Louisianan and North Carolinian infantry battling Pennsylvanian cannoneers. Hand spikes, rocks, clubs, anything came into play as the two sides death-gripped in the raging darkness.

As the fighting peaked, Harry Hays saw troops approaching from the west that he hoped against hope were Robert Rodes's. Accordingly, he ordered some of his Tigers to hold fire. Instead, his boys were hit by Krzyzanowski, and his XI Corps regiments were followed quickly by two regiments under Carl Schurz. The combined Federal weight brutally drove the Tigers past Weidrich's guns and off the heights. Further south, Samuel Carroll's sprinting Unionists led by the 14th Indiana knifed past the cemetery gatehouse on the Baltimore Pike and plowed through a vortex of jammed caissons, rearing horses, and panicked

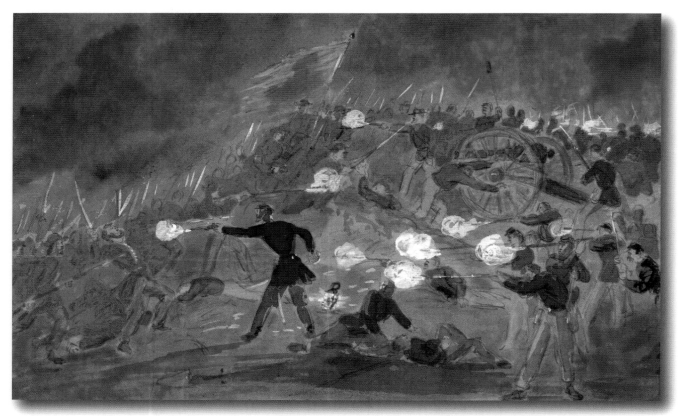

10. The Louisiana Tigers crest East Cemetery Hill and overrun Weidrich's Battery. *(LOC)*

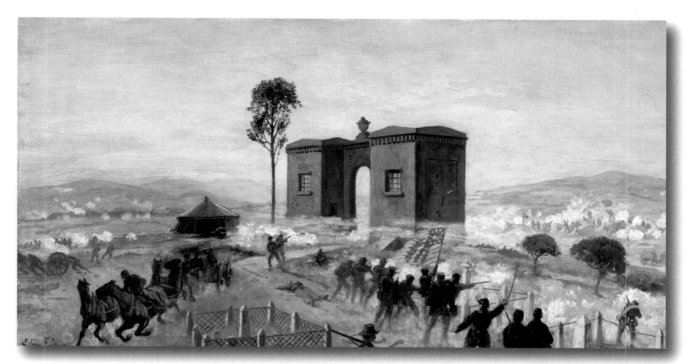

11. As Early's infantrymen battle Union cannoneers among their guns (right distance), Krzyzanowski (left distance) and Carroll (right foreground) arrive in response to the attack. *(LOC)*

Unionists. Ahead in the flickering darkness blazed the brawl for Ricketts's guns. Carroll's boys let out a cheer, triggered one volley, then crashed into the melee. Their combined force drove the overwhelmed Rebels down the hill and across the wall and lane.

As the Southerners disappeared in the darkness. Carroll called his men to halt and pulled them back to the wall along Brickyard Lane. While Harris, von Gilsa, and Ames's bedraggled troops returned to their original positions, Ames begged Carroll to stay there as he had no confidence his Germans would hold the position. Carroll's temper burst. He damned Ames for his distrust then expanded his spleen to include the entire XI Corps, officers and men included. Again, an unaccountable German rupture had to be plugged by

A West Point grad from a prominent Washington D.C. family, Col. Samuel Carroll enjoyed the confidence of his superiors and the respect of his men, a potent combination for the dashing, young, and vigorous officer. Carroll began the war as colonel of the 8th Ohio, but he took on brigade command in May of 1862. He remained there despite compiling a sturdy service record, most likely because of a blistering (and probably unfair) condemnation from his superior at the Battle of Port Republic. Still, his command—976 troops in four regiments—called themselves "Sam Carroll's Men," and that alone is tribute enough. *(LOC)*

troops from outside Howard's corps, and Carroll—a veteran of Chancellorsville—had had enough. Still, he reluctantly hunkered down with his three regiments along Brickyard Lane among the dead and the wounded of both sides and peered out into the night.

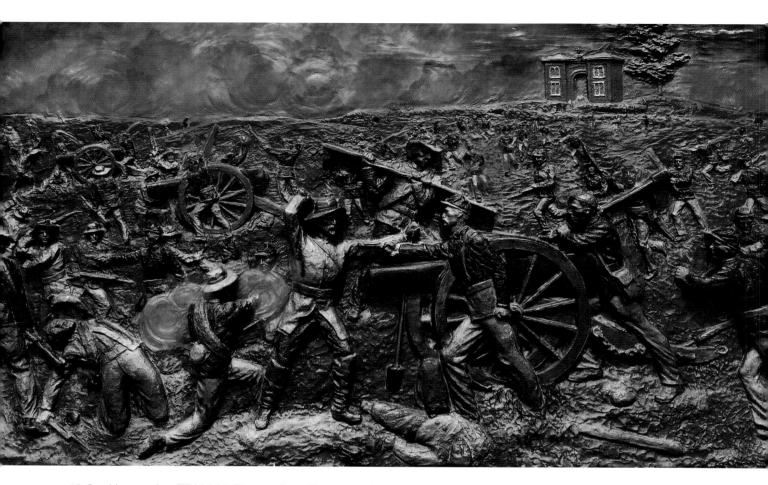

12. Looking south at Weidrich's Battery, Carroll's troops (right mid-distance) and Krzyzanowski's boys (right foreground) crash into Early's division and drive them down the hill. *(GNMP, Photo by John Kamerer)*

❧THE LEISTER HOUSE❧

Hancock stood near Ziegler's Grove when Eliakim Sherrill marched his Harpers Ferry cowards back from their sturdy work at Plum Run. Hancock indignantly questioned why they had abandoned the front and ordered Sherrill under arrest, even though Willard had ordered the withdrawal just before he was killed. The Harpers Ferry cowards found themselves again under a cloud.

❦

With a certain amount of satisfaction, George Meade sat down around 8:00 p.m. and apprised titular General in Chief Henry Halleck of the day's events. After four hours of battle, the desperate enemy attacks all along the line had been repelled. The cost had been high, so much

so that he had yet to determine how many men would be available for tomorrow's operations. Of one thing he was sure: the Northerners had given as good as they got. After Meade sent off his report, Colonel George Sharpe of the Bureau of Military Information delivered a revealing intelligence briefing to Meade, Hancock, and Slocum. The army presently held prisoners from almost 100 enemy regiments representing every Confederate brigade except those in Pickett's division. Meade could make a quick and easy calculation. He had John Sedgwick's fresh VI Corps to counter Pickett's command for Friday's upcoming fight. Hancock was elated and declared the battle practically won. Still, Meade wanted to discuss the situation with all of his people. He called for a council of war.

Within an hour, Meade's corps commanders—including John Gibbon and Alpheus Williams—along with chief of staff Daniel Butterfield, Henry Hunt, and

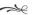

A bespectacled George Meade oversees his council of war. *(LOC)*

Gouverneur Warren all shoehorned into Leister's twelve-by-twelve-foot home. A single candle shed flickering light, and cigar smoke wrapped the participants. Warren promptly went to sleep, and the rest engaged in brief conversation, whereupon the meeting got down to business. Meade queried as to the condition of his army. His subalterns agreed they still had about 58,000 effectives. David Birney declared his III Corps useless, but Howard felt his suspect XI Corps could hold Cemetery Hill—perhaps as long as Samuel Carroll's brigade remained. There was talk of consolidating the army's position east of Rock Creek. A possible retreat to the ever-alluring Pipe Creek line at the Maryland border was also floated. Supplies were low, and such a move would place the army closer to its depot at Westminster, Maryland.

Butterfield spoke up. He asked for a vote whether the army should stay or fall back on its supply line. All wanted to stay, but the left flank near the Round Tops needed adjustment. Should the next day's fight be offensive or defensive? All strongly thought that remaining on the defensive was the best bet. Finally,

Butterfield asked how long they should wait to be attacked. One day, at the most. Meade liked what he saw, a conviction radiating from his lieutenants that they were winning this thing, the many setbacks be damned. He quietly agreed with their assessments, and the council ended.

Before he left, Gibbon approached Meade. Birney had grumbled about matters of rank concerning Hancock's assignment over the III Corps during that day's crisis, and the army commander curtly dismissed the complaint. Alone, Meade and John Gibbon shared some final thoughts. As a division commander, Gibbon had felt some misgivings attending a war council, but Meade warmly said he wanted Gibbon there. The commanding general then told the officer that since Robert E. Lee had attacked both flanks and failed, he would no doubt target the Union center tomorrow. That would be Gibbon's front. A tough and eager fighter, Gibbon said he certainly hoped so.

Gibbon then departed, joining the rest of Meade's lieutenants riding into the night to ready their boys for day three.

⧼THE THOMPSON HOUSE⧽

No such spirit infused the Army of Northern Virginia. From one end of the line to another, the general sense permeated the Confederate officer corps that July the Second's operation had been badly bungled. "Disjointed" and "unsupported" seemed to be the operative phrases in a litany of complaints. The terrain had prevented Hood from landing a coordinated blow. There was Pender's wounding, Hood's wounding, Barksdale's wounding, so many woundings. A.P. Hill appeared to be invisible and had left Richard Anderson isolated. Anderson himself had done nothing to manage his brigades. McLaws had started too late to support Hood. Wright was late supporting Wilcox and Lang. Rodes was late assisting Early. And no accord meant no results.

The bloodletting had been fierce and the losses staggering. Lee baldly admitted the day had not been as successful as he had hoped. Still, he held no council of war. Unlike every other battle they had fought together, Lee had no face-to-face with the recalcitrant Longstreet, and he didn't seek the opinions of the chimeric A.P. Hill or the tight-wired Richard Ewell. Struggling with his bad heart and unremitting diarrhea, at around 10:00 p.m., Lee issued orders for July 3. With the support of E.P. Alexander's artillery at the Peach Orchard, Longstreet would continue the assault on the enemy's left with the addition of Pickett's newly arrived division. Ewell meantime would enlarge on his gains at Culp's Hill. Again, the Yankee flanks would be tested, again the Yankees would panic, and the indomitable scarecrows of Lee's Army of Northern Virginia would pancake the Yankee army and win this final battle.

The assaults would begin at daybreak.

Just one more push…

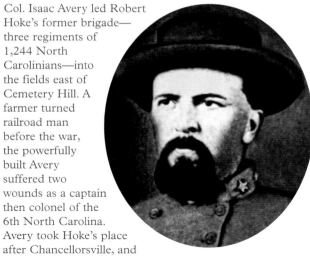

Col. Isaac Avery led Robert Hoke's former brigade—three regiments of 1,244 North Carolinians—into the fields east of Cemetery Hill. A farmer turned railroad man before the war, the powerfully built Avery suffered two wounds as a captain then colonel of the 6th North Carolina. Avery took Hoke's place after Chancellorsville, and Gettysburg would be his first battle in brigade command. *(Biographical History of North Carolina, Vol. 7)*

Lee chose not to meet with any of his lieutenants. The next day's operations would be his and his alone. *(LOC)*

Hit during the attack on East Cemetery Hill and lying in the field mortally wounded, Avery asked a staffer for pencil and paper. His right arm hung uselessly, but he managed to scrawl a note with his left hand that read, "Major, tell my father that I died with my face to the enemy. IE Avery." *(North Carolina Department of Natural and Cultural Resources)*

CHAPTER 3

AS NIGHT CLOSED, AN unearthly moan punctuated by screams and supplications rose from the battlefield. Ghouls darted about, rifling dead bodies for booty. Rooting hogs tore at the corpses. Occasional picket fire cracked, but an unofficial truce was declared by no one in particular. Unlike the night before, part of the battlefield had become a no-man's-land, and a lot of soldiers were about to comb over it on missions of mercy. This work of collecting the wounded in the dark was hard enough. They didn't need people shooting at

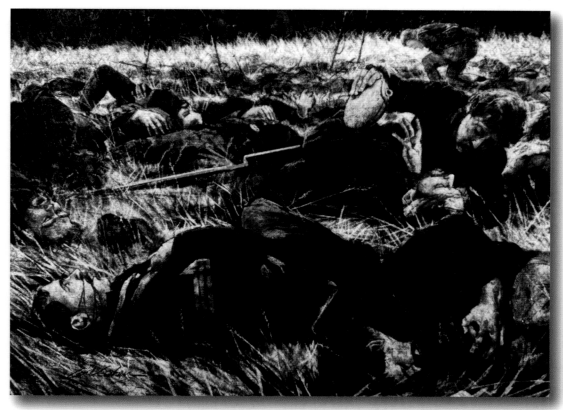

The battle's aftermath in the Wheatfield proves to be especially hellish. Crews from both sides have difficulty accessing the area that had become a particularly dangerous no-man's-land. For the time being, the wounded there are on their own. *(GNMP, Photo by John Kamerer)*

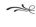
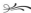

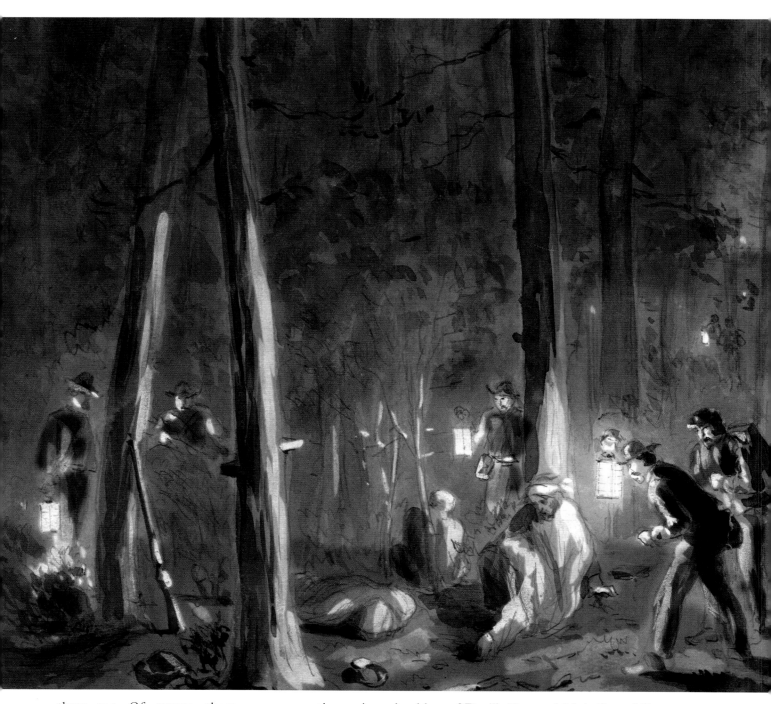

them too. Of course, there were exceptions. A Pennsylvanian near Devil's Den who received assurances that his mission of mercy relieving a wounded Confederate's thirst would go unchallenged took a bullet to his brain. The resulting picket fire proved particularly heated.

Lanterns began to jounce in the bare moonlight. Crews inched their way through the wheat fields and orchards, along Plum Run and Rock Creek, among the boulders of Devil's Den and Little Round Top, across Houck's Ridge and Stony Hill, near Brickyard Lane and the Emmitsburg Road. Slaves who had accompanied Confederate officers on the campaign searched the darkness for their missing masters. Thousands of wounded soldiers blue and gray were carted off the blasted battlefield to a network of improvised field hospitals. The medical teams confiscated homes and barns, churches, and sheds and

A later war image of crews searching the field for the wounded. *(LOC)*

Regiments gathered around their flags, and there began a terribly sad exercise. Roll calls started. A soldier's name rang out with no answer. A comrade might pipe up that he saw the man killed by shellfire or bullet or badly injured, perhaps alive. For some names, silence was the only answer. As the casualty totals mounted and the depth of the loss became apparent, tears and sobs accompanied the tolling.

As was typical when the armies crouched so close together, a command circulated prohibiting fires. There would be no cooked rations or the much-beloved coffee for the Unionists, and no tobacco for the Confederates. The soldiers out on the line ate what they had carried in their haversacks or could scrounge from their surroundings. Water came from the blood-smeared, marshy attenuations of Plum Run and Rock Creek or the various farm wells. Near Culp's Hill, wary opponents filled their canteens at Spangler's Spring. Sleep came to the exhausted young men who had learned to put the gore out of mind—at least for the moment.

George Meade attended to two matters that had surfaced during his war council. Slocum ordered Alpheus Williams to retake his lost XII Corps trenches on Culp's Hill, and Brigadier General Horatio Wright received the assignment to secure the Taneytown Road east of the Round Tops with part of his VI Corps division. Samuel Crawford had directed his one Pennsylvania Reserves brigade that had sat out the Valley of Death assault to secure Big Round Top. That brigade's commander, Colonel Joseph Fisher, had shown little energy in accomplishing the task, so Strong Vincent's successor, Colonel James Rice, asked Joshua Chamberlain and his 20th Maine to take the reins. The Mainers ascended the forested slope, captured a company of Texans, and shooed away some sleeping Rebels—probably Alabamans. Eventually two more regiments from Rice's brigade made the climb to join Chamberlain, while Fisher's dilatory relief party got spooked in the dark before reaching the top. Meade's left flank now curled across the peak of Round Top and ended with Horatio Wright's troops 1,000 yards to the east.

went to work separating the gut-shot and head-wounded from the treatable and the hopeful. Then they commenced the gruesome job of sawing off broken arms and legs, sewing up gaping flesh, and fighting their own battles to save lives in this sea of misery. Piles of severed limbs mushroomed outside open windows as the surgeons raced to staunch the mortal flow. The bodies needing treatment grew beyond anyone's ability to comprehend the scale. There was always one more.

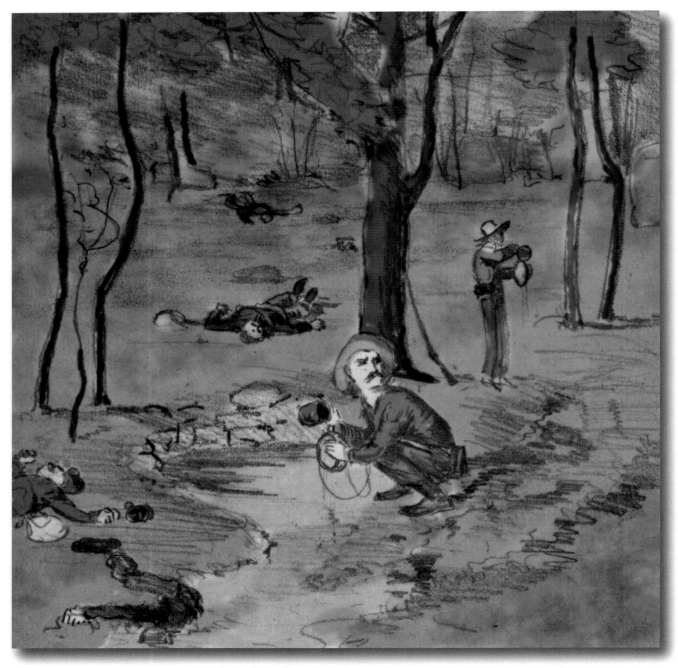

1. Soldiers from both sides find relief at Spangler's Spring, dangerously located in the no-man's-land at the southern base of Culp's Hill. *(LOC)*

In Washington D.C., a careworn Abraham Lincoln made hourly visits to the telegraph office in the War Department. Secretary of the Navy Gideon Welles often found the president there poring over Meade's dispatches. Anxiety hung heavy, nearly unbearably, but then, something changed. Meade's 8:00 p.m. report described a day of successes. Numerous Rebel attacks had been thwarted at every turn, and the army stood intact and inspirited. The promise of more fighting seemed implicit in Meade's missive, so this battle at Gettysburg was sure to continue. But from the gloom of McClellan's foibles, Burnside's incompetence, and Hooker's bravado, there glowed for Lincoln a ray of hope.

No such communication system ran to Richmond, Virginia. In the Confederate White House, Jefferson Davis sat alone with his thoughts. In May, he and Robert E. Lee had devised a plan to extend the war. Two weeks later, Lee and the army departed Fredericksburg to take the war north and fight a decisive battle. That was three weeks ago. Davis understood that they had crossed the Potomac and now operated in Pennsylvania. Concerning an epic fight at the crossroads town of Gettysburg, he knew nothing.

Perhaps the only civilians in America who had a true grasp of the battle were Gettysburg's inhabitants themselves. They had experienced the crash of cannonballs and shells, the zip and thud of lead bullets. They felt the ground shake as artillery volleys thundered from the ridge with the seminary and the hill with their cemetery. They watched with horror as the two armies battled on their farms and their streets, and they helped ease the pain of the wounded soldiers who now crowded into their churches and their homes. Already, the smell of the Rebels had shocked their sensibilities; with few exceptions, these soldiers hadn't bathed or changed their clothes in weeks. Now, however, the stench of death overwhelmed everything as it rose from the blasted wheat fields and rocky ridges, the rounded hills and the meandering creeks. One of their own, a woman named Jennie Wade, was killed by a stray bullet in her sister's kitchen. Lost boys, dead horses, discarded and broken equipment, shirkers and cowards, the ravenous living, and the grateful dead all congealed to turn the once placid burg into a slaughterhouse. Perhaps the citizens of Gettysburg knew it. Perhaps they all knew it. Nothing would ever be the same.

Jennie Wade, the only civilian casualty of the battle. *(LOC)*

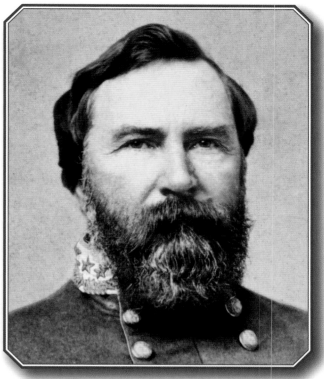

South Carolina-born but Georgia-bred, Lt. Gen. James Longstreet stood second in command of the Army of Northern Virginia, a consummate soldier who Robert E. Lee called "my war horse." A below-average student at West Point, who combined great physical strength with superb horsemanship, "Dutch" Longstreet took a wound at Chapultepec in the Mexican War then spent a decade as a paymaster at a series of cheerless outposts. With the outbreak of the Civil War, Longstreet showed a genius for soldiering as he rose quickly through the brigade, division, then corps command. Although he organized and implemented at Second Manassas, the war's single most devastating infantry attack, the general believed fighting on the defensive—inflicting the most damage while saving the most manpower—was the best strategy to win the war. *(LOC)*

⚜EMMITSBURG ROAD⚜

James Longstreet was nothing if not persistent. Lee wanted to continue Thursday's attacks on Friday, but the corps commander clung to the perceived "understanding" with his general that the army should find good ground and let the Yankees do the attacking. During the night, Longstreet sent out scouts south and east of Big Round Top. Despite missing Horatio Wright's VI Corps force that had taken up post there, the scouts returned to describe good ground that awaited the Confederates if they just followed

The Plan
39° 48'43.96 N 77° 14'25.88 W. Google Earth Pro. 9/6/2013. 8/25/2022.

Longstreet's advice. Evidently ignoring Lee's orders for the day, the Georgian prepared to move his corps around the Yankee left.

Robert E. Lee arrived at James Longstreet's headquarters around 4:30 a.m. on the morning of July 3. He expected to find Longstreet's boys readying to renew the battle, but Longstreet had not received Lee's word to attack at dawn. Instead, Lee's "Old War Horse" confronted him with his own plan. Impatient and no doubt angry, Lee pointed at Cemetery Hill and told Longstreet that the enemy was there, and there he would strike them. However, with Pickett's division not yet up, Lee recognized the changed circumstances demanded a new plan.

To the northeast, the thunder of artillery echoed across the ridges. Lee sent a message to Ewell to delay his attack on Culp's Hill.

Lee, Longstreet, and their staffs then trotted off to inspect the new assault zone. Lee soon calculated that McLaws and Evander Law—who had taken Hood's place—could not move their divisions north without exposing their troops to the enemy on Cemetery Ridge and the Round Tops. Lee therefore reconceived his tactics. Instead, the attack would go forward with Pickett's division, Harry Heth's four brigades, and two of Dorsey Pender's brigades. Lee chose Heth and Pender simply because of location: they were the closest forces to the new assault zone. Both had been wounded, so Brigadier General Johnston Pettigrew took on Heth's division, and Isaac Trimble would command James Lane's and Alfred Scales's brigades from Pender's division. Support would come from various elements of Longstreet and A.P. Hill's corps. All told, 15,000 troops would make up the assault force. Couriers departed to alert the principals of the new arrangement.

Longstreet then summoned a lifetime of soldiering, arguing that no 15,000 soldiers dead or alive could accomplish the operation Lee had laid out. Lee told Longstreet to prepare his corps to attack.

Lee desired a massive artillery barrage to precede the charge. Tear the enemy lines apart then rush infantry through the breach. This raised a problem. The army had a Chief of Artillery, Brigadier General William Pendleton. Longstreet had his own artillery commander, Colonel James Walton. But for this momentous operation, Longstreet wanted the brilliant and youthful E.P. Alexander to manage the long arm.

Feelings were sure to be bruised, but the moment demanded the best of the best, protocol be damned.

At some point in the middle of these preparations, Lee received a message from Ewell. Allegheny Johnson's attack was already underway.

⤙CULP'S HILL⤚

During the night, Alpheus Williams positioned his former division—now led by Brigadier General Thomas Ruger—on an arc from the Baltimore Pike to Rock Creek to retake his lost entrenchments on the low southern slope of Culp's Hill. Up on the hill, John Geary's entire division now muscled into the defenses. At the traverse and extending southwest along a farm lane, two

Large of frame—six-foot-six and over two hundred pounds—and fearlessly quick to violence, Brig. Gen. John Geary practically demanded respect—and a wide berth. A pre-war civil engineer, he participated in Pennsylvania militia activities from a young age. Hit five times during the Mexican War, Geary parlayed his wounded hero status into a series of government jobs, eventually landing the governorship of the "Bleeding Kansas" territory. With the guns of Sumter, he raised the 28th Pennsylvania then attained brigade command in April of 1862 and division command in October. He and his boys saw hard action at Chancellorsville, and they marched north—3,964 rifles in three brigades—with a well-won fighting reputation. *(LOC)*

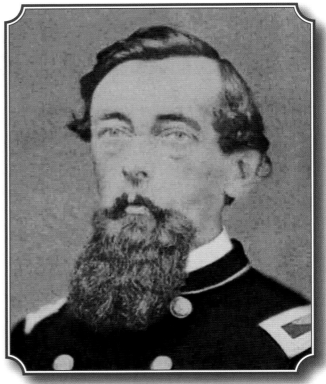

Col. Charles Candy epitomized the "soldier's soldier." A regular army teen-aged volunteer, Kentuckian Candy spent ten years with the dragoons and the infantry. He started the war as a staffer but gained a colonelcy in December of 1861 with the 66th Ohio. He followed John Geary in brigade command at Cedar Mountain and stood with Geary in the bloodbath at Chancellorsville. Candy directed six regiments of 1,798 men onto the fields of Gettysburg. *(LOC)*

Brig. Gen. Thomas Kane held titular command of Geary's 2nd Brigade, but various serious infirmities meant that Col. George Cobham Jr. of the 111th Pennsylvania directed the 700 infantrymen in three regiments for most of the battle. Cobham was a Liverpudlian by birth but migrated to Pennsylvania when he was ten. He worked as a contractor but quit with the onset of hostilities to help raise the 111th. After a bout of typhoid, Cobham became the unit's colonel and had the honor of capturing a Rebel battle flag at Chancellorsville. Geary himself regarded Cobham as a beloved, valuable officer. *(LOC)*

regiments from Colonel Charles Candy's brigade connected with Brigadier General Thomas Kane's three Pennsylvania regiments. Further up, Candy's remaining regiments joined Greene's boys at the front. One of Candy's units—the 66th Ohio—took on the unenviable task of jumping the earthworks at the hill's peak and forming at right angles off Greene's left flank. Williams also arrayed twenty-six guns near Powers Hill and along the Baltimore Pike to take the captured works under fire. At first light, the movement would begin.

Richard Ewell meanwhile was determined to strike the Yankees hard. He took two of Robert Rodes's brigades and placed them in support of Allegheny Johnson's right flank. He also advanced Jubal Early's reserve, the three Virginia regiments of Brigadier General William "Extra Billy" Smith's brigade. Even with the new troops, the same men who had bloodied the slopes the night before would lead the initial assault, to be followed by the nearly full division of reinforcements. Coincidently, this operation would also begin at daybreak.

At 4:30 a.m., the Union guns on and near Powers Hill sent a storm of shot and shell across an intervening meadow and plastered the captured works for fifteen minutes. It proved to be a noisy effort that did little damage to Maryland Steuart's dug-in Rebels. When the barrage lifted, the Confederates struck first. Jesse Williams's Louisianans joined John M. Jones's Virginians—now commanded by Lieutenant Colonel Robert Dungan—in scrambling up the hill's eastern

2. The Federal firepower sweeping down the hillside creates a kill zone for any living thing caught in the crossfire. *(LOC)*

face and opening on the Yankee line. Meanwhile, Steuart's troops dueled with the Federal infantry across the meadow. Other than the wan morning light, little changed from the previous night's action. The combined Northern firepower eviscerated the Southern ranks. On the Rebel right just below the hill's peak, Dungan's six Virginia regiments took additional flank fire from the fortunately located 66th Ohio. On the other flank, Union artillery showered Steuart's people with an iron hail. Johnson's infantry could only hunker down behind trees and boulders and try to survive the murderous storm.

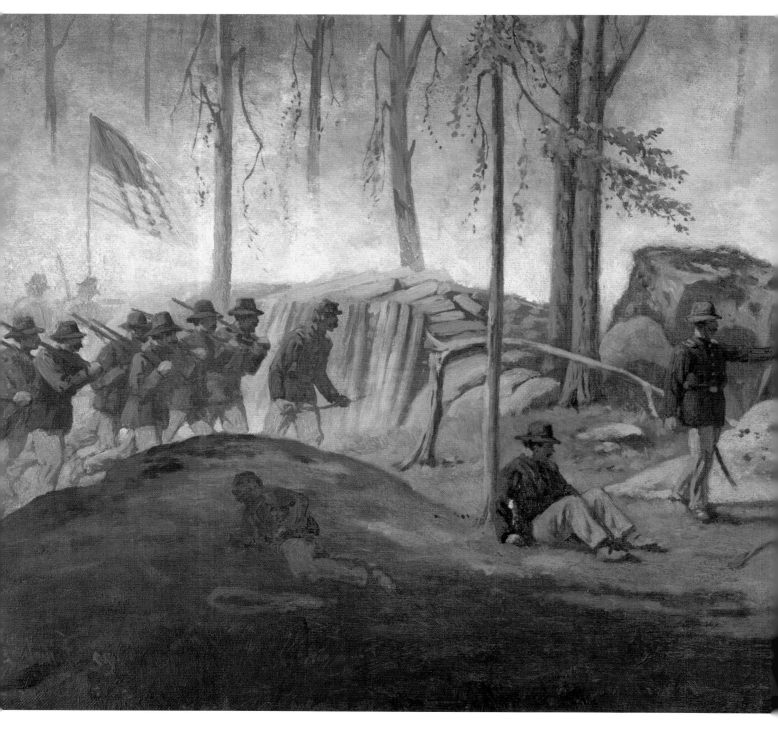

3. Well-protected by George Greene's entrenchments, Geary's Unionists rain hell upon Allegheny Johnson's numerous assaults up Culp's Hill. The Confederates never came close to breaking the line.

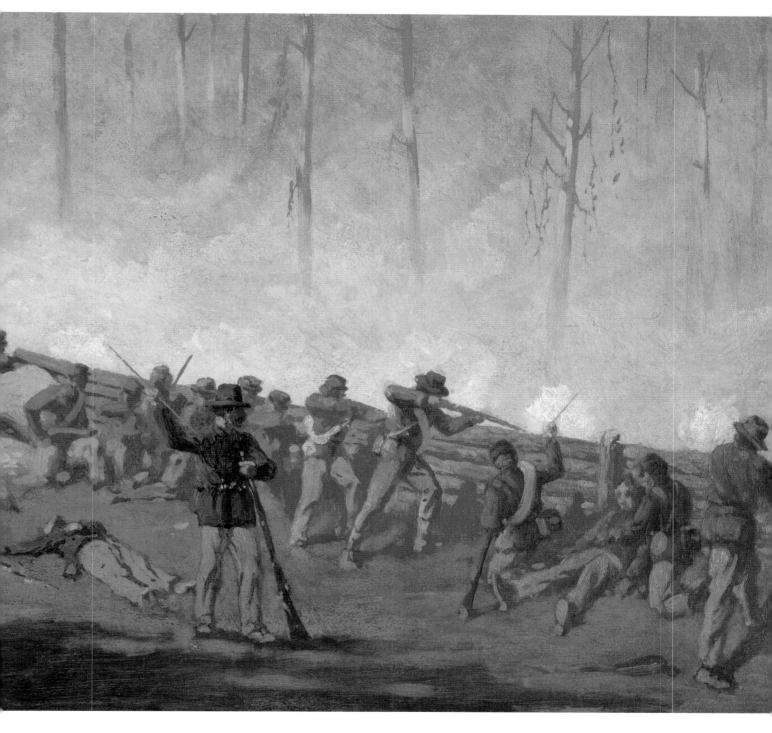

Relief troops approach from the left to take their turn along the blazing front. Greene cleverly employs some of the boulders (center) into the works for added protection. *(LOC)*

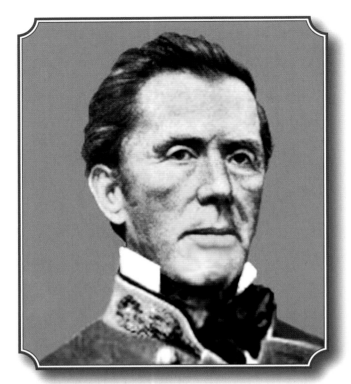

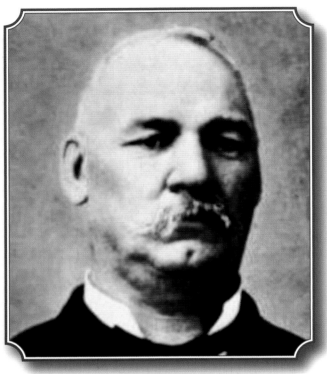

A well-known American celebrity, Brig. Gen. William Smith had served as an antebellum governor of Virginia and four-term congressman whose patronage expertise in extending his postal routes for added cash earned him the nickname "Extra." Born in 1799, Smith turned down a brigadier's commission after Sumter as he knew nothing about military matters. However, an early experience fighting off a raiding party led him to the colonelcy of the 49th Virginia. Despite his advanced age and inexperience, he performed well from First Manassas to Sharpsburg when three wounds and exhaustion nearly killed him. At Chancellorsville, his first battle in charge of Jubal Early's former brigade, Smith showed off his military deficiencies. His imagining of a Union threat to his flank on July 1 helped slow the Confederate late-day momentum, putting his three regiments of 806 Virginians out of that crucial action. *(PHOTCW)*

Native Virginian Brig. Gen. James Walker was a few weeks from graduating from VMI when a run-in with Major Thomas Jackson (soon to be "Stonewall") got the cadet expelled. Instead, he studied the law and passed the bar while organizing a militia unit in his hometown. The onset of the war prompted Walker to march his militia men north to become part of the 4th Virginia. He quickly became colonel of the 13th Virginia in Jubal Early's brigade where he excelled on the Peninsula and throughout the Maryland Campaign. When Jackson was mortally wounded at Chancellorsville, Lee placed Walker in command of the Stonewall Brigade, much to the consternation of the officers who wanted the promotion to come from within. However, Walker's outgoing personality and fighting spirit quickly won over the five regiments of 1,323 Virginians. *(PHOTCW)*

The Unionists devised a clever plan. A hollow about fifty yards behind Greene's line became a depot for the soldiers to replenish their ammo, clean their weapons, and get a little rest. As each regiment fired off its final rounds, the men would fall back to the hollow to be replaced by a unit that had just completed their own refurbishing. As a result, the Federals maintained an extraordinary fire rate, and the only time the blue-coated riflemen came under direct enemy aim was when they traversed the space between the front and the hollow. No wonder that trees on the hillside began to crack and fall as Union lead shattered their trunks.

By 7:00 a.m., Extra Billy Smith shoehorned his Virginians onto Johnson's left flank. They anchored their left on Rock Creek and faced south over the meadow. Brigadier General James Walker also pushed the Virginians of the famed Stonewall Brigade into line between Steuart and Williams. The sons of the Old Dominion peered up the smoky incline and fired at the musket blasts flickering in the murk. Within an hour, O'Neal's brigade from Rodes's division bolstered Williams's Louisianans and tried to mount an attack of their own. They too ground down before the Yankee volleys.

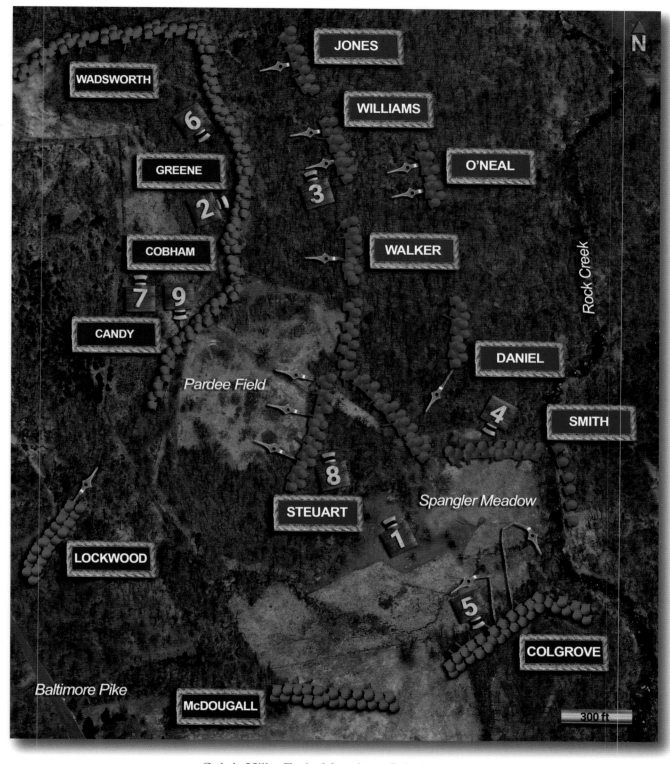

Culp's Hill—Early Morning—July 3, 1863

39° 49'03.37 N 77° 13'02.58 W. Google Earth Pro. 9/6/2013. 8/25/2022.

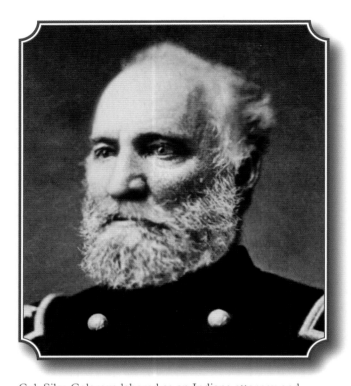

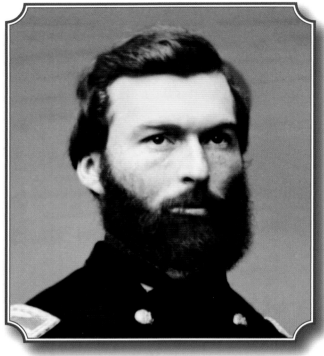

Col. Silas Colgrove labored as an Indiana attorney and politician when the guns of Sumter prompted him to join the 90-day volunteers of the 8th Indiana. He soon became colonel of the 27th Indiana where he compiled a solid record from the Valley Campaign through Antietam to Chancellorsville. When Thomas Ruger took over the division at Gettysburg, Colgrove ascended to brigade command. *(LOC)*

Brig. Gen. Thomas Ruger excelled in his time at West Point, but the transplanted Wisconsin man quit the army to return home and study law. He began the war as colonel of the 3rd Wisconsin where he shone as a battle commander in the Valley Campaign and at Cedar Mountain. He rose to temporary brigade command in the charnel house of Antietam and earned his stars a few months later. He and other XII Corps soldiers endured the hard blows of Chancellorsville, and he led the battle-tested five regiments of 1,598 rifles to Gettysburg, only to rise to divisional command when Alpheus Williams took over the corps. *(LOC)*

Around this time, Ewell learned that Longstreet's assault would be delayed. His men's morning effort had meant nothing.

Geary recognized the concentration points of the main Rebel efforts, and he expertly juggled his available troops to meet them. Two of Lysander Cutler's I Corps regiments were pulled off the north face of Culp's to bolster Greene's fighters. Henry Lockwood's two Maryland regiments also found spots on the firing line. Geary meanwhile summoned Brigadier General Alexander Shaler's brigade from the VI Corps. Even as his people blasted the Rebel attacks apart, Geary refused to underestimate his opponent's heart.

Colonel Silas Colgrove's XII Corps brigade had held the corps' right flank for much of the morning.

His four regiments had formed a three-sided box on a raised piece of forested ground not 150 yards south of Extra Billy Smith's Virginians. His right flank had dueled with Virginian and North Carolinian skirmishers on the east bank of Rock Creek, but with the open, marshy meadow separating the Unionists from the Rebs, there appeared to be little chance the colonel would see much action. The noise of the last Rebel attack had died down, so he was taken aback when his divisional commander (and former brigade commander), Thomas Ruger, ordered him to advance two of his regiments and knock the enemy from his strong position. Ruger would later insist he only desired a demonstration, but that hardly mattered. Colgrove commanded the 2nd Massachusetts and his own 27th Indiana to take on the doomed task.

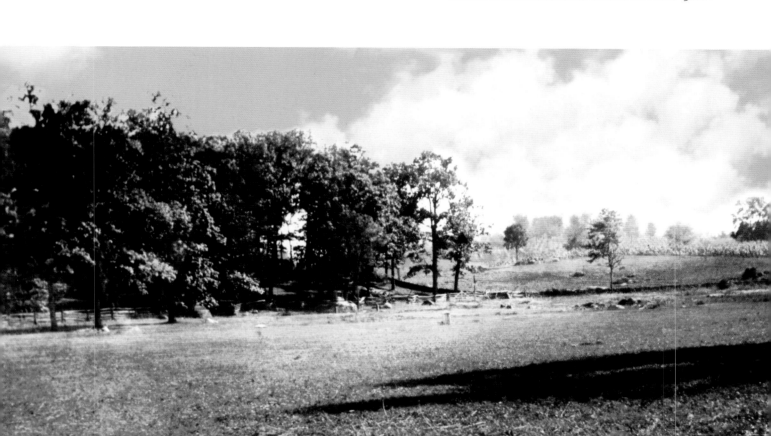

4. Looking south across Spangler's Meadow from Extra Billy Smith's positions. The Union artillery concentrates on Powers Hill, the tree-lined heights in the right distance. Colgrove's brigade occupies the hill behind the trees on the left. The 2nd Massachusetts barely makes it out of the trees (left center) and the 27th Indiana covers almost half the distance across the field (left) when the concentrated fire of Smith's Virginians pulverizes the assault. The 2nd breaks to the west (right) and the 27th curls to the east (left) to escape the furies. *(Adams County Historical Society)*

5. Colgrove's brigade lined the hill in the background, and the two regiments in the attack moved down the hill toward the monument. Erected in 1879, the 2nd Massachusetts monument was the first permanent regimental marker on the battlefield.
(Sue Boardman Collection)

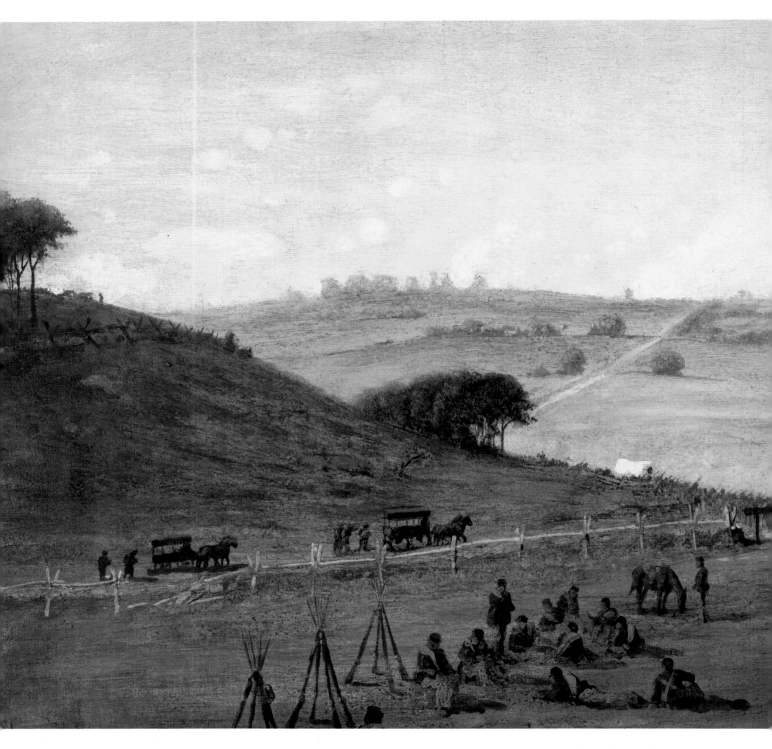

Looking northwest at activity in the Union rear in the mid-morning. Federal artillery on Powers Hill (left) continues to pummel the Confederates on smoke-enshrouded Culp's Hill (right distance). Marching to join the fight, Shaler's XII Corps brigade is moving up the Baltimore Pike as the road ascends Cemetery Hill (center distance). Two ambulances are parked on Granite Schoolhouse Lane at the base of Powers Hill while McDougall's XII Corps Brigade forms in the fields around McAllister's Hill/Wolf's Hill (right). *(LOC)*

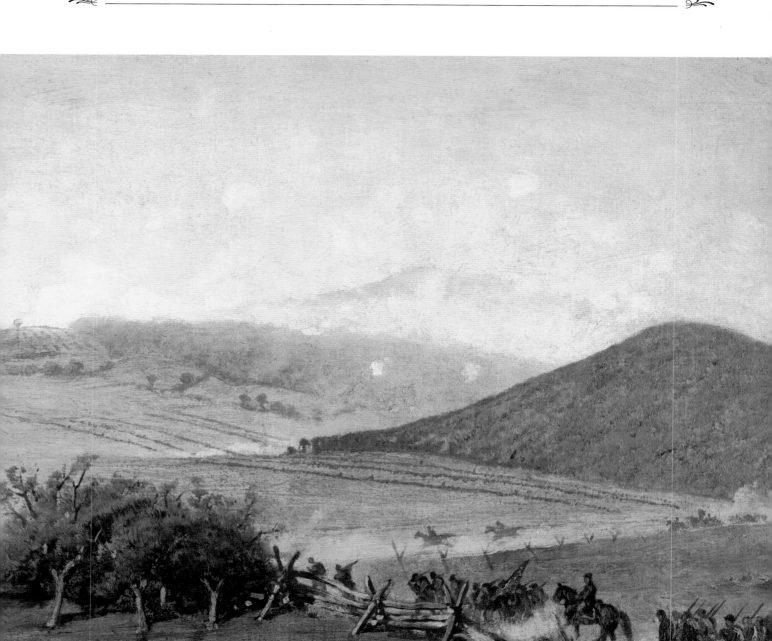

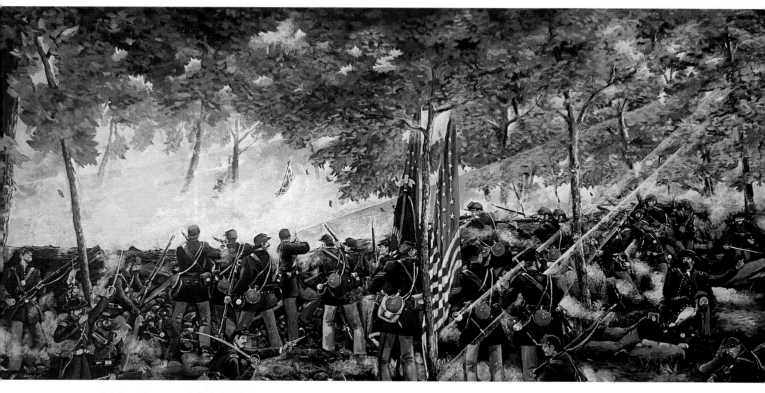

6. Near the top of Culp's Hill, the 150th New York of Lockwood's brigade hammers the renewed Confederate assaults on the Federal bastion. *("Timid Youths to Hardened Veterans" by James Shockley)*

The Bay Staters went first. Halfway across the meadow, Smith's Virginians plastered their line, and the Northerners withered to a halt. The Indianans then advanced on the 2nd's right where another Confederate volley lashed the 27th's front. Some thought the right companies simply disappeared in the murderous storm. The Bay Staters grimly retreated 200 yards to the west and reformed behind a stone wall, while the Indianans curled to their right and fell back to the woods where they helped repel a Virginian counterattack.

It was now mid-morning. After two failed efforts, Allegheny Johnson ordered one more. His lieutenants

A Maryland native son, West Point graduate, and regular army veteran, Brig. Gen. George Steuart got the nickname "Maryland" to differentiate him from the cavalryman Jeb Stuart. A stickler for regulations, Steuart's by-the-book methods raised the ire of the volunteers who eventually came to appreciate the discipline. He ascended to brigade command in March of 1862, but a wounding at Cross Keys in June knocked him out of service for nearly a year. He returned after Chancellorsville to helm 2,121 soldiers in six regiments. *(PHOTCW)*

voiced strong disapproval to no avail. With the Stonewall Brigade on the right, Brig. Gen. Junius Daniel's North Carolinians from Rodes's division in the center, and Maryland Steuart's boys on the left, the three bone-tired brigades went forward in one last spasm.

The two brigades attacking Culp's eastern face received the usual treatment, melting before Yankee volleys augmented by Shaler's New Yorkers and Pennsylvanians. Steuart's troops jostled out of the captured trenches and swept across an intervening meadow where the Unionists lining the traverse and the farm lane blasted them into the dirt. The 20th Connecticut advanced to the southern border of the meadow and sprayed Steuart's left flank. The crushed Confederates fell back to the trenches.

7. The 29th Pennsylvania leaves the shelter of the protective hollow and advances to the traverse just before "Maryland" Steuart launches his assault across Pardee Field. *(Battles and Leaders of the Civil War, hereafter B&L)*

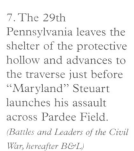

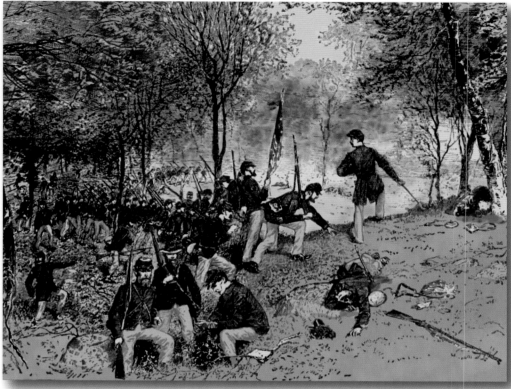

8. At the opposite end of the field, Steuart's boys form in the woods before storming the Union lines along Spangler Lane and the traverse. *(B&L)*

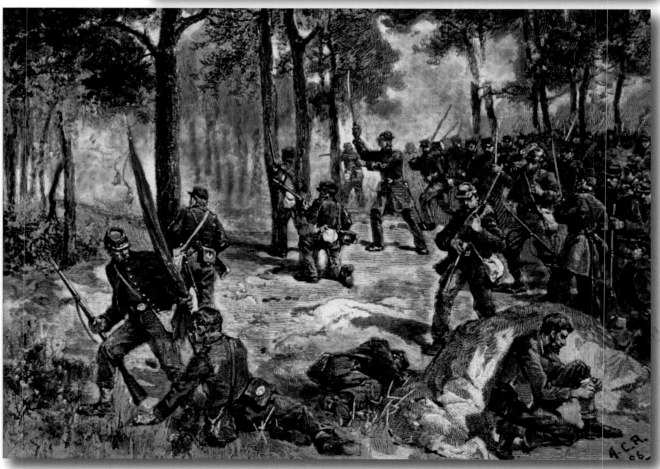

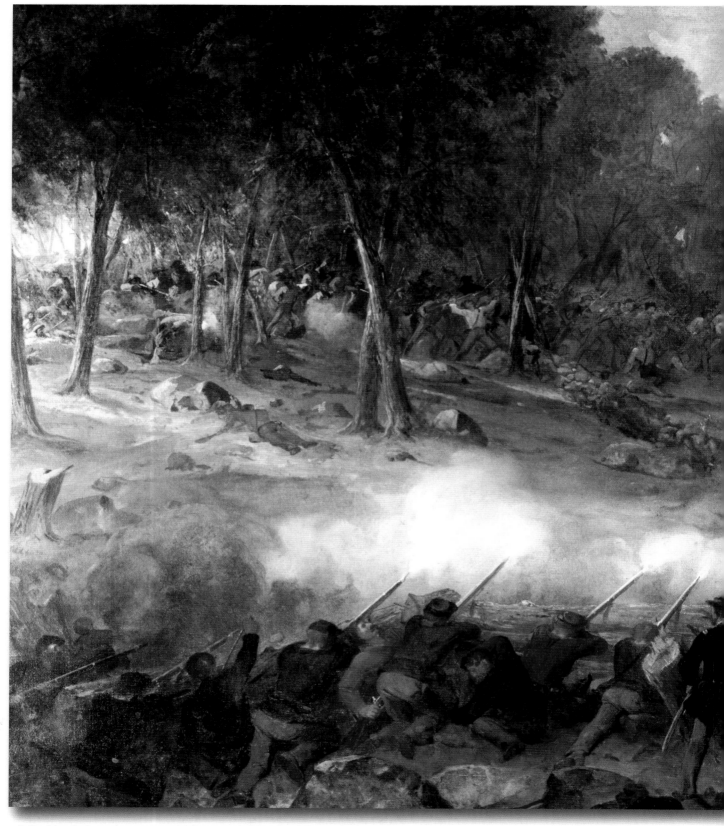

9. Led by their canine mascot (right center), Maryland Steuart's six regiments storm out of the woods (distance) and onto Pardee Field. A stone boundary fence (center) disrupts the formation, but that makes little difference.

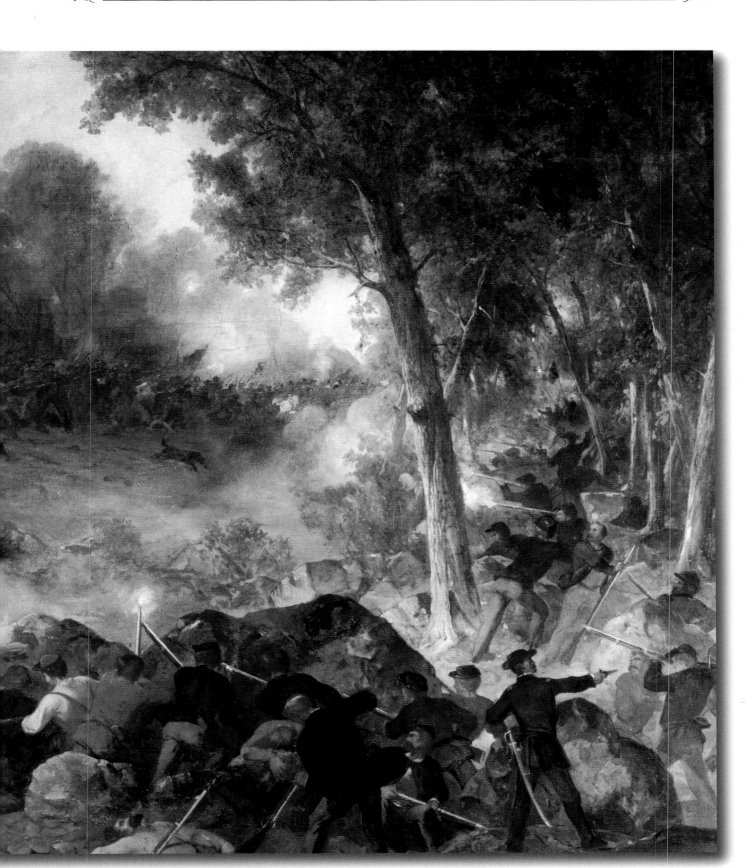

The 29th Pennsylvania (foreground), the 5th Ohio (right border), and the 147th Pennsylvania (above the 5th Ohio) meet the attack with shivering volleys that drive the Confederates to ground. *(Courtesy of The State Museum of Pennsylvania, Pennsylvania Historical and Museum Commission)*

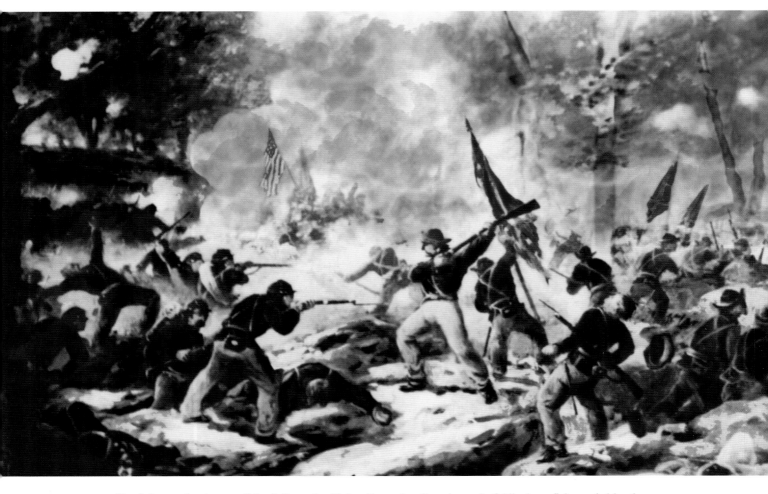

Confederates begin to pull back from the Union lines, signaling the end of Allegheny Johnson's bloody attempt to take Culp's Hill. *(GNMP)*

Now, exhausted Rebels on Culp's hillside began to wave white rags and surrender, whereupon a Johnson staffer rode forward to make them stop. Witnesses marveled at his gallantry, but the Blueclad soldiers still shot him dead.

Johnson called for an end to the bleeding. Most of the Confederates fell back to Rock Creek, but Steuart's boys stayed in their battered trenches, and Extra Billy Smith's Virginians remained ensconced among the boulders and the trees between Steuart's left and Rock Creek. Yankee artillery continued to unleash their pummeling blows, but after six hours of intense combat, most thought the battle over.

SEMINARY RIDGE

Around 7:30 a.m., about the time Allegheny Johnson's second wave ascended Culp's Hill, the van of George Pickett's division approached Seminary Ridge near Spangler Woods. Confederate politico Brigadier General James Kemper guided his five Virginia regiments past some gruesome burial parties and through the woods. Breaking into the open, they shuffled behind a low ridge to the Spangler farm where they formed in a shallow vale just south of the buildings. Brigadier General Richard Garnett's five regiments of Virginians trailed Kemper's route to the farm and extended the grouping north of the farm. Brigadier General Lewis Armistead positioned his brigade about 200 yards behind Garnett, along and in the eastern border of Spangler Woods.

A native Virginian with deep ties in the Old Dominion, Maj. Gen. George Pickett cut quite a figure. As a Confederate general, he adopted the appearance of a dashing dandy with perfumed locks, a sculpted moustache, and a perfectly tailored uniform. He had displayed incredible bravery facing down Mexican bullets at Chapultepec and the British navy in the so-called Pig War. However, Pickett had finished dead last in his West Point class, and many questioned his brains and his dedication.

Still, he began the Civil War as a colonel and took on a brigade in February of 1862, but Pickett took a bullet under odd circumstances during the Seven Days that put him on the sidelines. Largely due to the patronage of his friend James Longstreet, Pickett received a division when he returned in September. By missing Fredericksburg and Chancellorsville, he had little chance to exercise his new authority. Whispers also accompanied his infatuation with a teenage girl almost two decades his junior, and as he guided his three brigades of 5,474 Virginians into Pennsylvania, those who questioned the likable officer's abilities

Officers ordered the soldiers to lay down, but curiosity drove many to mount the low ridge to see what lay ahead. About a mile to their right spread some woods, with the Round Tops rising ominously behind. To their front and left, also about a mile away, across the Emmitsburg Road and up the gentle incline of Cemetery Ridge lay the enemy front. Near the center rose a copse of trees, practically the only natural break on the entire crest. The Virginians quickly surmised they would be leading an assault on this Yankee stronghold, and although they felt confident of their ultimate success, they noticeably refrained from the typical joking before a fight. This one looked deadly serious, probably the last attack for many of them, but if that's what it took to win the day, so be it.

Around 10:00 a.m., Johnston Pettigrew initiated the formation of his four-brigade division behind Seminary Ridge some 200 yards north of Armistead. Longstreet explained to the intellectual North Carolinian that he wanted Pettigrew to dress on Pickett and hit the Yank center on a wide front, which meant that once the operation began, Pettigrew would have to march nearly a quarter mile to catch up to Pickett's front two brigades. While Isaac Trimble formed his two North Carolina brigades behind Pettigrew, Richard Anderson advised his remaining brigades to be prepared to support the attack. As the various cogs moved into place, Confederate officers began to discuss the operation with their comrades. Decorum prevailed but taking a good look at what lay ahead of them, some thought with grave concern that their assignment looked like suicide.

Lee and Longstreet trotted back and forth along the ridgeline. They would stop often and inspect the enemy's formations through their field glasses. The waiting soldiers watched them join in serious discussion, then the two officers would mount up and move on. George Pickett meanwhile began the morning thrilled that his boys would lead the assault. Even as the weight of the responsibility grew with the passing hours—not to mention the thought of crossing that bald plain under Yankee fire—Pickett remained sure that glory was but a short way off.

After all, he was leading the attack that could win the war.

⇜CULP'S HILL⇝

A lull mercifully fell on the sector. Allegheny Johnson had time to ponder the harsh reality that the morning's verdict had gone against him. Accordingly, he pulled Steuart's tattered brigade out of the captured trenches to the relative safety of Rock Creek. Connecticut skirmishers recognized the Rebel retreat and crept forward with fair deliberation. Then, Colonel Archibald McDougall pushed his XII Corps brigade across the bloody pasture and reclaimed Culp's Hill for the Union. Except for the potshots from skirmishers, the seven hours of sustained combat had finally closed.

Among the dead, a member of the Stonewall Brigade, Private John Wesley Culp. He had come home to Gettysburg wearing the uniform of a Confederate soldier, to die near his cousin's hill.

Pvt. John Wesley Culp. *(PHOTCW)*

CHAPTER 4

A S THE MORNING WANED, two more Confederate brigades deployed on the right to support Longstreet's assault. Cadmus Wilcox lined up his four Alabama regiments not 300 yards ahead of Kemper, and David Lang's three Florida units formed just north of Wilcox. Both had been badly damaged assaulting the same ground the day before and would serve today in a secondary role. On the northern flank, Robert Rodes's remaining three brigades still held their ground from their aborted advance the night before, forming on Long Lane some 500 yards north and ahead of Pettigrew's left flank. All the infantry pieces were now in place.

Meanwhile, two artillery officers roamed the field preparing for the coming storm. E.P. Alexander worked with a will to summon and position every available Confederate gun. Four batteries fanned out along the Trostle farm lane east of the Emmitsburg Road, while a powerful line of fifteen batteries fronting Pickett, Wilcox, and Lang ran north along the western shoulder of the road then northwest to Seminary Ridge. The rest of the Rebel cannon stood along the ridge's eastern base all the way up to McMillan Woods near the Fairfield Road. By the time the last battery deployed, Alexander had command of seventy-five guns with another ninety-six from the other two corps ready to join in.

Alexander held some deep misgivings about the operation. He didn't like the idea of charging the center of the enemy line across that open field. He also worried that the titular commander of the Army's artillery, Brigadier General William Pendleton, lacked the energy and ingenuity to coordinate such a massive endeavor. His worries hardly slowed his pace. Alexander scanned the Federal lines and methodically located his quarry. In the center, Lee and Longstreet had evidently designated a clump of trees as the central strike point. To the right of the oaks, Alexander identified perhaps two batteries planted along the infantry line. Three more dropped trail north of the copse: a six-gun battery next to the trees, another near the ridge's crest north of the first battery, and a third further north fronting a grove. Here was his prey. To each of his batteries, he assigned specific targets.

Across the way, Henry Hunt thundered about with his usual skill and energy. He observed with great interest the Rebel guns jostling into position and guessed that Robert E. Lee had decided to assault the center of Meade's army. He planned accordingly. Lieutenant Benjamin Rittenhouse now commanded Hazlett's battery atop Little Round Top, and McGilvery's concentration of 41 guns remained in the swale east of Plum Run, hidden from Rebel lookouts as it fronted Abner Doubleday's I Corps division. Five batteries deployed to support the various II Corps brigades of Hays and Gibbon's divisions, eventually connecting with the XI Corps flank and its massed gunnery on Cemetery Hill.

Hunt had a very specific idea on how the coming battle would be fought. The Rebel long arm would

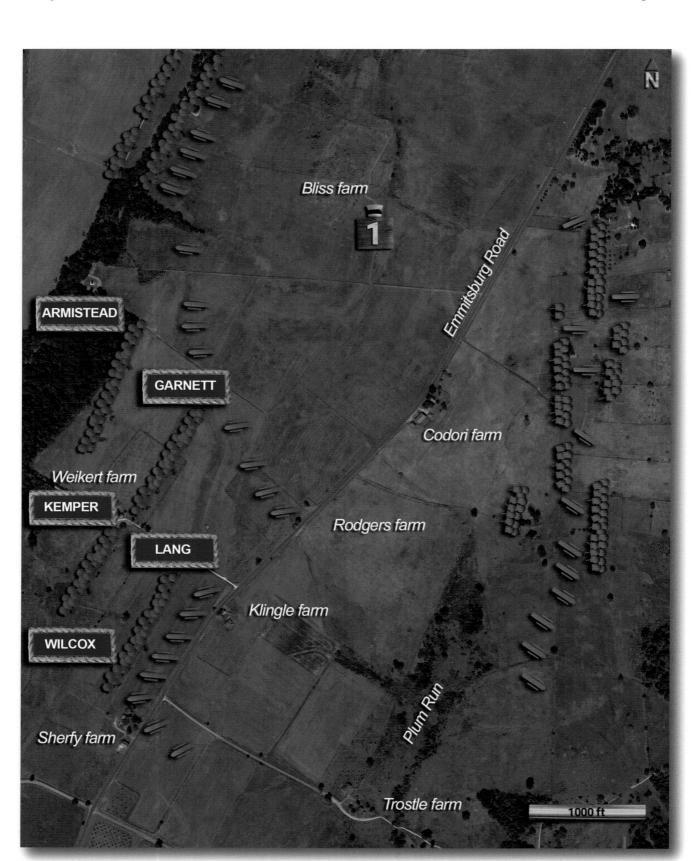

Artillery Formations—Noon—July 3, 1863
39° 48'43.96 N 77° 14'25.88 W. Google Earth Pro. 9/6/2013. 8/25/2022.

1. Confederates and Unionists battle over the Bliss barn as smoke billows out of the second floor windows.
(GNMP, Photo by John Kamerer)

batter the Union lines with a wanton barrage, but Hunt's gunners would wait fifteen minutes then reply slowly and deliberately, with an emphasis on accuracy rather than volume. He would conserve his firepower and replenish any injured front-line crews with weapons from the 81 guns in his centrally located Artillery Reserve. Once the barrage ended, the infantry assault would begin, and when the Grayclad troops got close, Hunt's cannoneers would blow them to smithereens. Galloping from crew to crew, he told his boys what he expected of them. At Malvern Hill the year before, his thirty-seven guns crushed a Rebel attack before it got started. Today he commanded 119 cannon directly facing Seminary Ridge. For Henry Hunt, Gettysburg would be Malvern Hill—times three.

⚬⚭⚬

For two days, skirmishers had fought doggedly over the Bliss farm buildings, and the combative Alexander

Hays was fed up with the stalemate. He sent a combined New Jersey/Delaware battalion to oust the Mississippian sharpshooters currently bedeviling his troops, but a Confederate counterattack drove the Yankees away. Hays tried again, dispatching 100 rifles from a Connecticut unit to win the buildings back, but the fight escalated as more Rebels leaked onto the scene. Finally, around 11:00 a.m., Hancock wanted the fight ended. He knew that Meade did not want to trigger a larger battle over an insignificant position, and his old friend Hays agreed. Hays sent forward some arsonists, and fires soon engulfed the structures, with dark smoke rising into the clear sky. The Unionists gathered their wounded and returned to their lines; their mission accomplished.

⚬⚭⚬

Meade made another move to secure his wings: he ordered Alfred Pleasonton to mass his cavalry on both

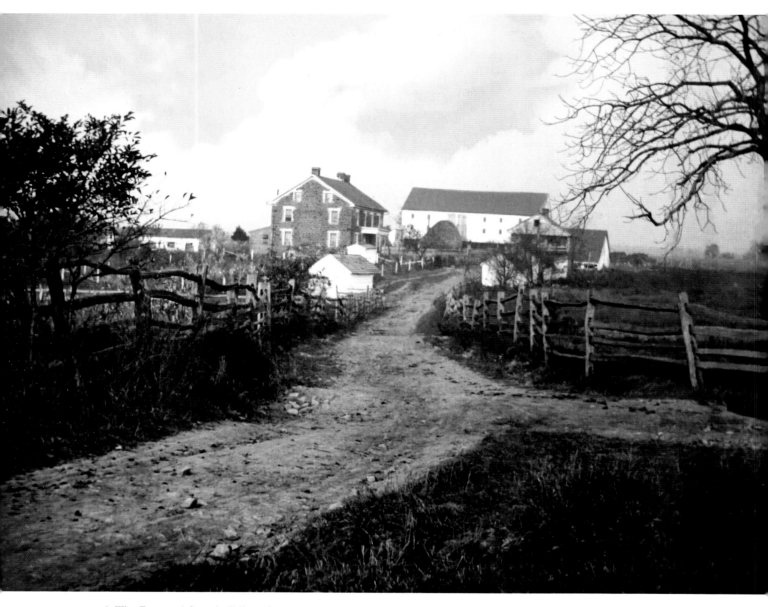

2. The Rummel farm buildings from the southeast. Both major Confederate assaults form in the right distance and advance across the field to the right (northeast) of the buildings. McIntosh's dismounted Federals line the farm lane off camera to the left. *(Sue Boardman Collection)*

flanks. From Two Taverns, Brig. Gen. Judson Kilpatrick was to advance a brigade to the Round Tops and join Wesley Merritt's brigade marching north from Emmitsburg. Together they would probe the Rebel right. Kilpatrick was also told to dispatch Brigadier General George Custer's Michigan brigade to the Union right flank near the Hanover Road to aid David McMurtrie Gregg in suppressing the enemy there. The Union cavalrymen spent the morning clattering to their new assignments.

Custer reached the Hanover Road around 9:00 a.m. and immediately sent out scouts in every direction. A company of Michiganders rode a mile and a half north across the Rummel farm to Cress Ridge, which provided a fine panorama of the area. Within the hour, they glimpsed a Rebel cavalry column working their way east and heading straight for them. A trooper thundered south to inform the "Boy General" that the enemy were on their way.

❦ THE RUMMEL FARM ❦

Morning came early for the Confederate horsemen who had endured Stuart's circuitous route to get to the battlefield. They had spent most of the previous day filtering into Gettysburg from Carlisle and collapsing north of Richard Ewell's corps. Around 5,000 of them now rose from their camps and trotted east on the York Pike. Lee had told his wayward cavalry chieftain to protect Ewell's flank, so Stuart led Wade Hampton, Fitz Lee, and Brigadier General Alfred Jenkins's winnowed brigades to an eminence three miles east of town called Cress Ridge. Jenkins had been laid low by an artillery projectile the day before and was replaced by Colonel Milton Ferguson who ordered some of his mounted troopers forward from the heights. They descended onto the nearby Rummel farm where they raided the springhouse and took the owner, John Rummel, prisoner.

It was mid-morning, and as the troopers rummaged through the foodstuffs, Jeb had two of his accompanying cannon blast off some shots, one of which targeted the Hanover Road to the south. Stuart had watched the end of the fighting the night before on nearby Brinkerhoff Ridge, and he knew Yankee cavalry lurked in the area. He also knew that the Low Dutch Road ran south from the Hanover Road to the Baltimore Pike, offering access to the enemy's rear. A

Stuart staffer recalled that Jeb was simply trying to locate his foemen with his artillery summons. If attracting attention was what he sought, the cavalry commander got his wish.

Meanwhile, George Custer found himself in a bind. Here, confronted by an enemy buildup, the newly minted general received orders from Pleasonton to retire his command south to the Round Tops. After consulting with David Gregg, both officers decided to disobey orders. Custer remained to bolster Colonel John McIntosh's arriving brigade and deployed Lieutenant A.C.M. Pennington's artillery, which immediately blew Stuart's two guns off Cress Ridge. Concurrently, Gregg shook out McIntosh's brigade and prepared to fight.

❦ CEMETERY RIDGE ❦

Amid scattered clouds, the sun reached its apex. Temperatures spiked into the upper 80s. Even the gulf dwellers from Louisiana thought the air humid. Once the noise of the fights at the Bliss farm and Culp's Hill receded, a strange, almost unearthly lull cocooned the battlefield. Federal skirmishers crouched in the fields west of the Emmitsburg Road and peered at the forbidding line of enemy cannon to the east. Soldiers lying along the ridge crests stuck their muskets in the ground and draped bits of cloth and blankets from the improvised tent poles to provide some shade. Burial details interred the uncounted corpses. Small fires sprang up to brew coffee and cook rations. Birds soared and bees buzzed. For a few, brief moments, July the Third, 1863, seemed like a typical, lazy summer day—except the oppressive silence portended an equal, opposite fury.

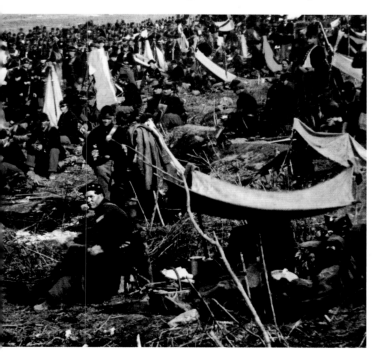

VI Corps troops during the Chancellorsville Campaign improvise tents to shield themselves from the sun. *(National Archives, hereafter NA, with thanks to Bob Zeller and the Center for Civil War Photography)*

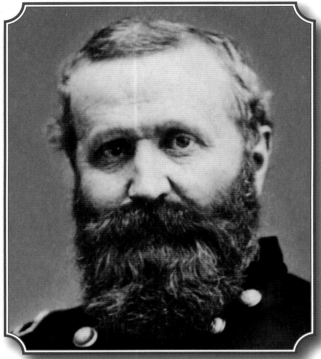

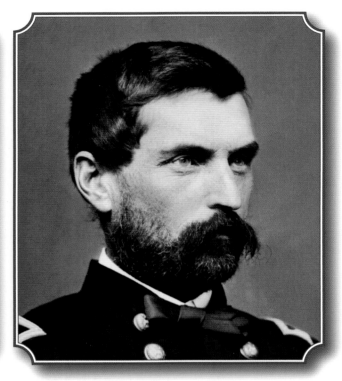

Perhaps the epitome of a fighting general, Brig. Gen. Alexander Hays displayed a love of both drinking and brawling in equal measures. Hays matriculated at West Point, fought in the Mexican War, then tried his luck in the California Gold Rush before returning home to Pennsylvania. When the South seceded, Hays raised the 63rd Pennsylvania and led it with distinction from Seven Days to Second Bull Run. A leg wound knocked him out of action for half a year, and he was spinning his wheels as a newly minted brigadier in the Washington D.C. defenses when the Gettysburg Campaign commenced. Assigned two more brigades, Hays found himself in divisional command for the first time—three brigades of 3,643 men—on the eve of battle. Two facts remained. Soldiers would joyfully follow the ferocious Pennsylvanian to Hell, and Hays would be more than happy to lead them there. *(LOC)*

Possibly the best division commander in the Army of the Potomac, Philadelphian Brig. Gen. John Gibbon spent much of his professional life deeply considering the science of artillery. After service in the Mexican and Seminole wars, Gibbon returned to West Point to teach the long arm, and he eventually codified his thoughts in *The Artillerist's Manual*, which became the army's Bible on the subject. With the fall of Sumter, Gibbon left the artillery and took on a five-regiment organization that he molded into the famed "Iron Brigade." Such was his standing that he led divisions in both the I Corps and the II Corps. Professional, remote, and a straight shooter, Gibbon and his three brigades of 3,588 infantrymen were as tough as any bunch in the army. *(LOC)*

Alexander Hays positively glowed. At age 43, he lived for moments like these, an issue to be settled by arms and a man. He boasted a West Point education but left the service after the Mexican War, only to re-enlist when the Civil War erupted. His men loved his intense fighting spirit and would follow him anywhere. One of his brigades—Samuel Carroll's—still manned the Brickyard Lane at East Cemetery Hill, although Carroll's 8th Ohio remained on Hays's skirmish line out past the Emmitsburg Road. With his remaining two brigades, Hays held the northern sector of the II Corps line, forming his boys in a grove owned by a farmer named Ziegler and along a stone wall on a farm owned by a freeman named Abraham Brian.

Just to the south, John Gibbon ranged up and down his divisional lines inspecting the formations, analyzing fields of fire, and posting and re-posting his long arm. Before the war, the veteran cannoneer had written *The Artillerist's Manual* for his classes at West Point. When war came, he faced down the tragedy many families experienced. Born in Philadelphia but raised in North Carolina, his sense of duty kept him with the Union, much to the chagrin of many of his relatives—including his cousin, Johnston Pettigrew, just then but

a mile away. Having attained an infantry command a year into the conflict, his tough love turned a gaggle of western regiments into the Iron Brigade. At 36 years old, he now led three brigades protecting the very heart of the Army of the Potomac.

Further south, in response to Hancock's orders, George Stannard's Vermont brigade collected nearby fence rails and built a bulwark on some high ground in advance of the main line.

One of Gibbon's staffers found an old rooster and some potatoes and made a stew. Before long, Gibbon, Hancock, John Newton, Alfred Pleasonton, and George Meade all joined in the rough lunch. Meade ate quickly and headed back to his pressing duties at the Leister house, but the others lolled about in the early afternoon heat and enjoyed some cigars.

Boom. A single Rebel cannon fired off somewhere to the south.

From an earlier war image, the Washington Artillery Battalion prepare to fire off one of their pieces. The honor of firing the first shot of the bombardment fell to these Louisianans. *(In Camp and Battle with the Washington Artillery of New Orleans)*

⋖SEMINARY RIDGE⋗

As the moment for the artillery barrage grew closer, James Longstreet faced the inevitable. He had opposed Lee's tactical concept and stated so clearly without reservation. He was overruled. He went to work with his usual determined skill and paid special note to Alexander's guns. This barrage was intended to pulverize the Yankee long arm and concuss their infantry, and Longstreet helped his artillerist locate the targets and triangulate his resources. But the stoic Georgian could not shake his conviction that the attack would fail, and he could not resist sharing his conviction with a few of his fellow officers.

Longstreet informed Alexander just before noon that he would rely on the artillerist's analysis of the barrage's effectiveness to determine if and when Pickett should go forward. The notion that the young artillery officer would be given such massive responsibility gob-smacked Alexander. He quickly responded that the attendant smoke alone would make such an appraisal difficult at best, and that if Longstreet entertained an alternative to the frontal

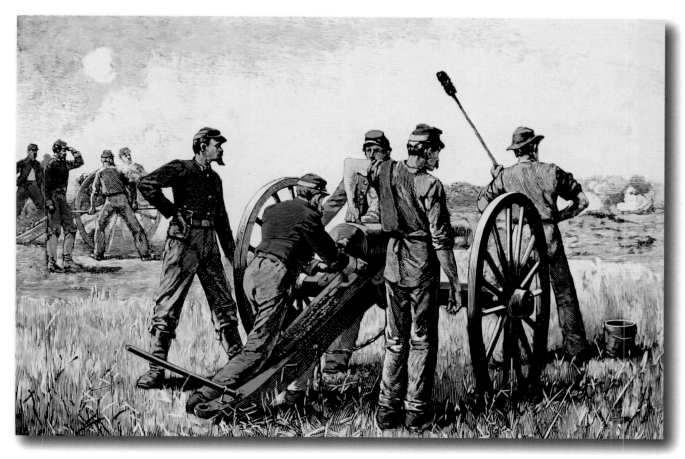

assault, now was the time to seriously consider it. By the artillerist's reckoning, the cost of the plan as is, even if successful, would be massive.

Longstreet shot back that Alexander should alert Pickett when the barrage accomplished its desired goal. Alexander went to Pickett to learn the general's take on the matter. Pickett exuded absolute confidence, satisfying Alexander's mind that a supreme effort by his artillery would be matched by a supreme effort from the infantry. As the clock approached one, the artillerist informed Longstreet that he would alert Pickett when the barrage had done its worst. Longstreet sent word to Colonel Walton to start the bombardment.

Fronting Wilcox and Lang's brigades, Walton was standing with the Louisianans of the Washington Artillery near the Klingle house on the Emmitsburg Road when a courier thundered up. Walton's day had gone poorly, what with a junior officer superseding him on a battlefield, but he quickly commanded two guns to set off the signal sequence. The first cannon fired; its report doubly loud as the hour-long lull came to an abrupt end. The second gun, however, suffered a defective friction primer and sat there mute. Some quick adjustments, and it too fired.

Up on Little Round Top, Henry Hunt heard the twin booms.

First the artillery, then the infantry.

Robert E. Lee had thrown down the gauntlet.

⤖CEMETERY RIDGE⤗

With bugles trumpeting the order to commence firing, the artillery detonations rolled north in a crashing wave. The cannonade then became general, birthing a sound whose loudness lay beyond the ability of most to describe. The soldiers fell back on apocalyptic terms to give form to the experience. Seething, deafening, earth-shaking, God-awful cacophony, as though the world were coming to an end. Hissing projectiles screaming though the air and shells bursting overhead scattering chunks of deadly metal. The eerie whir of the shells from the long-range Whitworth rifles spinning through the air, the teeth-rattling concussion of solid shot slamming into the ground. Dust and dirt rising and scattering, choking throats and burning eyes. The Unionists dove to the earth and hugged it mightily as the Rebel metal began to strike home. Comrades getting eviscerated, decapitated, and disemboweled.

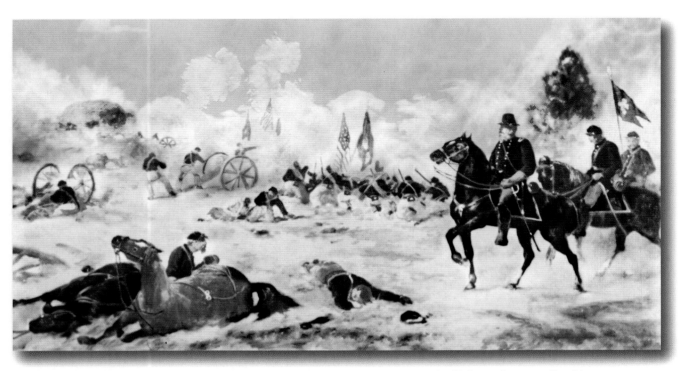

At the very height of the Confederate bombardment, Hancock traverses the II Corps front, steeling his men for the work ahead. *(GNMP)*

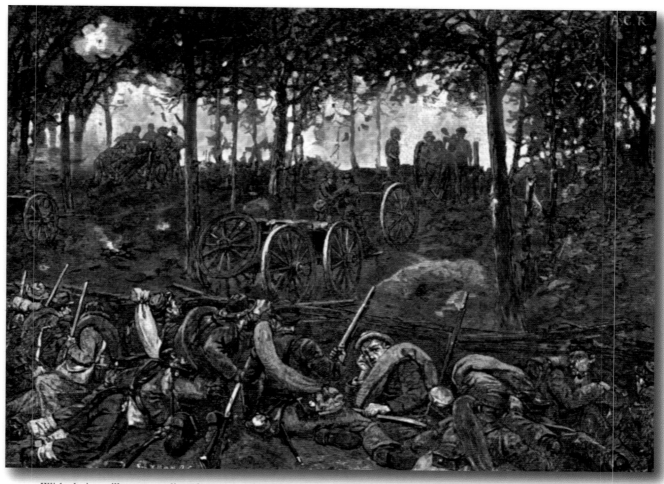

With their artillery pounding the enemy lines (background), Confederate infantry hunker down among the trees and across the broken ground of Seminary Ridge, awaiting their turn to join the battle. *(B&L)*

Body parts flying through the air and striking the quaking survivors. Horses rearing with legs shot off, pathetic whinnying as they tumble down to die. Some soldiers simply got up and ran. Whole units began to panic, and officers moved in to steady them.

Both Union division commanders rose to the occasion. Alexander Hays rode among his men, screaming at them to hold fast, warning them that an infantry attack would surely follow the pounding, and pausing occasionally to loudly and colorfully curse the Rebels. John Gibbon also circulated along his front, calmly watching the barrage cross-armed as though nothing was out of the ordinary. At one point, he walked into the field fronting Webb's Pennsylvanians and sat down, a stunning lesson in thumbing your nose at the danger. His and Hays's nervy actions immeasurably steeled their troops.

Perhaps no single image stayed with the Northerners longer than the next. From the right of the II Corps, Winfield Scott Hancock and a single orderly bearing the corps flag ignored the hissing metal and slowly trotted across the entire front. An unknown regiment's band launched into "The Star-Spangled Banner," and the corps commander waved his hat to his boys and grinned. Someone tried to warn him of the danger, but he calculated that today his life didn't much count.

Henry Hunt also leaped into action. He raced down Little Round Top and met with McGilvery. He then rode north and inspected all the artillery units all the way to Cemetery Hill. As he sped along, smoke began to fill the valley between the ridges. The view of the opposing lines constricted then disappeared, just as E.P. Alexander had expected and feared. For the Yanks, the awesome

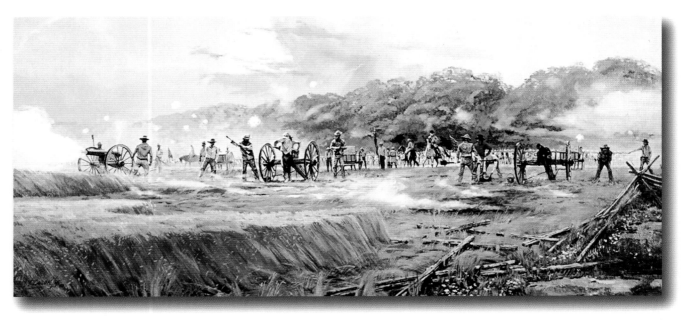

In an image illustrating an incident later in the battle, Confederate artillery pounds the Union lines.
("Summer Lightning" by Dale Gallon)

portrait of Alexander's Rebel artillery line devolved into flashes of fire in the roiling veil. For the Rebs, Cemetery Ridge's crest disappeared behind the powder cloud, revealed occasionally by the barest of breezes. Alexander found it impossible to analyze his effectiveness by sight and had to quickly develop other methods to gauge his success. He began to pay close attention to one variable in particular: the rate of the Yankee return fire.

Union guns on Little Round Top and Cemetery Hill along with two batteries just north of McGilvery, perhaps thirty-five pieces in total, responded deliberately. Their aim tended to be high, and they more likely hit the Rebel infantry in the rear of their targets rather than the targets themselves. As per Hunt's instructions, however, the five II Corps batteries were waiting the prescribed fifteen minutes before responding. When Winfield Hancock detected their reticence, he would have none of it. He wanted his infantrymen to see, hear, and feel their artillery responding. The raging general rushed to his various gun crews and profanely insisted that they answer back to the Rebel temerity. Caught between obeying the army's chief artillerist or their threateningly insistent corps commander, the gunners chose the better part of valor and went to work.

Suddenly, with twenty-five guns adding their weight to the barrage, the intensity of the bombardment in noise and metal increased dramatically. Kemper and Garnett's infantrymen felt the sting in particular, but the troops lying behind Seminary Ridge also absorbed their share of punishment. Yet even when the cannonade reached its fiercest degree, Pickett's men marveled when James Longstreet calmly rode by. He told his boys to hold on, that their artillery was pounding the Yankees, and that they would charge the enemy soon enough.

Although Confederate projectiles scored a number of direct hits, many overshot the Union front and scoured the fields adjacent to the Taneytown Road and the Baltimore Pike. Shellfire and solid shot riddled Meade's headquarters at the Leister house, forcing the army commander to relocate to Powers Hill. A VI Corps column got caught on the Taneytown Road and had to disperse, and the Artillery Reserve rumbled south to get out of range. Medical teams evacuated nearby field hospitals. Teamsters and skulkers scattered. The Unionists on the front lines soon recognized the errant work. The realization began to spread that the rear of the ridge was far more dangerous than the crest. Some Northerners lulled by the constant noise actually fell asleep.

Among the II Corps artillery units, Alexander's careful preparations produced deadly results. Anchoring the southern flank of Hays's ridge line, Captain William Arnold's six guns of Battery A, 1st Rhode Island Light

Artillery had one piece destroyed and three men killed. Twenty-two-year-old Lieutenant Alonzo Cushing and his six guns of Battery A, 4th United States Artillery took the most heat. Located just north of the clump of trees, Cushing lost four guns and a number of ammo chests in the maelstrom, and Rebel shell fragments wounded the young officer and many of his men. Just south of the copse, Brown's Battery—now commanded by Lieutenant William Perrin after their hard work the day before—only deployed four serviceable guns. The barrage destroyed one of their cannon and killed or wounded all of the officers. Captain James Rorty headed the four guns of Battery B, the 1st New York Light Artillery 280 yards south of the copse. Rebel fire destroyed two of the pieces and killed Rorty along with nine of his boys. Infantrymen from the nearby 19th Massachusetts had to help the survivors keep the remaining pieces in action.

Meanwhile, Hancock rode down to McGilvery's line and colorfully demanded to know why his cannon weren't firing. McGilvery shot back that his orders from Hunt were to husband his ammo for the infantry assault, and that's exactly what he intended to do.

Hancock left angrily, but McGilvery stuck to his guns. Around the same time on Cemetery Hill, Henry Hunt fell into a discussion with Oliver Howard, Carl Schurz, a roving George Meade, and XI Corps artillery commander Thomas Osborn. Some of Richard Ewell's long arm were enfilading the II Corps line, and Osborn had engaged in suppression fire. The officers wondered if they might fool the Rebel artillerists into thinking they had succeeded if the Yanks ceased firing. Hunt okayed the ruse and rode south to further implement it.

Finding that the barrage had exhausted most of his long-range ammo, Hunt successively ordered the batteries to cease firing. Working his way south, the officer pulled Arnold's crew off the line save one piece that he reassigned to Cushing's sector. He also commanded Brown's decimated unit to withdraw and ordered forward replacements for both. Bolstering McGilvery's line and readying his artillery reserve to plunge into the breach, Hunt finally stopped near Captain Andrew Cowan's New York Light Artillery: 1st Battery near McGilvery, fairly satisfied that he had done all he could do. Henry Hunt now merely awaited the next move.

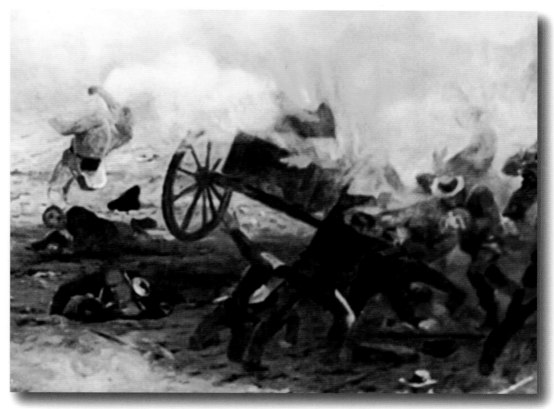

A Federal artillery caisson takes a direct hit. *(Gettysburg Cyclorama, Photo by Bill Dowling)*

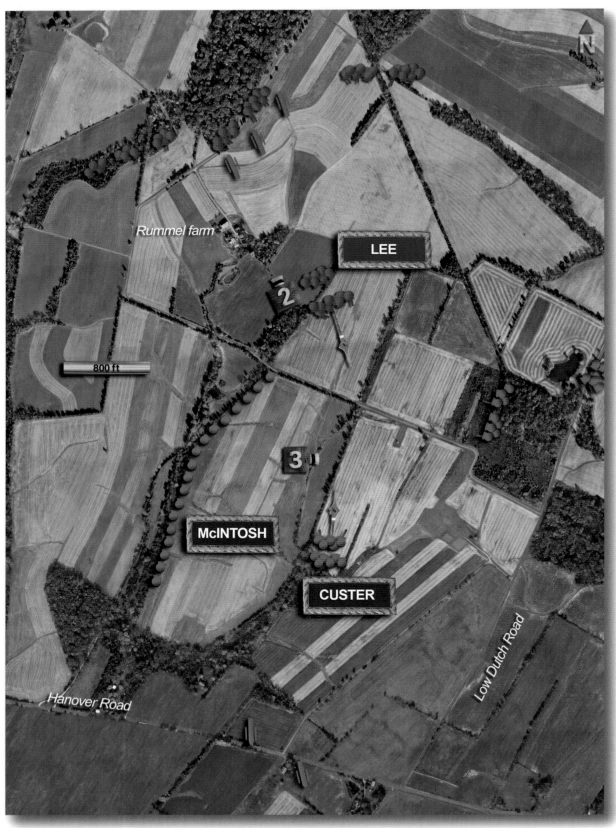

The Rummel Farm—Early Afternoon—July 3, 1863

39° 49'33.82 N 77° 10'00.60 W. Google Earth Pro. 9/6/2013. 8/25/2022.

Below: Brig. Gen. George Custer managed to finish last in the West Point class of 1861 then spent the first two years of the war on various staffs. By June of 1863, his greatest achievements were of a sartorial and grooming nature. He wore colorful outfits and perfumed his long, curly locks but no doubt longed for real action. In late June, his mentor Alfred Pleasonton shook up the cavalry corps and elevated three youngsters to brigade command—Custer being one. The Ohioan now led four regiments of 1,924 Michiganders. *(LOC)*

A nephew of Robert E. Lee, Brig. Gen. Fitzhugh Lee could easily be called his Uncle Robert's opposite. A boisterous and good-humored Virginian, Fitz Lee was a poor student at West Point but a magnificent horseman, and he began the war as a lieutenant on Richard Ewell's staff. His irrepressible nature greased his rise to a brigadier within a year, and despite his evident weakness as a strategist, Lee compiled an enviable battle record. His 1,912 horsemen in six regiments were as good as cavalry got. *(LOC)*

3. Viewed from the west, Custer leads his Michiganders north (left) into the action. *(Recollections of a Private)*

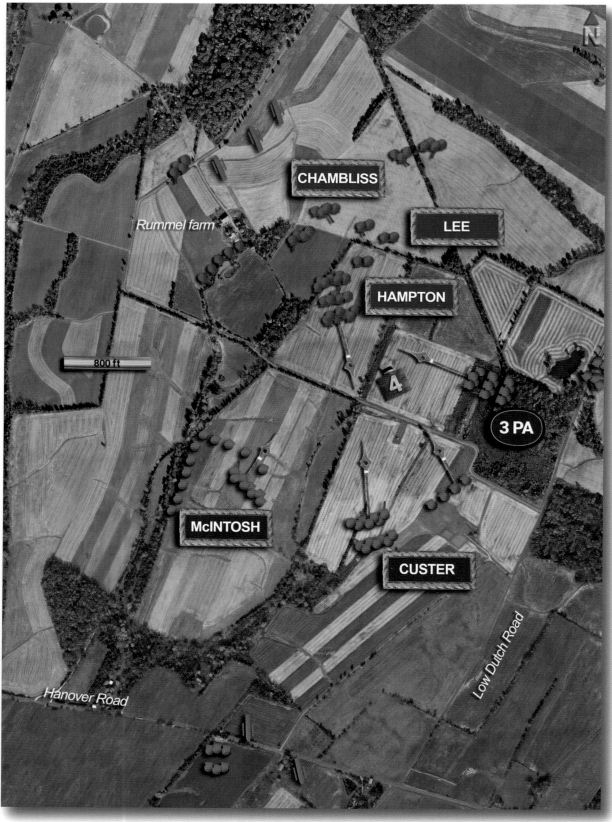

The Rummel Farm—Mid-Afternoon—July 3, 1863
39° 49'33.82 N 77° 10'00.60 W. Google Earth Pro. 9/6/2013. 8/25/2022.

4. In one of the last actions of the battle, the troopers of the 3rd Pennsylvania Cavalry charge to the west (left) and hammer the left flank of Wade Hampton's assault. *(Deeds of Valor)*

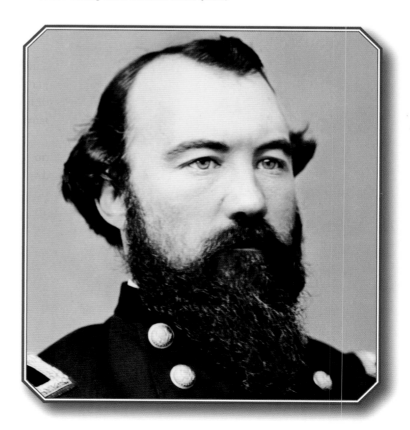

Floridian Col. John McIntosh got his first taste of military life as a midshipman during the Mexican War, which would also be his last until the guns of Sumter. When hostilities commenced, McIntosh joined the 5th United States Cavalry but soon earned the colonelcy of the 3rd Pennsylvania Cavalry. He had a solid combat record, and when Percy Wyndham fell wounded at Brandy Station, McIntosh took over his brigade command. With his relative inexperience heightened by severe intestinal problems, McIntosh faced unique challenges guiding his seven regiments of 1,311 troopers onto the field. *(LOC)*

THE RUMMEL FARM

Both sides paused for a moment to marvel at the thunder and billowing smoke produced by the massive barrage off to the west. One cavalryman thought the town of Gettysburg was on fire. Then the gathered got down to the nasty business of drawing blood. Union artillery quickly gained the upper hand over their counterparts, blasting the Confederate artillery to pieces with impunity. About 300 yards south of Rummel's farm, dismounted troopers engaged in a vicious firefight over a slight watercourse called Little's Run. The fighting pulsed back and forth, and neither side could hammer out an advantage. Stuart decided to press the issue. Soon, Fitz Lee's 1st Virginia Cavalry came rolling down the fields east of Rummel's, to which Custer led the 7th Michigan Cavalry in a countercharge that crashed into the Virginians in a tidal explosion. The Confederate cavaliers fell back, but elements from all of Jeb's brigades throttled the Michigander breakthrough and initiated a second southern wave spearheaded by Wade Hampton's Georgians and Carolinians.

Hampton's troopers advanced with parade ground precision, but David Gregg responded with calm efficiency. First, Gregg's artillery battered the Rebel ranks. Then, the 1st Michigan with Custer again in the lead crashed into Hampton's van while the 3rd Pennsylvania sliced up the Rebel left. Col. John McIntosh's dismounted Federals battling along Little Run turned to fire on Hampton's right flank. In a dizzying, dust-choked melee, Hampton went down with two sabre wounds to the head, and the Southern advance ground to a halt.

Stuart soon accepted his fate. The Hanover Road and the Low Dutch Road would remain in Union hands, while he and his spent cavalry units slowly disengaged from the tenacious Bluecoats and abandoned the field.

SEMINARY RIDGE

E.P. Alexander scanned the enemy lines looking for the slightest clue to guide his thoughts. At first, he thought a fifteen-minute bombardment would do the trick. However, when the Yankee guns redoubled their efforts—thanks to Winfield Scott—Alexander could not bring himself to trigger the assault. Pickett pestered him with inquiries: was it time yet? The barrage had lasted nearly a half-hour and still the enemy guns on the ridge kept up their pace. Some of his men had blood trickling from their ears from the continuous concussions. Finally, perhaps ten minutes later, Union crews started removing guns, and the overall firing seemed to slacken. Alexander's own gunners were reaching the bottom of their ammo chests. It was time. He ordered the barrage to end, and he alerted Pickett to come quick as the enemy artillery near the tree clump had been driven off and his own ammo was running low. Up near his three brigades, Pickett read the note and rode off to consult with Longstreet.

Pickett asked if he should advance.

After a silent pause, Longstreet nodded.

Pickett then announced he would lead his boys forward.

Longstreet said nothing. Pickett galloped away to spread the word.

Longstreet had one more card to play. He sought out Alexander where he discovered that the Confederate caissons were nearly empty. Longstreet thundered that Pickett should be halted while Alexander replenished his ammo. The artillerist countered that such a move would delay the attack by at least an hour, allowing the stricken enemy to recover. Alexander declared they should strike now with the hot iron. James Longstreet took a moment then vented that he didn't want to make the assault, that the operation was doomed, and that he was only following Lee's orders.

Silence. A breeze blew up and started to clear the barrage's choking smoke from the Pennsylvania air.

Behind them a great noisy bustle rose from the forest crowning Seminary Ridge, then massed rows of Confederate soldiers shouldered through the trees into the powder-burnt sunshine painting the fields.

Whatever dark thoughts filled James Longstreet's mind mattered little now. The Grand Charge had begun.

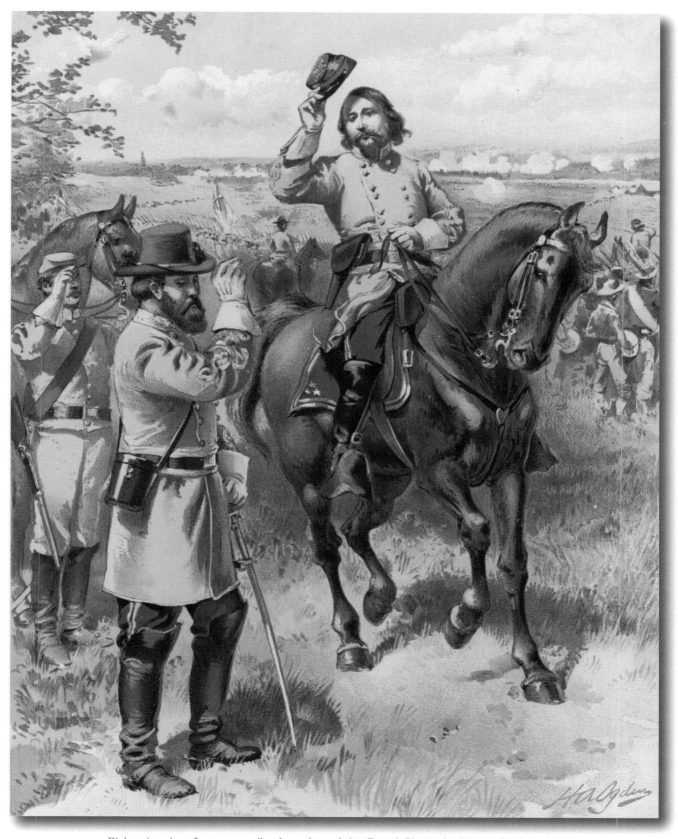

Pickett inquires, Longstreet silently nods, and the Grand Charge is about to begin. *(LOC)*

CHAPTER 5

FROM THE LOWLIEST PRIVATE to the loftiest general, they nudged each other and pointed, "Here they come." At the southern end of the formation, Kemper's and Garnett's infantrymen seemed to rise out of the ground as they exited their swale. Behind them, Armistead's boys departed the trees and stepped into the light. Further north, Pettigrew's four brigades rolled out of the forest on the distant ridge and formed into a massive half-mile line. Behind them came Trimble's two brigades. The Grayclad soldiers began dressing their ranks. A panoply of flags shook out and flapped in the light breeze. None of these Unionists had ever seen anything like it. Some thought it unfair that they would soon be called upon to bleed it and destroy it. But almost every Billy Yank shared a similar reaction when the great charge began: here they come.

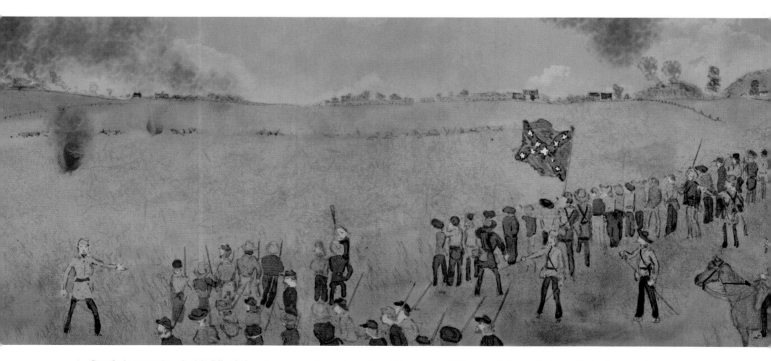

1. Confederates (probably Virginians) emerge from tree-lined Seminary Ridge and dress their ranks before setting across the open fields to attack the Federals. On the horizon (from left to right): the clump of trees, the Codori farm, the Klingle house (above the flag), the Sherfy farm, Little Round Top, the Wentz house, and Big Round Top. *(LOC)*

~CEMETERY RIDGE~

The Union center burst into a hive of activity. John Gibbon rushed up to the crest to see the approach of the gray wave. He knew he had around 2,700 veterans to hold the center, and he told his boys to fire low and slow. He also sent an aide to update Meade. To the north, Alexander Hays reassigned some troops from Colonel Eliakim Sherrill's brigade to bolster Colonel Thomas Smyth's three regiments manning the southern stretch of the Brian stone wall. He also advanced all of his troops who had sheltered in Ziegler's Grove to strengthen Sherrill's command along the northern portion of the wall. His soldiers had collected rifles from the battlefield and stacked them nearby to increase their firepower. Nearly all of the soldiers the pugnacious Hays commanded would be on the firing line.

From the wreckage of his position north of the tree clump, Alonzo Cushing pushed his two functioning guns to the wall south of the angle, in between the 69th Pennsylvania on his left and a wing of the 71st Pennsylvania on his right. The balance of the 71st along with the rest of Alexander Webb's brigade remained eighty yards back on the flank of Hays's line. Some infantrymen stared out at the Rebel tide and thought of life in a Confederate prison. Others recalled their hopeless charge against a similar wall at Fredericksburg almost eight months earlier and guessed this day could duplicate that experience only in reverse. Word spread to wait until the Rebels reached the Emmitsburg Road to open fire.

George Meade's plan to communicate by signal flag with his headquarters at the Leister house had fallen apart. He rode to re-establish himself at the now battered farmhouse while calling up reinforcements to bolster Hancock and the army's center. Meanwhile, medical teams rushed back to their field hospitals and prepared for the worst.

Behind the lines, artillery crews thundered up both the Taneytown Road and the Baltimore Pike from the reserve park at Powers Hill. Henry Hunt's foresight had arranged some 80 cannon aimed directly at Lee's grand charge, but he wanted more.

Nevertheless, the day's battle was proceeding exactly as Hunt thought it would.

Here they come?

Let 'em.

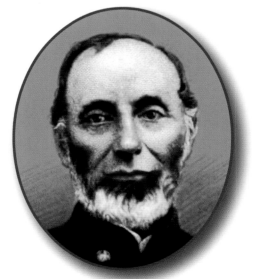

A son of County Cork, Ireland, who emigrated to Philadelphia, Col. Thomas Smyth got his first taste of the military when he joined William Walker's filibusters in Nicaragua. He began the Civil War in the 1st Delaware as a major. His steady and notable battle performances eventually earned him the regiment's colonelcy, then he rose to brigade command after Chancellorsville. Gettysburg would be Smyth's first battle at the head of four regiments of 1,069 men. *(LOC)*

A New York tanner and popular state politician, Col. Eliakim Sherrill used his pre-war experience as a militia major to raise the 126th New York and become its colonel. Badly wounded during the Antietam Campaign, Sherrill rejoined the regiment in January of 1863. He took over Willard's New York brigade when Willard was killed near Plum Run on July 2. *(Disaster, Struggle, Triumph: The Adventures of 1000 Boys in Blue)*

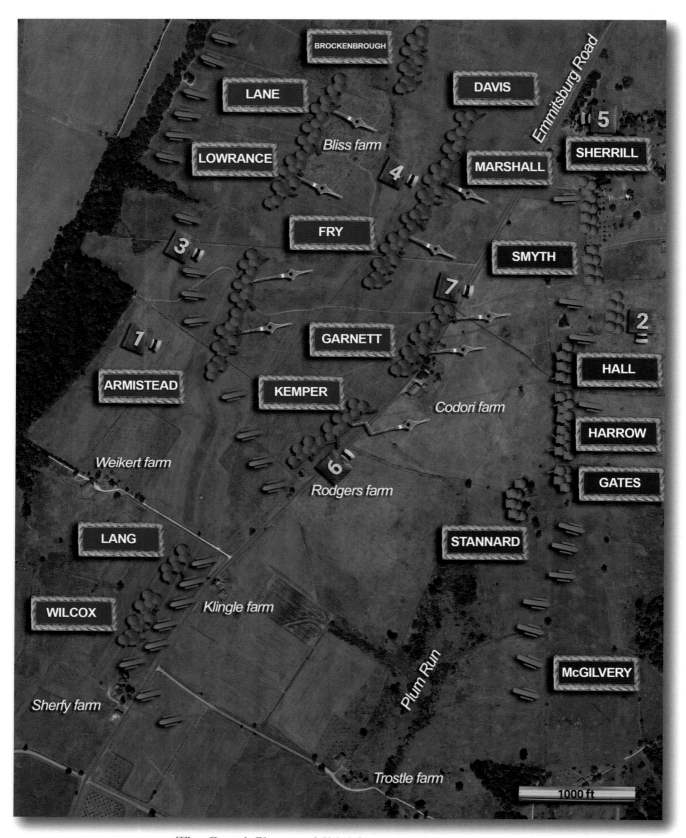

The Grand Charge—Mid-Afternoon—July 3, 1863
39° 48'43.96 N 77° 14'25.88 W. Google Earth Pro. 9/6/2013. 8/25/2022.

TO THE EMMITSBURG ROAD

Robert E. Lee's plan to pierce the Yankee center involved four moving parts, but central to the enterprise was James Archer's brigade now led by Colonel Birkett Fry. Fry's Alabamans and Tennesseans would march straight across the field toward the copse of trees, and Johnston Pettigrew's other three brigades would align on Fry, extending the line to the north. Isaac Trimble commanded the second component—Lane's and Scales's brigades—which followed in Pettigrew's wake by 150 yards. Kemper's and Garnett's brigades represented the third component of the charge. As both advanced independently to the east, they would also need to sidle about 500 yards to the north to link up with Fry and the rest of Pettigrew's formation. That would place six brigades coalescing on a broad front near the Emmitsburg Road to deliver the coup de grace. The fourth component, Armistead's brigade, only had to sidle 200 yards to the north to reach Trimble's axis of attack, putting three brigades in close support of the front.

Other brigades on both flanks would stand ready to exploit successes, but these nine represented the hammer.

Skirmishers raced forward and took on their blue-coated counterparts. When they got their first good look at the ground running up to the enemy lines, they were shocked by how flat and open it appeared.

Kemper's five Virginia regiments skirted north of Lang then strode through the artillery line—about

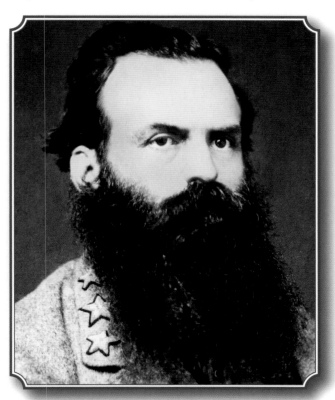

Virginian politician Brig. Gen. James Kemper had no military training to speak of other than his work as chairman of the state's Military Affairs Committee. However, his high profile earned him a colonelcy of the 7th Virginia when war broke out, and he fought well from First Manassas to the beginning of the Peninsula Campaign. Kemper took over A.P. Hill's brigade in early June of 1862 and led it through Second Manassas and Sharpsburg. Like Armistead, Kemper would see no more action until Gettysburg, but the somewhat bombastic politician who could break into a stump speech at a moment's notice earned the love and respect of the 1,634 Virginians in his five regiments. *(The Valentine)*

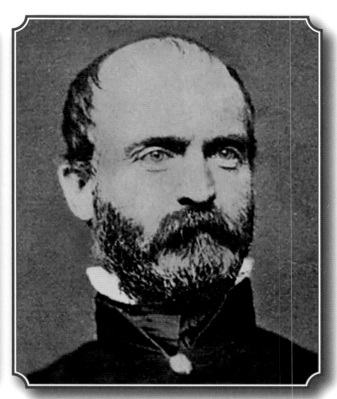

A West Point drop-out from a family deep with military traditions, Brig. Gen. Lewis Armistead had served in the army for twenty-two years when the Civil War began. He had excelled in the Mexican War and served in Los Angeles when news of Sumter arrived, the location of a tearful farewell with his friend, Winfield Scott Hancock. Arriving in Richmond in September of 1861, Armistead took charge of his home state's 57th Virginia but quickly ascended to brigade command. Known as a reserved, by-the-book, no-nonsense army lifer, he performed well during the Seven Days and at Second Manassas. However, he and his five regiments of 1,950 Virginians marched onto the field at Gettysburg not having seen any real action in a year. *(LOC)*

three hundred yards—where they took both the cheers of the cannoneers and words of caution from the Alabamans and Floridians who had covered this same ground yesterday. Suddenly, as they approached the fence-lined Emmitsburg Road, the Confederates entered the killing zone. First Rittenhouse's artillery on Little Round Top then McGilvery's hidden gunners opened with a pulverizing oblique fire from less than 1,000 yards. Solid shots thudded along the ground slicing up the formations, and shells burst overhead, pouring down a rain of destruction and death. The butternut lines would shudder in a jumble of blood and entrails, and officers screamed to close the ranks and dress to the left. Their flags would fall, and men would rush to pick them up. Kemper, mounted, pushed them all ahead.

Garnett's ranks received much the same treatment as more of the Federal artillery joined the contest. Shot and shell gouged the five Virginia regiments, and entire color companies fell under the barrage. Fence lines disrupted the brigade's order and slowed the pace of the advance. Earlier, Garnett had been kicked by a horse and could barely move. Orders had been issued for the brigadiers to walk, but Garnett had operated under a cloud since Stonewall Jackson had relieved him on the field at Kernstown two springs ago. He was not about to miss this. He gamely rode along in front of his charges, urging his men into the storm.

Lewis Armistead led his brigade from 20 paces in front, his upraised sword indicating his position. As they crested the artillery line, the Virginians could see their division mates getting hammered in the fields up ahead. When they covered more ground, their turn came to enter the killing zone. Yankee projectiles began to hollow their ranks, but the troops closed the gaps as though they were performing a drill. They followed Armistead east into the whirlwind.

Pickett advanced 100 yards behind his front. He noticed that Wilcox and Lang had held back, so he dispatched aides to get them moving. He also realized

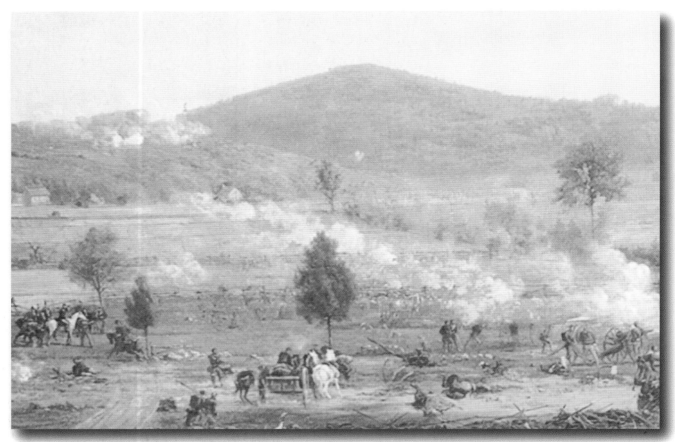

2. Looking south from near the clump of trees, the smoke from Rittenhouse's (formerly Hazlett's) battery on Little Round Top and McGilvery's artillery array along lower Cemetery Ridge (center) marks the southern stretch of Henry Hunt's response to the Confederate assault (out of view to the right). *(Gettysburg Cyclorama, Photo by Bill Dowling)*

With James Archer captured during Wednesday's battle, brigade command fell to Col. Birkett Fry, a man who truly knew his business. The Virginian matriculated at both VMI and West Point then studied law before enlisting for the Mexican War. He became a California "49er" and a lawyer in Sacramento then filibustered with William Walker in Nicaragua (rising to the rank of general) before moving to Alabama to engage in cotton manufacturing. With the outbreak of hostilities, Fry became colonel of the 13th Alabama, being wounded at Seven Pines, Antietam, and Chancellorsville. The Grand Charge would be Fry's first engagement commanding a brigade. *(PHOTCW)*

A scion of a family with deep ties to Virginia history, Col. James Marshall graduated from VMI with honors in 1860 but was teaching in North Carolina when war broke out. He spent the first year of the war as a captain in the 1st North Carolina then rose to colonelcy of the 52nd North Carolina in April of 1862. He had seen no action prior to Gettysburg as his unit was assigned to backwater guard duty up until May of 1863. When Pettigrew took over the division from Henry Heth after the first day's fight, Marshall ascended to brigade command for the Grand Charge. *(Virginia Military Institute Archives)*

that Kemper had fallen off the axis of the advance. He ordered his brigadier to dress left, an effort the politician executed in a sequence of zigging and zagging. With each gyration, momentum dissipated.

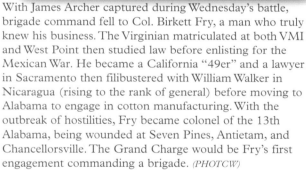

As Pickett's men began their movement, back by Seminary Ridge, Fry's boys also marched forward, with Pettigrew's former North Carolina brigade under Colonel James Marshall advancing on Fry's left and Joseph Davis's Mississippians and North Carolinians continuing the line to the north. However, John Brockenbrough had inexplicably divided his four Virginia regiments in two and assigned control of one

half to Colonel Robert Mayo. Whatever the command structure, neither grouping advanced with the division, leaving the other three brigades to be scourged in front by the II Corps artillery and on the flank by Major Thomas Osborn's XI Corps guns on Cemetery Hill. Finally, Brockenbrough's troops ran forward to try to catch up.

As with everywhere on the field, stout fences disordered the already struggling formations. Twice, under fire, Pettigrew dressed his now-bloodied ranks. His troops reached the still smoldering Bliss farm where they paused in the swale of Stevens Run. Near Long Lane, Brockenbrough's winded troops finally rushed up to take their proper place in line. Oblique fire from Cemetery Hill cut a terrifying path through

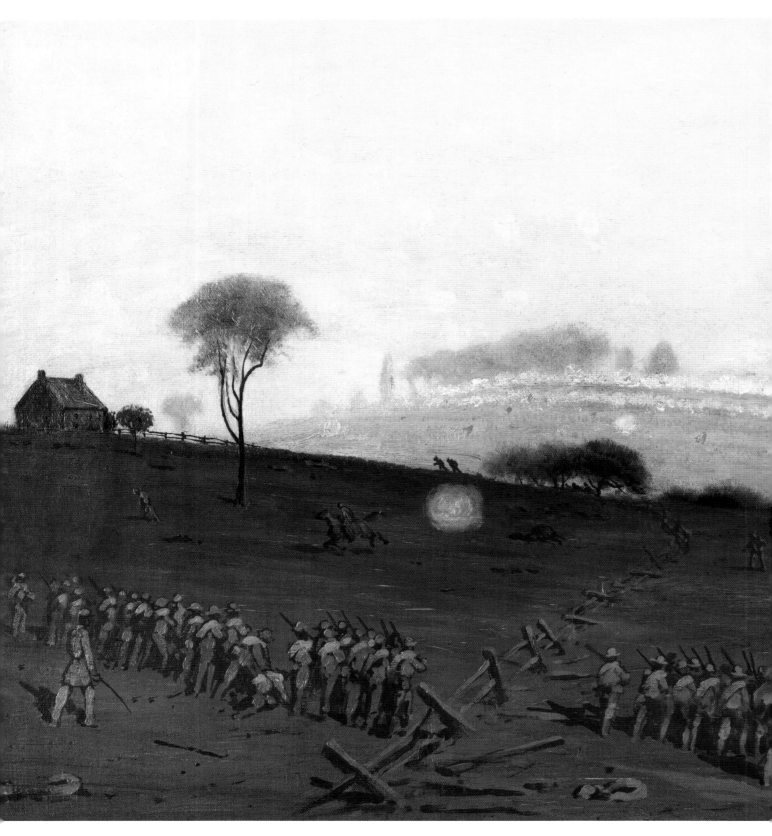

3. While the fronting brigades get pummeled by fire from the Federal battle lines, Isaac Trimble's second Confederate wave marches forward into the kill zone.

A Marylander by way of Virginia and Kentucky, Maj. Gen. Isaac Trimble graduated from West Point and served as an artillerist until he left the army to become a railroad man. The guns of Sumter prompted him to join the Confederacy as an engineer, but he quickly became a brigadier and served loudly and aggressively until an ankle wound at Second Manassas put him on the shelf. Trimble harangued himself a promotion to Major General, but he was given a backwater command in the Shenandoah that rankled. When Lee invaded Pennsylvania, the sixty-one-year-old Trimble tagged along as a volunteer staffer where he famously decried Ewell's decision not to attack Culp's Hill on Day 1. On the morning of July 3, Trimble finally got his divisional command with the brigades of Lane and Lowrance in the second wave—a body of troops he didn't meet until a few hours before the attack. *(LOC)*

Visible on the horizon is the Brian farm and Ziegler's Grove (left), Alexander Hays's division (center), and the clump of trees (right). *(LOC)*

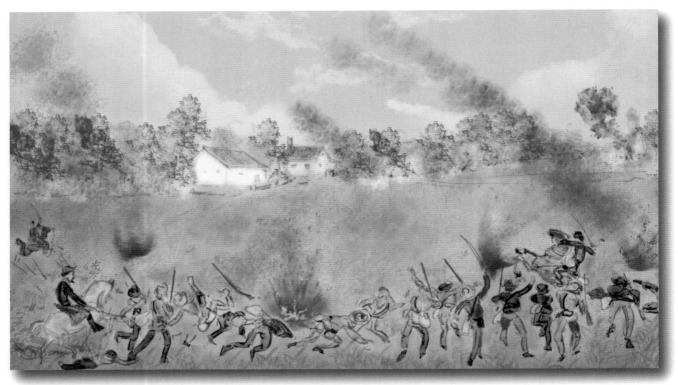

4. Union artillery lances Pettigrew's front three brigades. The Brian farm sits in front of Ziegler's Grove (left center) and Hays's artillery fires in line to the right (south). *(LOC)*

their left flank, raising a welter of eviscerated soldiery above the dust and the smoke. Out on the picket line, the 160 rifles of the 8th Ohio saw the destruction and decided to act. They advanced to a fence line 100 yards from the reeling Virginians and fired into the Rebels's faces. Some of Brockenbrough's boys returned the fire, a few others plowed on, but most simply broke for the rear. Trimble's people tried to stop them to no avail. Granted, questions already existed about the combat effectiveness of this unit, but the fact remained that a brigade in the Army of Northern Virginia had turned tail under fire and run.

With Brockenbrough gone, the 8th Ohio now found themselves propitiously north of the Rebel attack. The Ohioans wheeled to the left, then lay down behind a modest fence-lined ridge to face south. As Pettigrew's battle line rolled over the final stretch to the Emmitsburg Road, the Buckeyes hammered a volley into their unsuspecting left flank. Clots of Rebel infantrymen ignored their orders and stopped to shoot at both the gang of Ohio Bluecoats to the north and the smoke-choked enemy line up ahead. All the while, Osborn's Federal citadel on Cemetery Hill and

Woodruff's battery at Ziegler's Grove continued to punish Pettigrew's left flank.

To the south, Pickett's front reached the Emmitsburg Road.

⤔⚬⤖

Most of Kemper's Virginians crowded across the roadway between the Rodgers house and the Codori farm. Much of the fencing on the roadway's shoulders had been torn down, and what remained offered little hindrance. Past the road, the troops then tumbled down into a swale that provided a momentary veil of protection. Finally, with Kemper still in the saddle, his boys executed one last left wheel and started up the ridge toward the clump of trees, 400 yards to the northeast.

North of Cordori's, Garnett closed in on Fry's brigade and joined Pettigrew's grim grind toward the dual fences lining the Emmitsburg Road. Along the II Corps's front, Federal artillery captains had mostly been silent, having expended their long-range ammo at Hancock's insistence. However, now, with the Rebels in

range, they called for canister. The next series of explosions launched a murderous sheet of iron balls that ripped into the Gray ranks. Garnett's Virginians and Pettigrew's survivors willed themselves up to the fence and started to climb. Cohesion disappeared as more canister scorched the roadway. Then sweeping volleys exploded from the enemy positions as the Yankee rifles joined the battle. Bodies by the score crumpled into the dirt. The carnage was terrifying and mind-numbing. Some Rebels gave up. They burrowed behind the raise of the road's eastern shoulder and refused to move. Others summoned what will they had left and pushed over the second fence, dropping into the bare field that rose to the Yankee lines.

At the start of the charge, the Confederate front had stretched over a mile from end to end. Now, a half-hour later, tactics and Federal artillery had telescoped the van into a compact mass a half-mile wide. More and more Confederates poured over the fence, muscling into the teeming heap being flogged by cannon blasts and riflery. The cries of the wounded and the dying mixed with officers screaming for their boys to press on. Still miraculously in his saddle, Richard Garnett bellowed for everyone to move, for one more stab, for one more lunge. Now little more than a frenzied mob, Garnett's survivors unleashed a primal roar and staggered up the holy ridge.

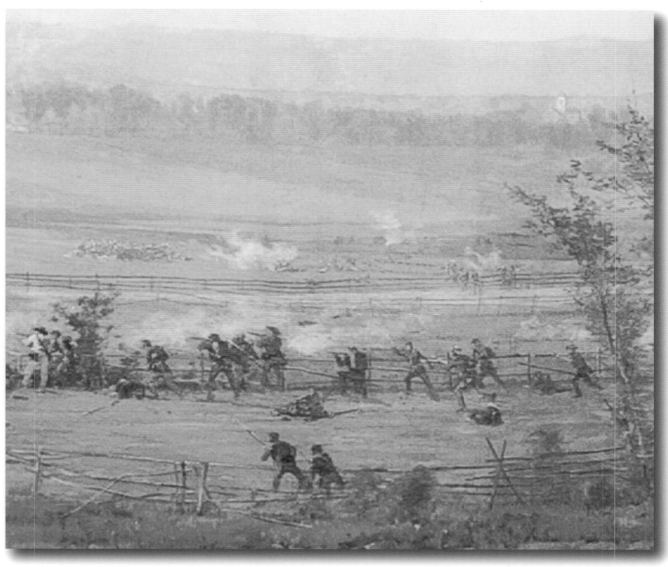

5. In the field west of the Emmitsburg Road (center) John Brockenbrough's brigade breaks under fire, allowing the Union skirmishers (middle foreground) to turn on Davis's brigade. *(Gettysburg Cyclorama, Photo by Bill Dowling)*

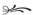

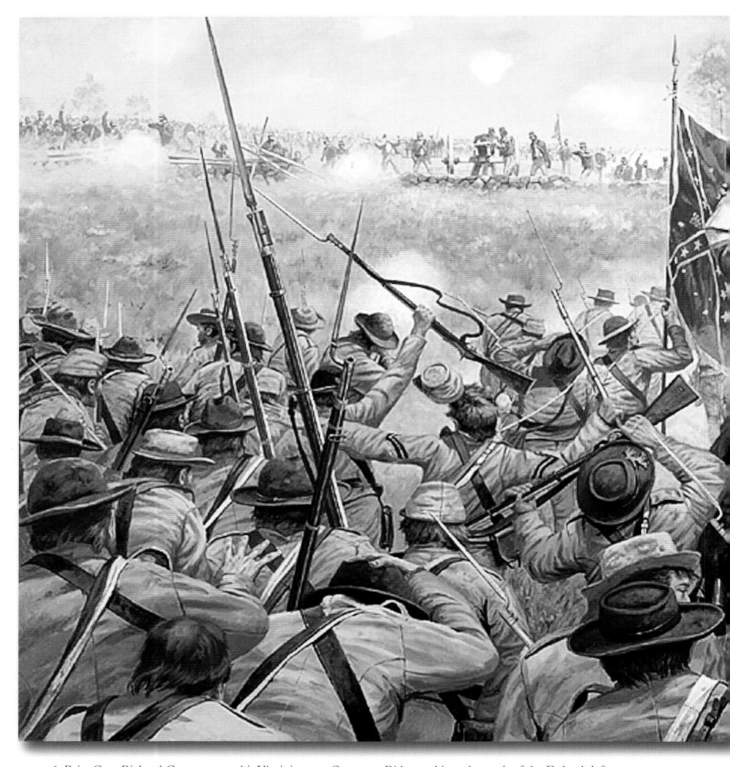

6. Brig. Gen. Richard Garnett urges his Virginians up Cemetery Ridge and into the teeth of the Federal defenses. Garnett reportedly was shot in the head as he waved his hat.

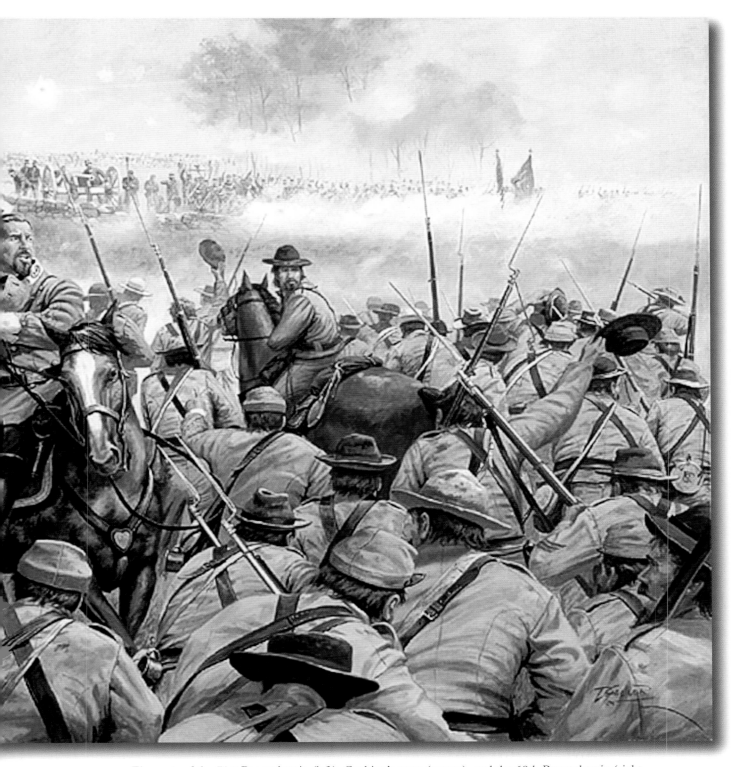

Elements of the 71st Pennsylvania (left), Cushing's guns (center), and the 69th Pennsylvania (right, fronting the clump of trees) lay down a killing fire. *("Confederate Glory" by Dale Gallon)*

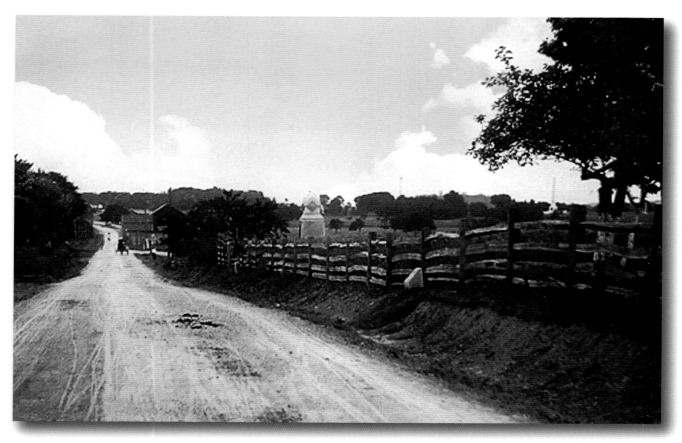

From the Rodgers house (left off-camera) to the Codori farm (red building, center) Kemper's brigade crosses this section of the Emmitsburg Road (from left to right) before angling to the northeast and the clump of trees. Note the natural trench that prompts many Confederates further north to stay put. *(Sue Boardman Collection)*

⌒CEMETERY RIDGE⌒

George Stannard's three Vermont regiments manned a bulwark about 500 yards south of the tree copse and some 100 yards west of the Union line. The 90-day men supposedly were counting the hours until their enlistments expired, but they had performed well the day before in fending off Wright's Rebels and retrieving Weir's guns. They seemed eager for more action. At first, Pickett's front appeared to head straight for them and their fence post works, but as Kemper maneuvered across the Emmitsburg Road and angled toward the copse of trees, the Virginians unintentionally presented their right wing to the Green Mountain boys. Stannard's men raked the Virginians.

The entire Union line now punished the game Rebel attackers. Colonel Theodore Gates commanded two of Thomas Rowley's I Corps regiments who had been roughed up two days before at the Seminary fight. In formation just north and east of the Vermonters, the New Yorkers and Pennsylvanians blasted at Kemper's struggling Virginians. Small gangs of Southerners stopped to return the fire while others drove further north. Now came the turn for the other two Union organizations from Gibbon's division that held the line up to Webb's troops at the copse of trees: the brigades of Brigadier General William Harrow and Colonel Norman Hall. Harrow's four regiments—the bloodied 1st Minnesota and units from Maine, New York, and Massachusetts—slammed volleys into Kemper's roiled ranks. Norman Hall commanded three regiments along the wall—Massachusetts, New York, and Michiganders—and two regiments sixty yards back supporting Andrew Cowan's repositioned artillery just south of the clump of trees. Hall's front liners waited for Kemper's survivors to close within a few dozen yards before their massed volley bowled them over in what seemed to be a game of grisly ten-pins.

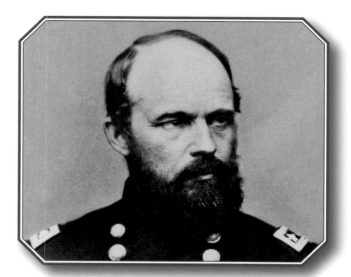

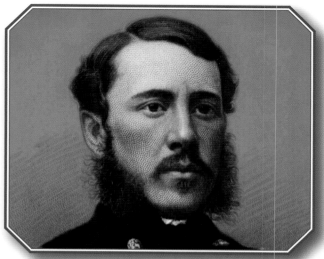

As a Vermont foundry operator before the war, Brig. Gen. George Stannard had risen to the rank of colonel in the state militia. As a result, he fought well at First Bull Run as a lieutenant colonel in the 2nd Vermont. His performance on the Peninsula earned him the colonelcy of the 9th Vermont but being part of the ignominious surrender at Harpers Ferry during the Antietam Campaign put him on the sidelines until March of 1863 when he was given a brigade of 90-day Vermont volunteers. They manned the Washington D.C. defenses, but Stannard's quiet competence and dedication to drill turned his three regiments of 1,918 rookies into a valuable organization who marched north to oppose Lee's invasion. *(LOC)*

An artillerist five years out of West Point, Col. Norman Hall was stationed at Fort Sumter in April of 1861 and got a first-hand view of the beginning of the war. A New Yorker with a fine professional reputation, he took various staff positions until July of 1862 when he assumed command of the 7th Michigan. Wounded at Antietam, Hall remained on the field and directed his brigade when its commander went down. At Fredericksburg, he famously led his brigade across the Rappahannock and ran out the tenacious Confederates manning the streets and houses of the ruined city. He and his five regiments of 922 rifles had distinguished themselves on their every field of battle. *(USAHEC)*

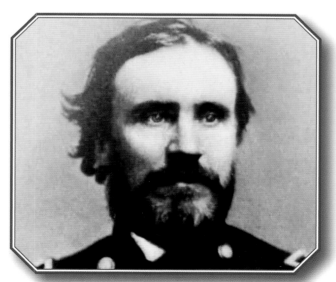

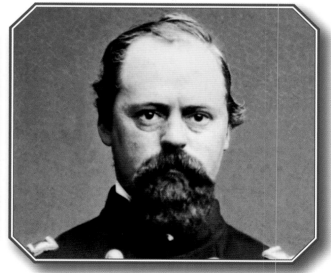

A native Kentuckian who moved to Illinois to practice law, Brig. Gen. William Harrow had no military experience to speak of when he began the war as a captain with the 14th Indiana. Within a year, he made colonel but spent much of his time recuperating from a variety of illnesses. Courageous and competent, Harrow had a prickly streak, but he fought off yet another bout of bad health to lead his four regiments of 1,346 soldiers into Pennsylvania. *(LOC)*

New York lawyer Col. Theodore Gates had spent the ten years before Sumter serving with the 20th New York State Militia, which put him in good stead when the war broke out. After the unit's 90-day service, Gates helped reorganize the regiment into the 80th New York and became its colonel at Antietam. *(LOC)*

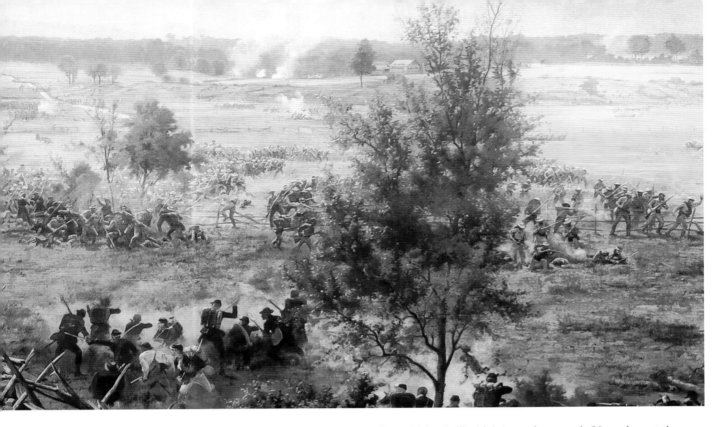

7. Looking west from Hays's left (southern) flank, Fry (left) and Marshall's (right) survivors push 80 yards past the Emmitsburg Road (fence line, middle distance) to come to grips with Hays's Unionists (foreground). Trimble's two brigades are visible beyond the road. *(Gettysburg Cyclorama, Photo by Bill Dowling)*

8. Looking north from Hays's left (southern) flank, Capt. William Arnold's Battery A of the 1st Rhode Island Light Artillery pumps canister into Pettigrew's front. In the background stands the Brian farm (left) and Ziegler's Grove (right) with Union reinforcements rushing to the front. *(Gettysburg Cyclorama, Photo by Bill Dowling)*

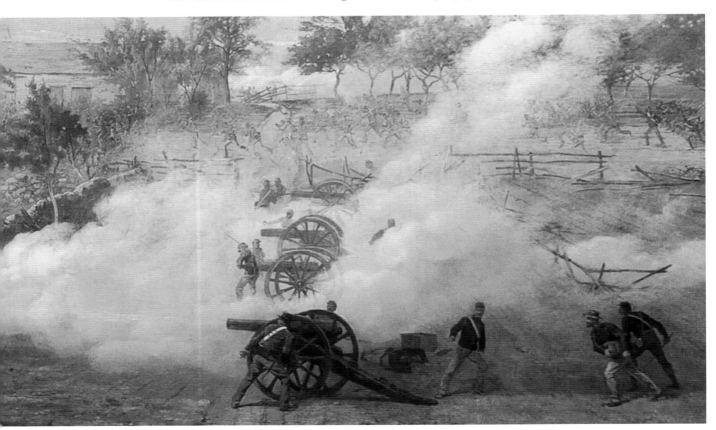

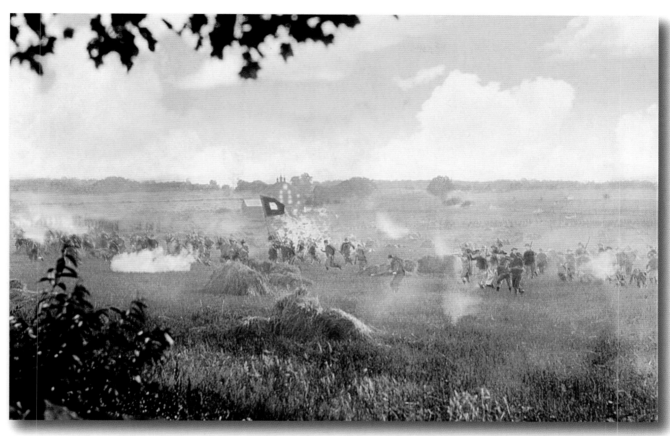

9. In 1922 on the ground where it happened, United States Marines reenact Garnett's Brigade covering the last few yards of their assault before hitting the Federal lines. The Codori farm is in the center background. *(Rich Kohr Collection)*

The six Confederate brigades leading the grand charge had almost ceased to exist as fighting organizations. Some of Kemper's units either went to ground exchanging rounds with the regiments of Stannard, Gates, Harrow, and Hall, while others pressed forward, still trying to reach the copse. As Kemper's boys ran the gauntlet, Garnett's survivors careened toward the Yankees manning the Angle: the Irish 69th Pennsylvania fronting the trees, Cushing's two guns, and the elements from the 71st Pennsylvania just north of Cushing. Further north on Pettigrew's front, while many Confederates remained on the road, others bent forward into the savage gale. Fry's winnowed Tennesseans and Alabamans pushed toward Thomas Smyth's Bluecoats on Hays's left while Marshall's North Carolinians hit the center and Joe Davis's Mississippians rushed Hays's right. Loading and firing, their flags fell and rose and fell again, victims of rifled Yankee lead or their murderous long arm. Across the entire front, Union firepower had gutted Confederate leadership. Kemper took a Yankee bullet that knocked him from his horse. Grapeshot creased Pettigrew's right hand, but he ignored the wound and called for his boys to continue. Garnett lay somewhere west of the copse, his body lost in the piles of his dead boys. Despite the losses, the Southern fighting men kept grinding it out on their own hook, getting closer, closer, ever so closer.

At the very point of the angle, the isolated wing of the 71st Pennsylvania reached their limit of endurance. Pickett's throng headed straight for their front, and Pettigrew's wave threatened to crush their exposed right flank. Only Cushing's decimated gun crews covered their left, and the panicked Pennsylvanians could take no more. They took off, rushing back across the Angle and through the detritus of Cushing's shattered battery for the safety of the rear. A badly wounded Alonzo Cushing pounded two last rounds into the teeming enemy mass then fell with a bullet to the brain. Screeching the Rebel yell, Confederates

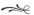

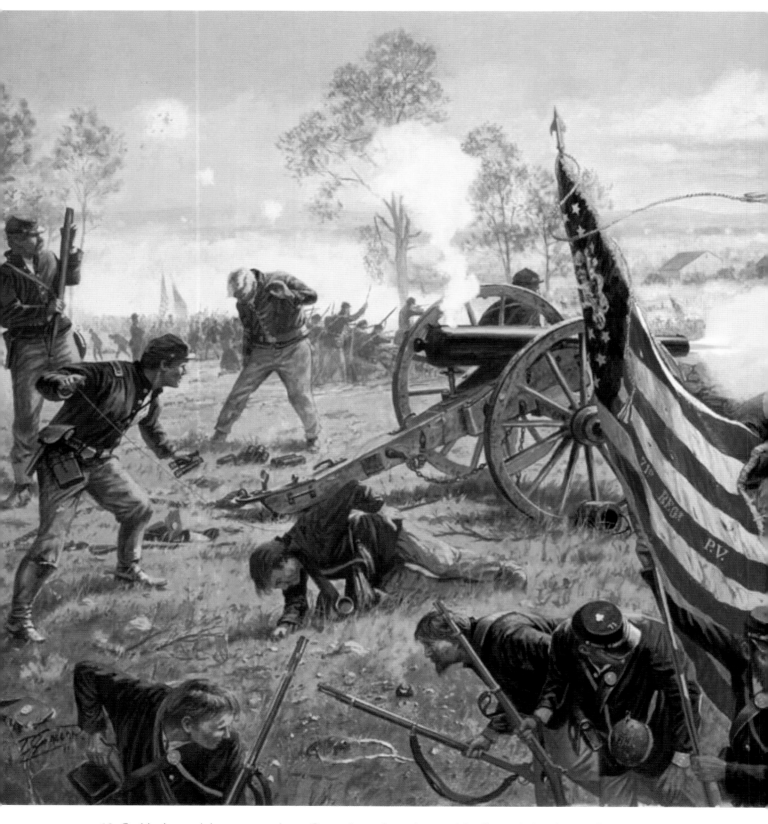

10. Cushing's remaining two guns lance Garnett's survivors (center right distance), but the 71st Pennsylvania begins to break at the point of the Angle (foreground).

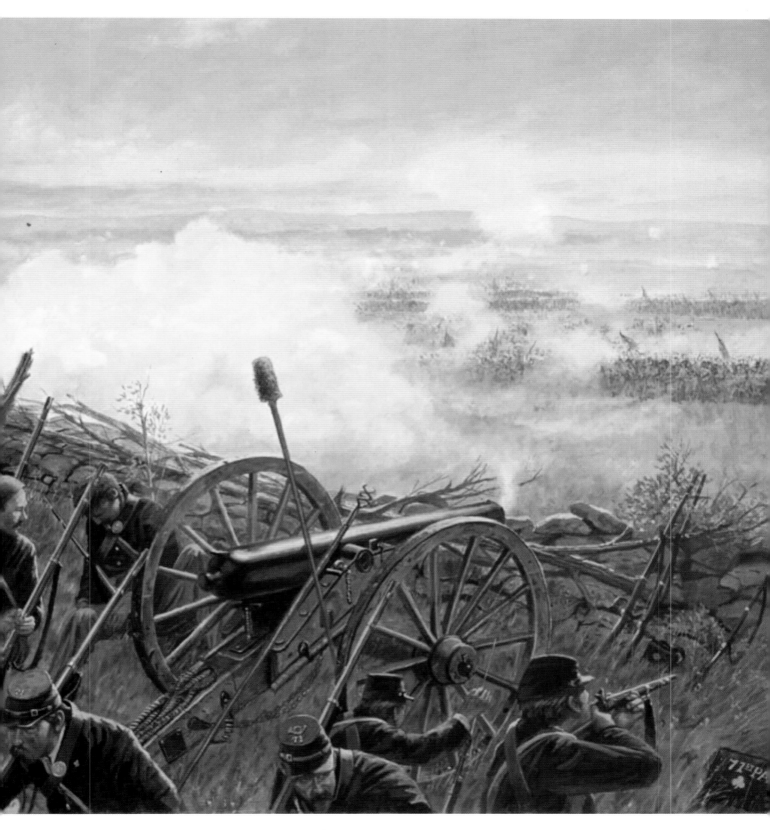

In the left background, the Irish of the 69th Pennsylvania maintain their lines fronting the copse of trees (far left). The Codori farm is visible in the middle distance. *("Pickett's Charge—Gettysburg 150th Anniversary" by Dale Gallon)*

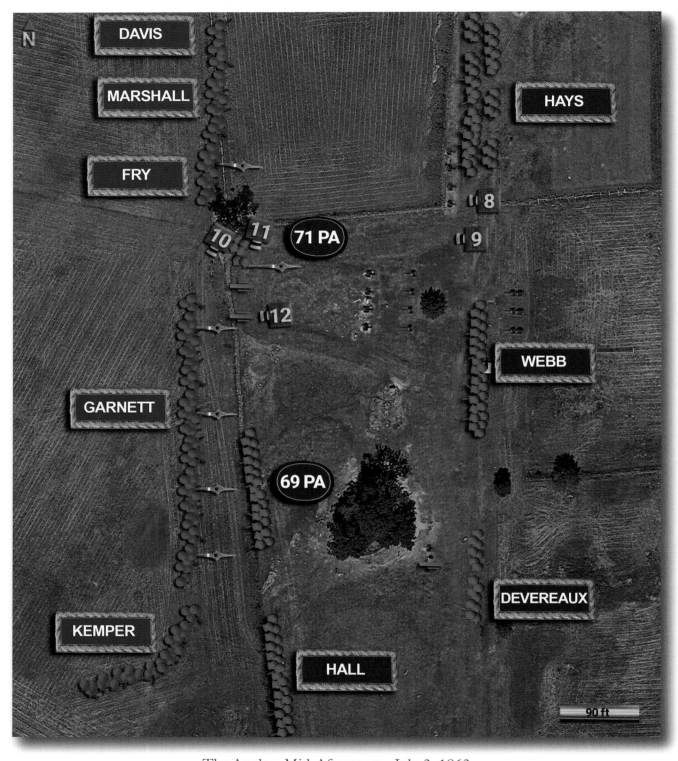

The Angle—Mid-Afternoon—July 3, 1863
39° 48'43.72 N 77° 14'09.54 W. Google Earth Pro. 9/6/2013. 8/25/2022.

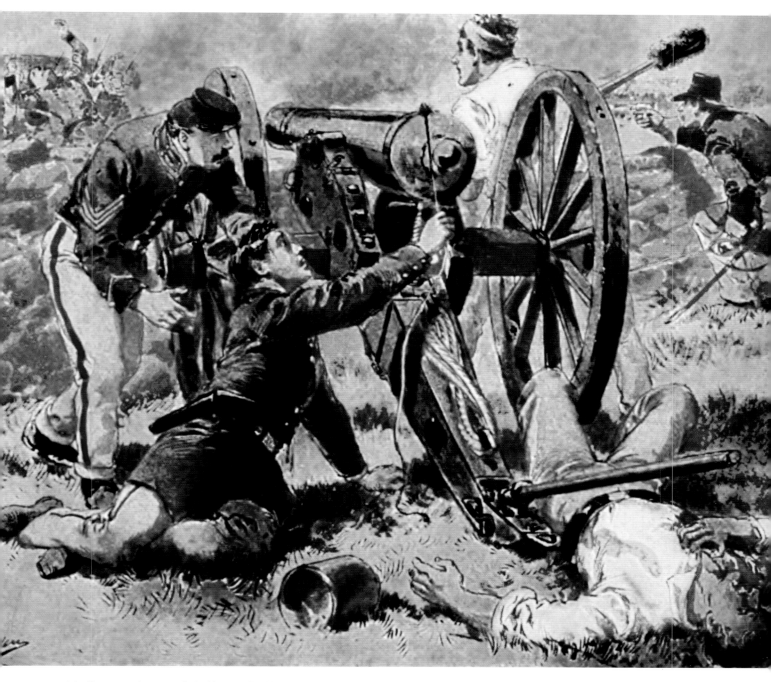

11. Gruesomely wounded, Alonzo Cushing gets off one last shot before falling to Confederate gunfire. *(The History of Our Country)*

knew their moment had arrived. Garnett's Virginians and their tattered banners rushed across the last few yards of the dead zone and crowded up to the wall fronting the 69th Pennsylvania and Cushing's now silent guns. They stood on the verge of breaching the enemy's defenses.

Yankees were running, just like they always did. Victory lay in their wake.

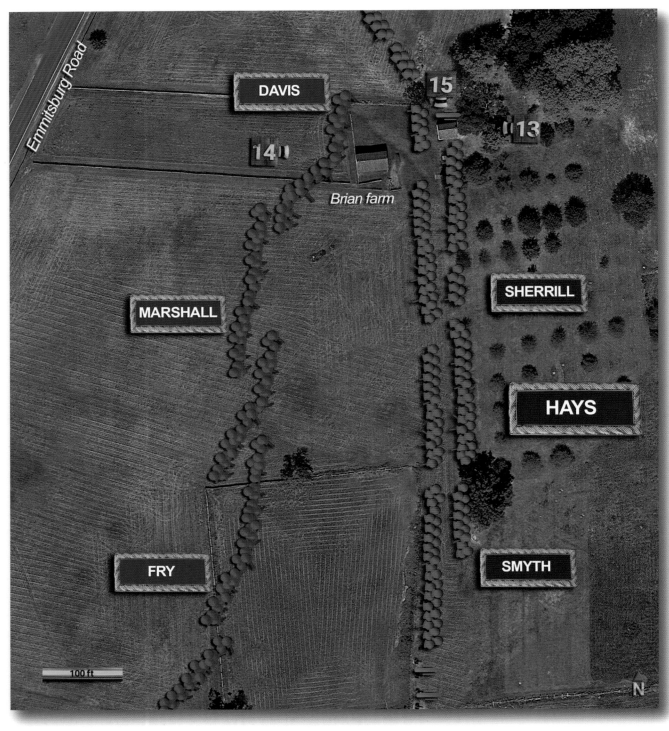

The Brian Farm—Mid-Afternoon—July 3, 1863
39° 48'53.72 N 77° 14'07.35 W. Google Earth Pro. 9/6/2013. 8/25/2022.

Robert E. Lee observed the assault from his post on Seminary Ridge. When gun smoke engulfed the front, he mounted his horse Traveller and rode forward.

Further south, James Longstreet sat on a fence and watched impassively as the action peaked.

George Meade rode north on the Taneytown Road toward the Leister house. To the west, rolls of musket fire beat a furious cacophony.

Birkett Fry had certainly done his job well. He was told to hit the enemy line north of the tree clump, and he managed to guide his ranks across the mile from Hell to that exact spot. But now, Fry lay in the dust near the Emmitsburg Road badly wounded, and his decimated survivors went to ground north and west of the angle's apex, some 80 yards from the Yankee rifles. With each Federal volley, each blast from their cannons, the Rebel toehold appeared to melt in the heat. The fusillades ravaged the Confederate color guards, and the battle flags lay on the blasted slope. Occasionally a pack of Southerners would rush forward only to be shot down.

12. Looking west two weeks after the fight, the Brian house shows the effects of the action with detritus from the battle littering the grounds. The Brian barn is out of camera range to the left (south). *(LOC)*

13. Viewed from the west, the men of the 11th Mississippi rally on their flag under a rain of fire and grimly advance to the protection of the Brian barn. The New Yorkers of Willard's Brigade (now under Eliakim Sherrill) man the Union line on both sides of the battered barn. Framed by Ziegler's Grove, the Brian house sits further back.

("Imperishable Glory" by Dale Gallon)

If anything, Marshall's Carolinians had it even worse. Woodruff's Federal artillery lashed their left, and the center of Hays's infantry scoured their front. One Yankee regiment flogged the Rebs with their .69 caliber buck and ball muskets which pounded a shotgun-like hail into the gray mass. Battle banners would lead a few dozen Rebels to within a few dozen feet of Hays's line. There, they would die for their efforts. Meanwhile, to the north, thirteen Mississippians from Davis's brigade darted to the relative safety of the Brian barn. They bunched up on its west side and played cat-and-mouse with Jerseymen and New Yorkers to the east. Turning to see no supports coming to their aid, they eventually found a white cloth and signaled surrender.

Pettigrew's men managed to exact some revenge on the Yankee mass. Hays's two brigade commanders, Thomas Smyth and Eliakim Sherrill, both fell in the firestorm, and the bunched-up Federal lines, in some places four and five deep, made for inviting targets. Badly bloodied and low on ammunition, a few of William Arnold's rifled cannon pulled out, but Gulian Weir's invigorated battery arrived to make up the loss. Hays however saw an opportunity. He ran two New

14. Looking south at the Brian house (left) and barn (center), members of the 39th New York carry the mortally wounded Col. Eliakim Sherrill to the rear (foreground). Lt. John Egan works his gun (left) from Woodruff's Battery I of the 1st United States Light Artillery. Hays's entire two brigade front is visible on both sides of the Brian barn as the Unionists battle the Confederate assault including the 11th Mississippi (right).

(Disaster, Struggle, Triumph: The Adventures of 1000 Boys in Blue)

York regiments, a group of Massachusetts sharpshooters, and two of Woodruff's guns onto the Brian farm lane, which ran north of the Rebel flank to the Emmitsburg Road. The resulting volleys pulverized Pettigrew's exposed left flank. There, Davis's exhausted Mississippians began running back to the protection of the roadbed. Others crawled forward and surrendered. The Rebel tide that had carried the hopes of a people to the very muzzles of the enemy guns began to ebb.

✈EMMITSBURG ROAD✈

A**S THEY CROSSED THE** fields west of the Emmitsburg Road, Lewis Armistead's Virginians pushed through the artillery blasts throttling their formations. They remained some 200 yards behind Pickett's and Pettigrew's front. Their last rush to the roadway however suffered less from the cannonade, as the Bluecoats had redirected their attention to the more immediate threat of the Confederates storming the ridge. Now, as Armistead's boys flooded onto the Emmitsburg Road near the Codori farm, a salvo of musketry buffeted them while they pushed past crumpled bodies of Garnett's unfortunates and negotiated the remnants of the roadway's fence lines. There, a violently breathtaking panorama greeted them. A fierce nightmare of smoke and fire shrouded the front, and scores of wounded and dead comrades littered the intervening 300 yards up to the blazing enemy lines. In a final convulsion, Garnett's and Kemper's men—at least those still moving—seemed to be converging on the clump of trees. Armistead placed his hat on the tip of his sword and trotted forward, his flinty men steadily following their leader. One Virginian cried out that home was up ahead, just beyond the heights.

Further north, Isaac Trimble's two brigades of North Carolinians found matters much the same. The Emmitsburg Road had transmogrified into a human charnel house with hundreds of Pettigrew's men sprawled in its dirt, broken and bleeding, dead and dying. Others bunched in its slight depression, unwilling to advance any farther. Ahead on the slope of the ridge, hundreds more lay wounded and dead while a pitiful few continued the contest. Unlike Armistead's boys, here the Confederates faced two lines. Alexander Hays's Yankees still manned the stone wall stretching across their front and maintained a ferocious fusillade. But now, to their north, Hays's improvised flanking brigade joined Woodruff's two cannon in forming a line from the ridge crest west to the Emmitsburg Road and beyond. The Carolinians found themselves wrapped in an iron arc. Any movement would take them deeper into a burning ring of fire.

Trimble's leftmost brigade, Brigadier General James Lane's five North Carolina regiments, wilted in the storm. Some faced north to take on Hays's flanking parties, while others barely made it over the second fence. The Yankee crossfire slaughtered the Tar Heels before their weight could aid their few comrades still slugging it out on the slope. On Trimble's right, the North Carolinians of Col. William Lee Lowrance's brigade had been ravaged two days before on Seminary Ridge. Today, Yankee firepower quickly reduced their numbers to what seemed like a skirmish line. Small groups of Tar Heels tried to follow Fry's path north of the angle. Not 100 yards away, Weir's Federal guns and Hays's rifles lacerated their advance and crushed it.

Before he took a Minié to his left leg and had to withdraw, Trimble knew his boys were in trouble.

A Virginian by birth, Brig. Gen. James Lane enjoyed a well-deserved reputation, having graduated 2nd in his VMI class then spending three years at the University of Virginia. He returned to VMI to teach then moved on to the classrooms of the North Carolina Military Institute. When the guns of Sumter thundered, Lane remained in state with his cadets, serving as a major in the 1st North Carolina followed by the colonelcy of the 28th North Carolina. He performed well on the Peninsula, at Cedar Mountain, and Second Manassas, and he took over his brigade at Sharpsburg when the commander was killed. In November of 1862, Lane became a brigadier and fought well at Fredericksburg and Chancellorsville. His brigade had marched to Gettysburg with 1,734 North Carolinians in five regiments and was not heavily engaged on July 1. *(Miscellaneous Subjects Image Collection (P0003), North Carolina Collection Photographic Archives, Wilson Special Collections Library, University of North Carolina at Chapel Hill)*

Federal firepower had ground up Pettigrew's brigades and now pinned down his own troops. His people had perhaps passed the limits of human endurance, and Trimble recognized the brutal math. The left wing of the Grand Charge teetered on the edge of disaster.

⭍CEMETERY RIDGE⭍

Amid the chaos, John Gibbon had found a horse. As he calmly trotted about giving orders and offering encouragement, a bullet slammed into his left arm and shoulder. He transferred command of his division to William Harrow and went to the rear. It barely mattered. This was now a soldier's fight.

In the cauldron of the angle, the broken 71st Pennsylvania had cleared the wrecked remains of Cushing's guns and disappeared into Alexander Webb's reserve—their comrades in the 71st, the levelled rifles of the 72nd Pennsylvania, and two companies of the 106th Pennsylvania. These three units lined the ridge crest, extending Alexander Hays's divisional line south toward the clump of trees. Eighty yards to the west, Garnett's Virginians crowded up against the low stone wall where their momentum seemed to dissipate.

Col. William Lowrance had spent the entire war with his home state's 34th North Carolina, rising to the unit's colonelcy in December of 1862. When brigade commander Alfred Scales fell during the first day's fighting, Lowrance took over the reins. *(Biographical History of North Carolina)*

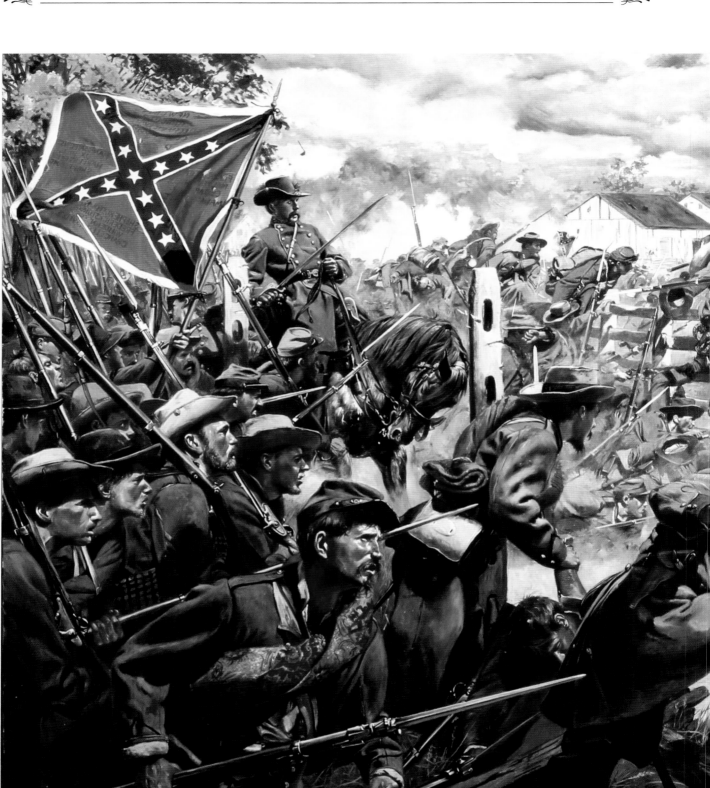

Isaac Trimble's two brigades of North Carolinians reach Emmitsburg Road. Here, they find remnants of Pettigrew's division who were either struck down by Federal firepower or simply refused to move on.

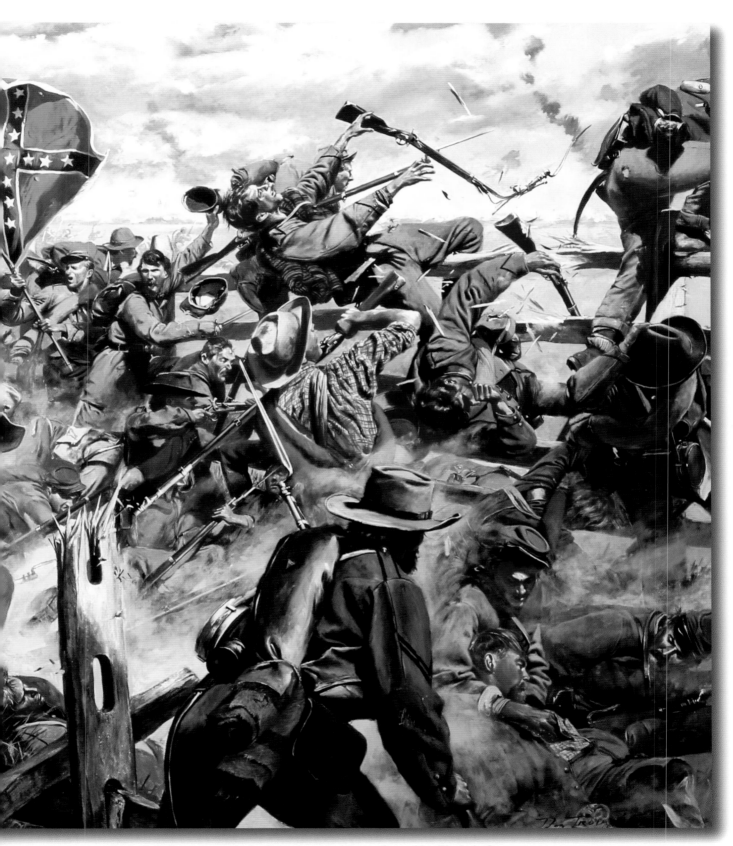

In the left distance stands the Brian barn and house framed by Ziegler's Grove. *("Emmitsburg Road" by Don Troiani)*

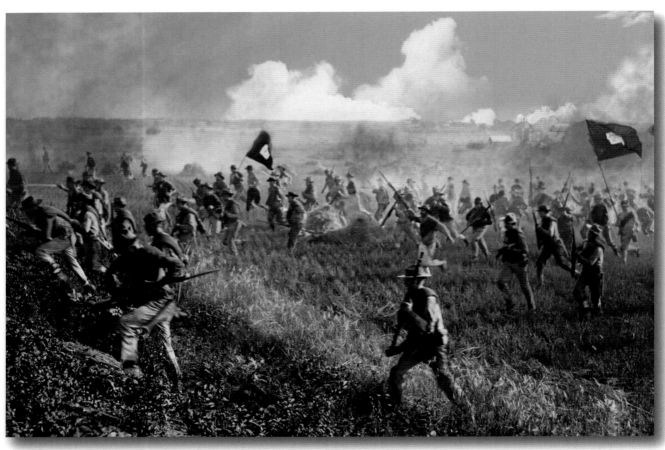

1. From the 1922 Marines reenactment on the ground where it happened, Armistead's men cover the last few yards before striking the Federal lines. *(Rich Kohr Collection)*

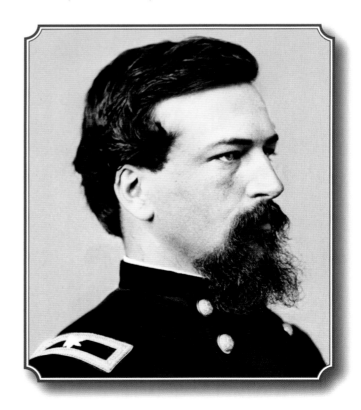

Brig. Gen. Alexander Webb had a reputation as a conscientious, hard-working staff officer who was considered a comer. The New York City native proved to be a decent student at West Point, and he spent some of his pre-war years teaching math at his alma mater. Once war came, Webb bounced around various high-profile staff assignments and eventually began working for V Corps and George Meade. When John Gibbon busted the commander of his Irish "Philadelphia Brigade" on the march to Gettysburg, Gibbon chose Webb to take command. Webb had no experience as a combat leader, but he immediately tried to instill some discipline into the recalcitrant sons of Erin who didn't appreciate an outsider—much less a non-Irishman—telling them what to do. Still, his four regiments of 1,224 Pennsylvanians were a potent force, whether they recognized their new brigadier or not. *(LOC)*

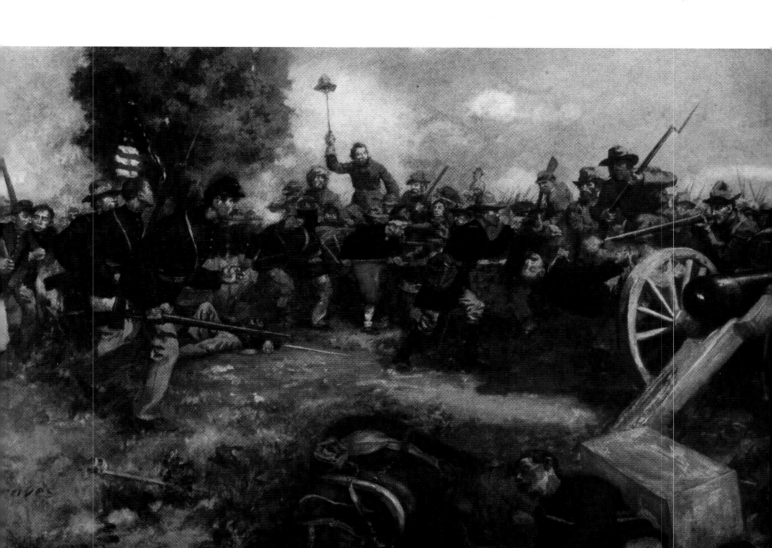

2. Looking south from Cushing's guns (right), Lewis Armistead leads his boys over the top.
The copse of trees rises in the left background. *(Deeds of Valor)*

Meanwhile, Armistead's troops took pelting flank fire from the Yankee line south of the angle as they followed their flags toward the center of the fight. In a final spasm, they reached the stone wall, joining what remained of Garnett's Brigade in a point-blank knockdown with the 69th Pennsylvania near the copse. Some filtered north to join the vicious exchange across the angle with Webb's reserves 80 yards to the east. Battle banners fell and rose in the chaos. Then Armistead screamed out to apply the cold steel. He clambered over the stone wall and lurched into the angle north of the copse near Cushing's silent guns. Perhaps two hundred Virginians followed him over the top.

Up at the crest, Webb—who had only held brigade command for a week—tried to get his men to charge Armistead's interlopers. They didn't recognize their newly installed commander and so ignored his entreaties. Mortified, he rushed into the copse toward the 69th Pennsylvania's position to face the enemy himself, passing and observing Armistead just a few feet away moving in the opposite direction.

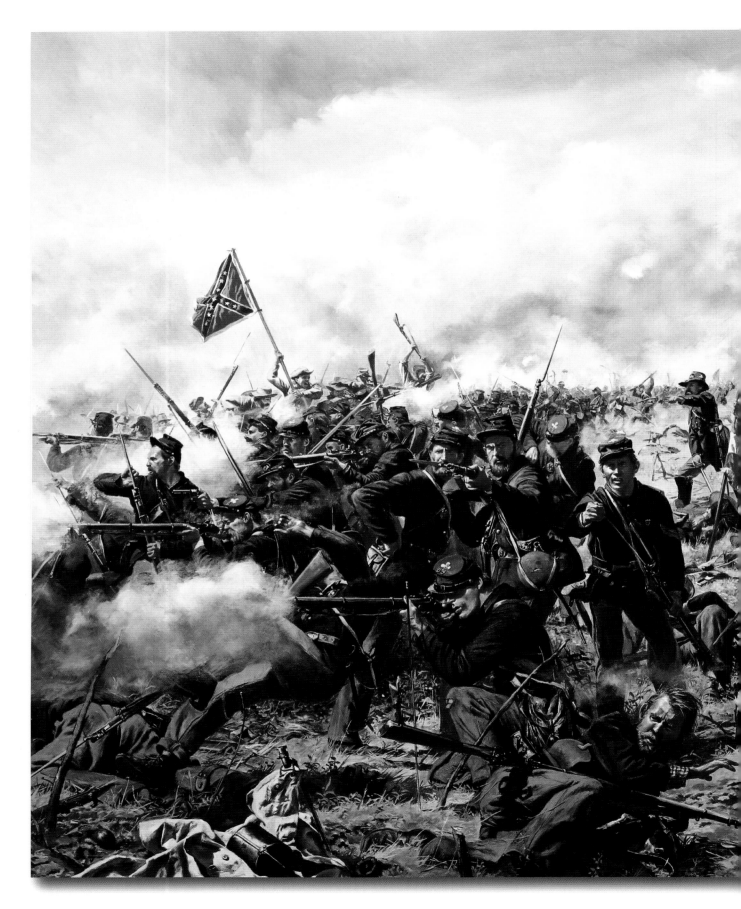

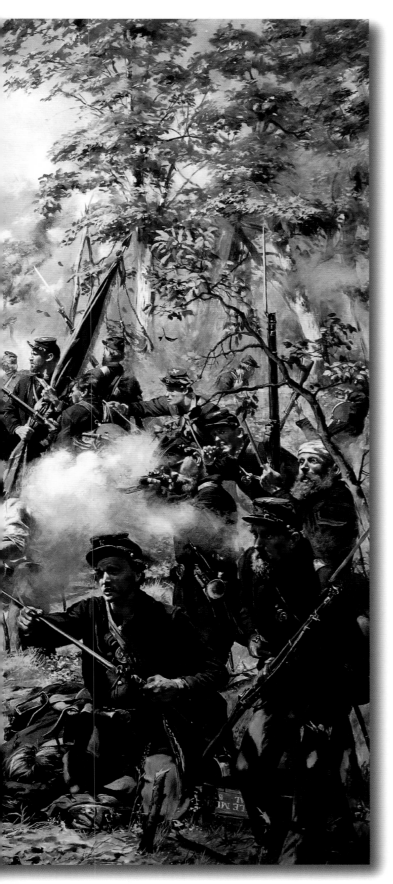

Back at the front, the 69th Pennsylvania refused its right flank to counter the Rebs now coursing into the Angle, triggering another ferocious bout of hand-to-hand combat. The rest of the Pennsylvanians held on to their wall and continued the violent, close-quarter contest with the Virginians, but, south of the Irishmen, a portion of their brigademates began to crumble, taking some of the 69th with them. A clutch of Confederates pounded through the rupture and angled for Cowan's guns, just as Henry Hunt rode up. Hunt joined the melee by firing off every round from his pistol into the Butternut wave. His horse went down, pinning Hunt to the ground, but Cowan's five Federal cannon volleyed together—double canister at ten yards—and mercilessly shredded the thrust.

3. Looking north in front of the copse of trees, the 69th Pennsylvania holds firm against the combined weight of Pickett's three brigades. Some of the Irishmen discover that a pack of Virginians have broken the Union line to the south. *("Rock of Erin" by Don Troiani)*

133

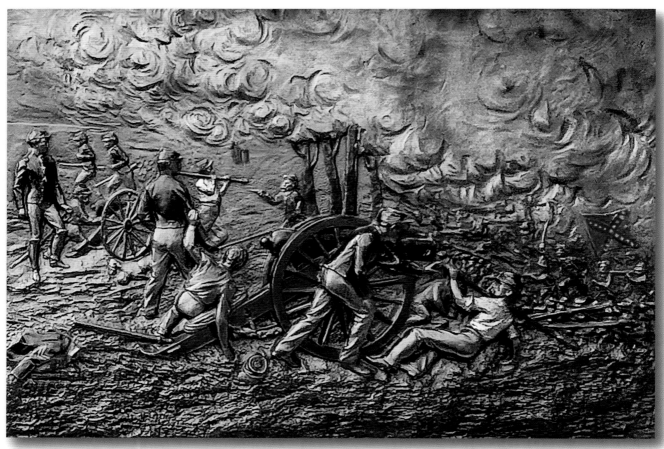

4. Capt. Andrew Cowan and his New York Light Artillery: 1st Battery deliver double-canister at ten yards and crush the Confederate breakthrough south of the copse of trees. *(GNMP, Photo by John Kamerer)*

The cannoneers from one of Cowan's crews that eviscerated the Confederate breakthrough south of the copse pose with their gun a few months after the battle. *(PHOTCW)*

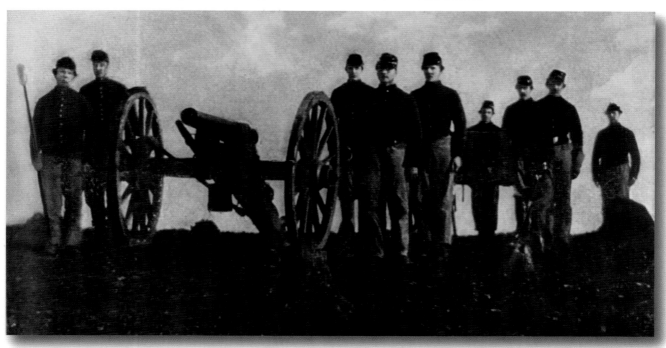

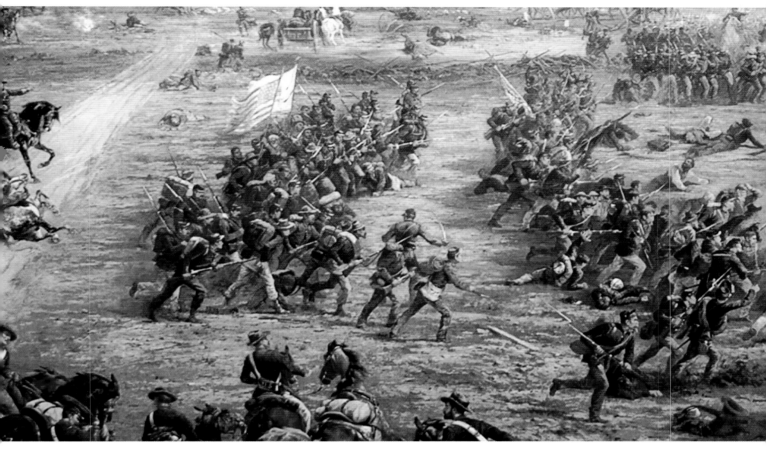

5. With Hancock urging them on (left, mounted on a black horse), Col. Arthur Devereaux drives two regiments from Hall's reserve into the copse to counter Armistead's breakthrough. *(Gettysburg Cyclorama, Photo by Bill Dowling)*

Behind Cowan, Colonel Arthur Devereaux nervously paced. He commanded Norman Hall's reserve, two undersized regiments that barely totaled 350 rifles. The copse's trees blocked most of his view, but he had seen the Pennsylvanians rushing east out of the angle, and he knew most of the artillery in the sector had fallen silent. Just then Hancock rode up. Devereaux asked the general if he could join the fight. Hancock, with his characteristic color, told him to do it damn quick. The New Yorkers and Massachusetts men stormed through the timber and collided with a mob of Virginians trying to slide around the 69th Pennsylvania's refused right flank. Dozens fell in the first, ruthless impact, but Devereaux's wild rush blunted the Rebel lunge and sealed the gap between Webb's reserve on the crest and the embattled 69th Pennsylvania fronting the clump of trees.

Further south, word filtered down Hall and Harrow's line of the emergency at the angle. With their front largely devoid of Rebels—most had either retreated or pushed on to the tree clump—whole Union regiments picked up and rushed north to the breakthrough. Suddenly, the 69th Pennsylvanians and Devereaux's band felt the weight of hundreds of Michiganders, New Yorkers, and Bay Staters rushing to the stone wall and squeezing into the trees to treble the violence. A claustrophobic swirl of savagery beggared description as the two mobs clawed each other. One Massachusetts man caught up in the moment cried out how glorious it all was just before a Rebel bullet ended his life.

It felt like a lifetime. In reality, it lasted a few short minutes.

Hancock galloped down the line filled with thoughts of flanking the enemy from the south. George Stannard

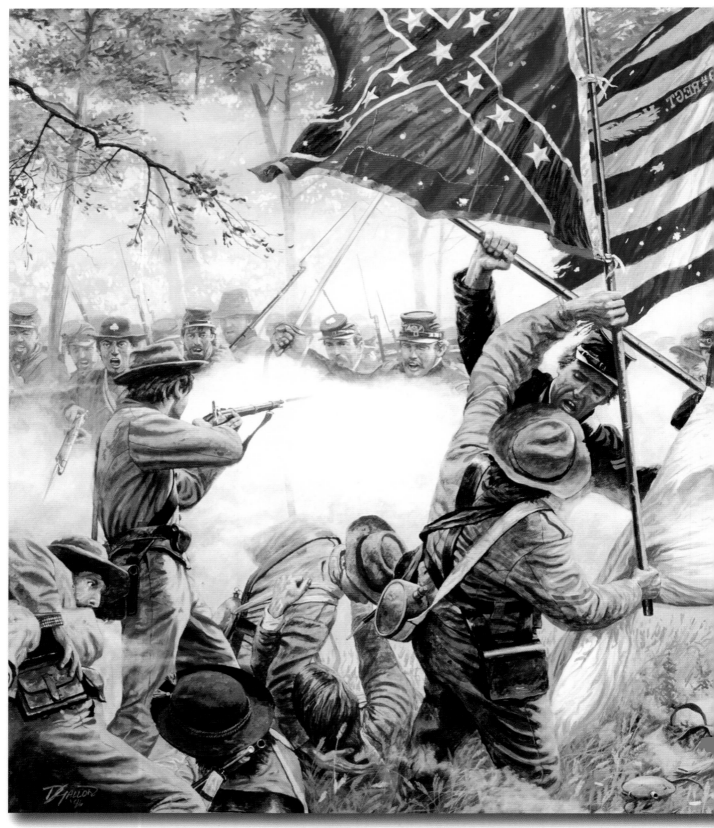

6. Major Edmund Rice of the 19th Massachusetts (sword raised, left) leads Devereaux's surge through the copse of trees and slams into elements of the 14th Virginia.

Twenty-eight years later, Rice would be awarded the Medal of Honor for his actions in sealing the breech south of the Angle. *("Clubs Are Trumps" by Dale Gallon)*

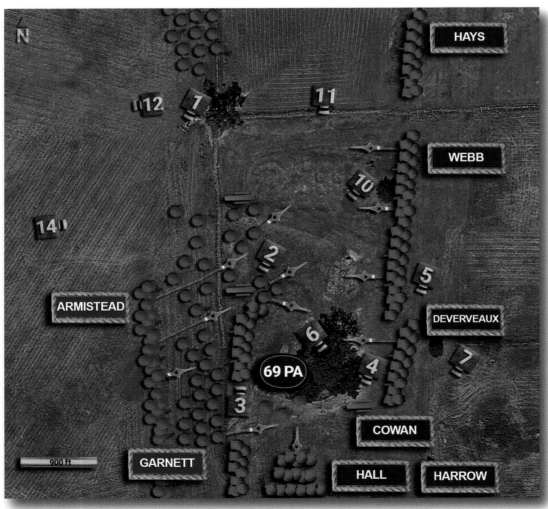

The Angle—Mid-Afternoon—July 3, 1863
39° 48'43.72 N 77° 14'09.54 W. Google Earth Pro. 9/6/2013. 8/25/2022.

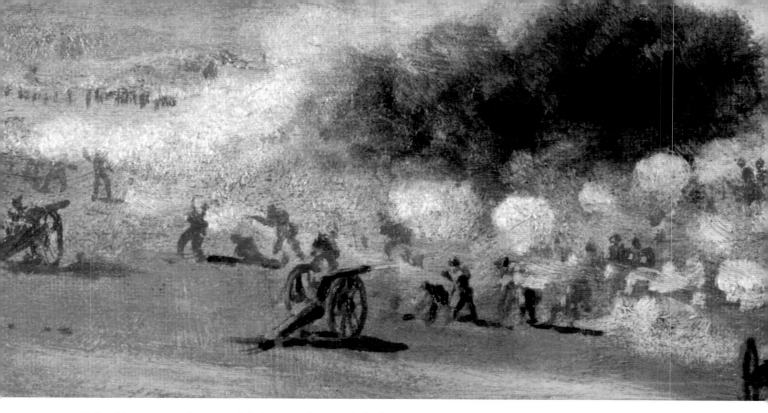

7. Looking west, while some of their comrades remain in line to deal with the remnants of Kemper's survivors (center distance), elements of Hall and Harrow's brigades rush north (to the right) to help seal the breakthrough at the Angle. Cowan's guns are in the foreground and the copse of trees is at the right. *(LOC)*

had already recognized the same opportunity. Earlier, Stannard's Vermont regiments had performed a clumsy right wheel and singed Kemper's dangling wing, forcing the Virginians to turn to meet the threat. Kemper now lay in the dust with a Yankee bullet encased in his groin. As some Virginian boys fought off would-be Union captors to carry the wounded officer to safety, the Vermonters pushed forward and slowly muscled the Virginians to the north. Exhausted and dispirited Confederates began to break for the rear. At the height of the exchange, a Virginia bullet ricocheted off Hancock's saddle and drove a nail into his upper thigh. A tourniquet probably saved his life, because the general refused to be moved until the issue was decided.

North of the angle, in front of Alexander Hays's still fiery bastion, the end finally came. First in fits and dribbles, then in a bloody flood, Pettigrew's spent survivors gave up the fight and broke for the rear. Some of Hays's worthies jumped their wall and started after the retreating Rebs. To the south, however, the fight continued. Armistead and his boys braved the volleys from Webb's reserve and reached one of Cushing's abandoned guns. Armistead screamed for his men to turn the cannon on the enemy.

8. At the height of his triumph, Hancock takes a bullet and a piece of a nail to his upper thigh. A tourniquet saves his life, and he gamely remains on the field. *(The History of Our Country)*

139

9. Looking northwest, Stannard's Vermonters continue to pour volleys into the right flank of Kemper's brigade (right distance), while Hancock's staffers tend to their wounded leader (left center foreground). An ambulance crew (right center foreground) rushes to the scene with a stretcher. *(https://vermontcivilwar.org)*

A Yankee bullet thudded into Lewis Armistead's left leg, and he crumpled to the ground. Two more would strike him as he helplessly lay in the detritus of Cushing's ravaged command.

Near the copse, a mad carnival of fists, bullets, rifle butts, bayonets, and rocks crescendoed in a brutal swirl. A great roar then arose, the deep-throated Union hurrah. In a lacerating heave, the Federals in the copse manhandled the Virginians into the open. At the same time, up on the crest, Gibbon aide Lt. Frank Haskell finally convinced Webb's reserve and some rallied elements of the 71st Pennsylvania to storm the angle. Webb's boys levelled their rifles and swept down the ridge through the ruins of Cushing's battery. There they hammered Armistead's now leaderless cadre into the dirt and struck down the Virginians near the trees. Now an irresistible wave, they roared up and over the Rebels still lining the low stone wall. Handkerchiefs began to wave, and hands began to show. Those Virginians who could made for the rear, but many called out for the shooting to end. Their strength sapped, their will broken, they simply gave up the effort and surrendered.

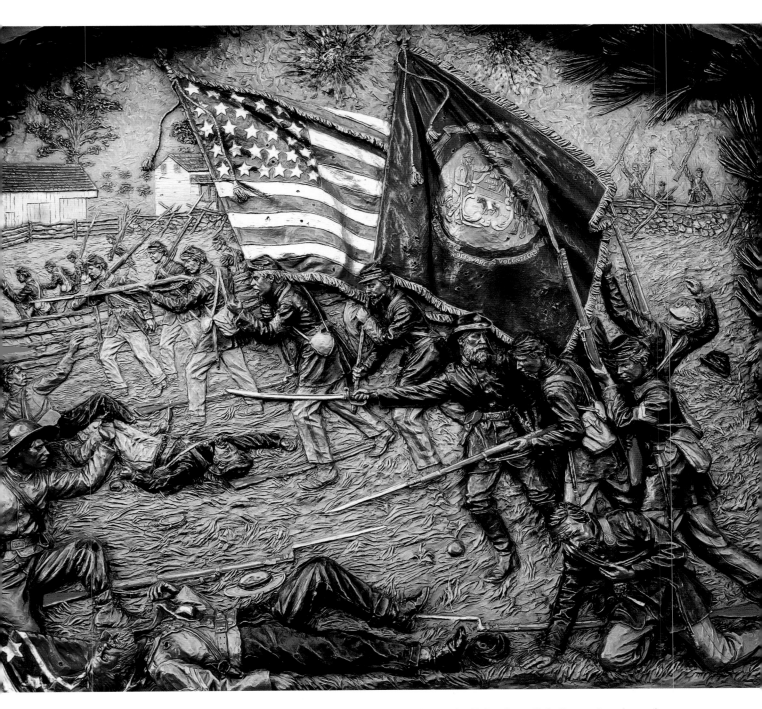

The men of the 1st Delaware from Smyth's brigade leap the wall near the Brian farm (left distance) and run down retreating Confederates from Pettigrew's and Trimble's wing of the attack. *(GNMP, Photo by John Kamerer)*

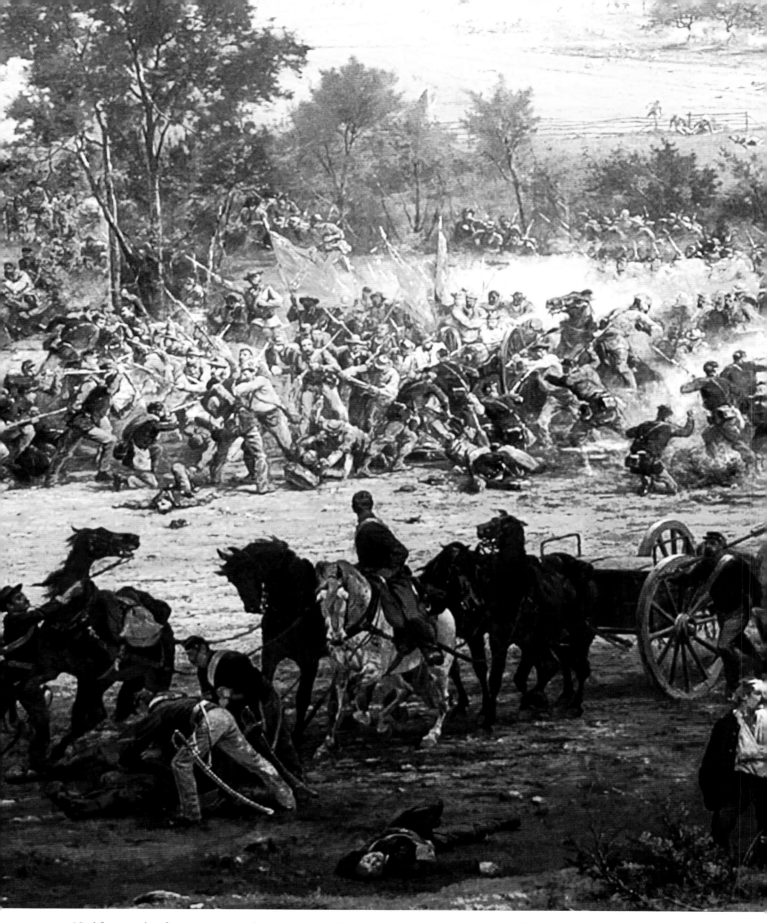

10. After pausing for a moment at the low stone wall, Armistead and his band overrun Cushing's guns and surge into the Angle. The artist mistakenly has Armistead mounted as he suffers his first wounding.

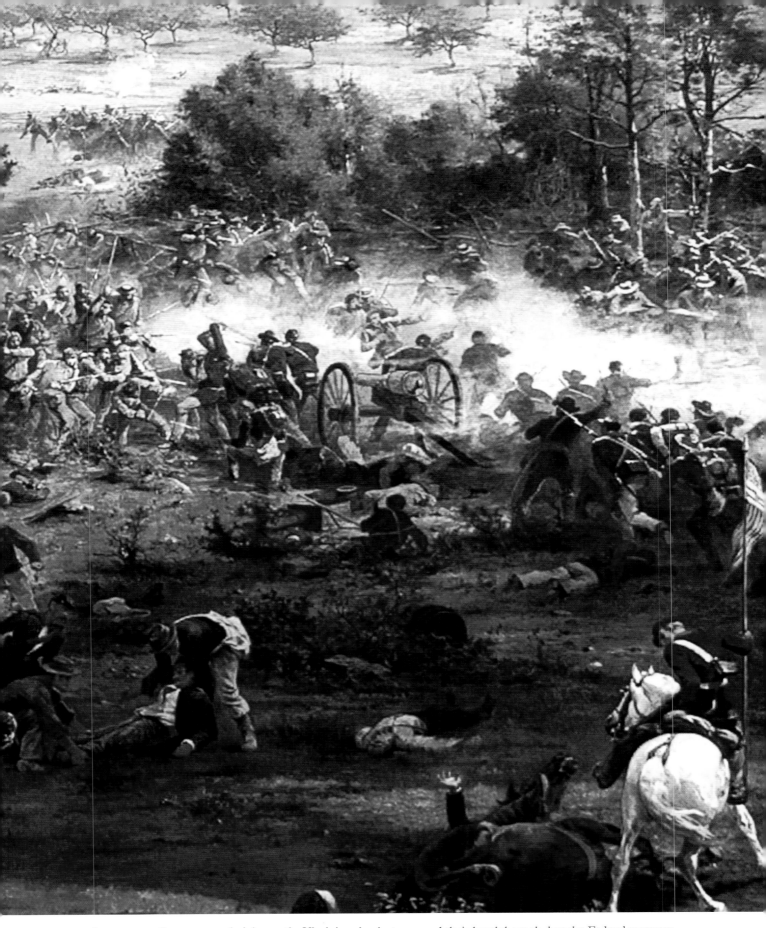

In a vortex of concentrated violence, the Virginians begin to expand their breakthrough, but the Federal response is already tightening the vice. *(Gettysburg Cyclorama, Photo by Bill Dowling)*

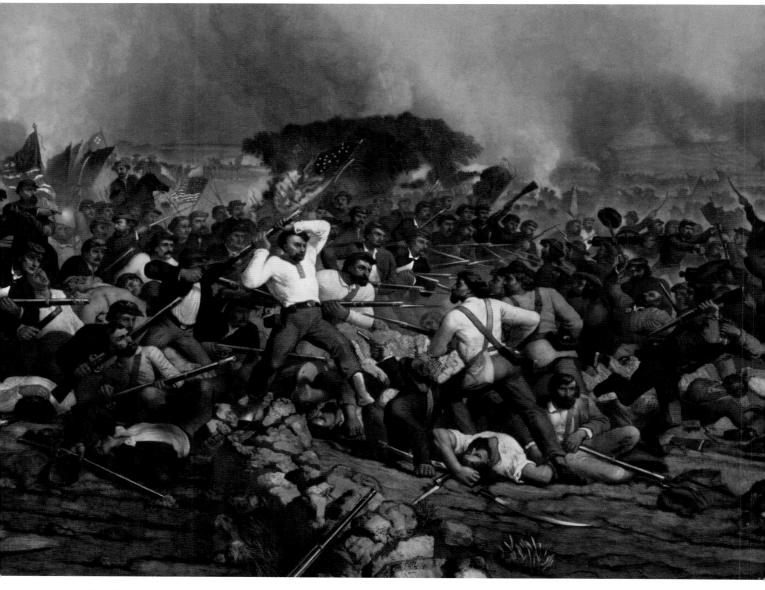

11. Looking south, Webb's reserve (left, center) charges into the Angle and collides with Armistead's survivors. Armistead is down (right, center) but still manages to keep his sword and his balanced hat aloft. The clump of trees dominates the center background. *(LOC)*

⤙SEMINARY RIDGE⤚

Richard Anderson's demi-division of Wright's and Posey's brigades crossed Seminary Ridge near Robert E. Lee's vantage point and mounted the artillery rise when word arrived from Longstreet to suspend their advance. In Long Lane, Robert Rodes considered throwing his three brigades into the fray. Richard Ewell, who was observing the charge from Seminary Ridge, warned Jubal Early to strike Cemetery Hill if opportunity beckoned. Anderson halted, Rodes thought the better of it, and Early saw nothing.

Robert E. Lee assumed Anderson, Rodes, and Ewell were to move in a timely manner to secure and expand Pickett's and Pettigrew's lodgment. Either through misunderstanding or direct orders, none did. To the south, the only two brigades from Lee's reserve to participate in the charge began the last act of the tragedy.

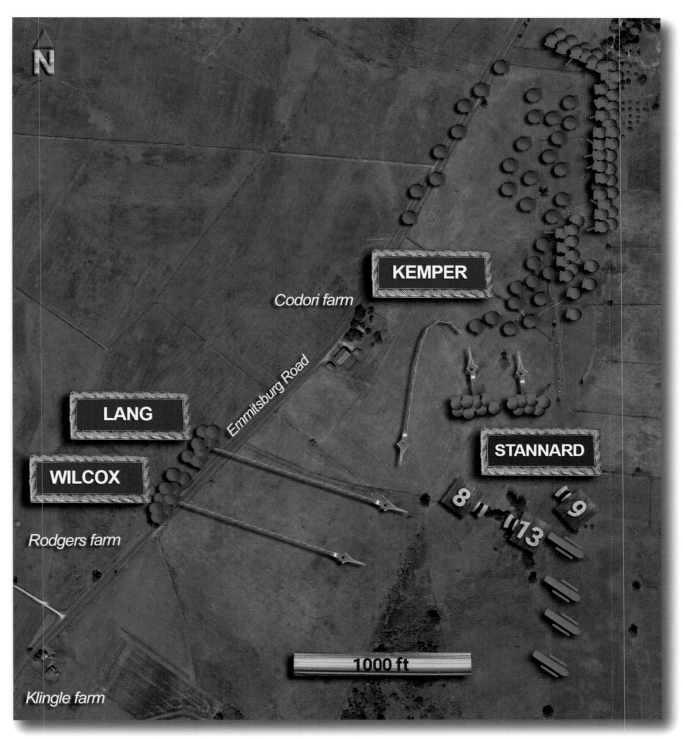

South of the Angle—Afternoon—July 3, 1863
39° 48'37.73 N 77° 14'13.44 W. Google Earth Pro. 9/6/2013. 8/25/2022

❧ EMMITSBURG ROAD ❧

Responding to Pickett's call for assistance, Cadmus Wilcox and David Lang left their sheltered swale near the Spangler farm and hustled their Alabamans and Floridians toward the Emmitsburg Road. In the smoke and confusion, neither officer knew exactly where Pickett's force had gone. Instead, they marched straight east. The guns on Little Round Top and McGilvery's Federal artillery line immediately exploded from a half-mile range and creased the two brigades. The Confederates took more casualties as they crossed the roadway then pushed forward a quarter mile toward the Plum Run valley. This was the route they had negotiated yesterday, and the bloated corpses of their comrades—dead now twenty-four hours—dotted the blasted landscape. Near the run, they went to ground among the boulders and bushes where they opened a half-hearted fire on their Yankee tormenters. Wilcox meanwhile rode back to request artillery support.

Colonel Wheelock Veazey commanded the 16th Vermont, one of the two units that had crushed James Kemper's flank and sent them tumbling back to the rear. Veazey now noticed Wilcox's and Lang's movement to his south. He reversed his boys and maneuvered them onto Lang's left wing whereupon he

Col. Wheelock Veazey, 16th Vermont. *(Italo Collection)*

charged the poorly positioned Butternuts. As elements from the nearby 14th Vermont wheeled to attack the Rebel front, Veazey's cheering boys overran Lang's leftmost regiments. Lang ordered an immediate retreat from the death trap, but most of his people were already in flight. With the Vermonters gathering up dozens of dazed Floridians, Wilcox's subalterns saw the futility of remaining where they were and pulled their Alabamans out of the marshy snare.

Wheelock Veazey would be awarded the Congressional Medal of Honor.

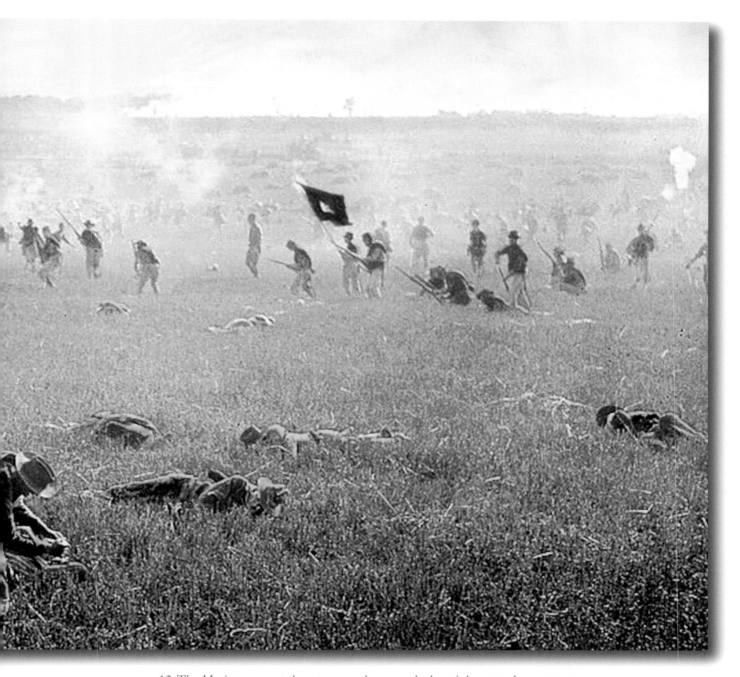

12. The Marines reenact the retreat on the ground where it happened. *(Rich Kohr Collection)*

‿∘‿

Lee arrived at E. P. Alexander's artillery lookout northeast of the Spangler farm, about 400 yards west of Emmitsburg Road. Cheers were ringing down from smoke-enshrouded Cemetery Ridge, and the general dispatched an aide to determine their source. Then the shattered remains of his grand charge started to stagger into view. What had begun earlier in the day as a regal display of martial prowess was now a nightmare incarnate as Yankee fire continued to punish the unfortunate survivors. Someone thought it looked like hunters picking off wild game. Lee rode forward to reform his boys and offer encouragement.

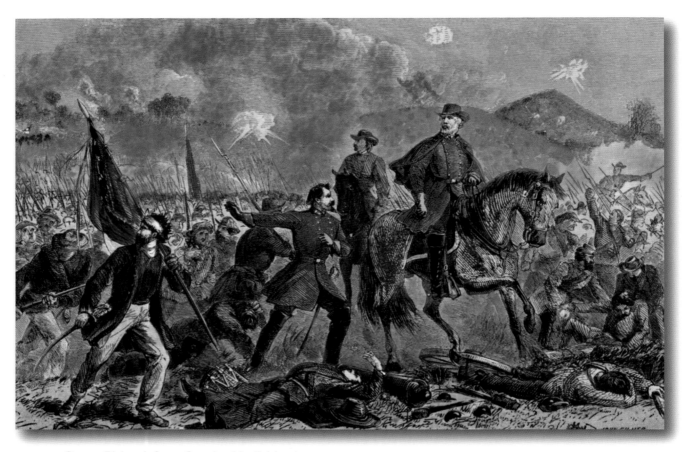

George Pickett informs Lee that his division is no more. *(Personal Reminiscences, Anecdotes, and Letters of Gen. Robert E. Lee)*

He encountered an inconsolable George Pickett who claimed his division no longer existed. He saw the badly wounded James Kemper who demanded justice be done for his brigade. Cadmus Wilcox arrived teary-eyed and claimed his brigade had disintegrated. Only Lee's Old Warhorse, James Longstreet, appeared ready for action. The titular commander of the great charge alerted McLaws to prepare Hood's division to meet a Yankee countercharge, and he called forward all available artillery to make a last stand.

Meanwhile, Lee kept repeating for his men to rally, that it was all his fault.

⤞CEMETERY RIDGE⤝

Alexander Hays could not contain himself. He grabbed some captured Confederate flags and steered his horse out onto the western incline of Cemetery Ridge. Picking his way through the wounded and dead Rebels, the general and two of his staffers took a victory lap around his entire division, dragging the ragged banners behind him. His men tossed their kepis and screamed their lungs out, hugging and dancing with unbridled emotion.

South of the angle, Unionists yelled "Fredericksburg" at the Southern recession as though the word were a curse—or, perhaps, a benediction.

George Gordon Meade—perhaps the only person on the ridge who saw not a moment of the charge—trotted up the eastern incline from the Leister house past some Confederate prisoners to find Hays in the middle of his celebratory ride. He asked an artillery officer if the Rebels had fallen back and received word that they had. Meade then moved south to the copse where he encountered Frank Haskell. Meade asked how things were going, to which Haskell responded, the Rebel charge had been thrown back. Meade seemed surprised and sought assurance. Haskell reiterated the stunning news.

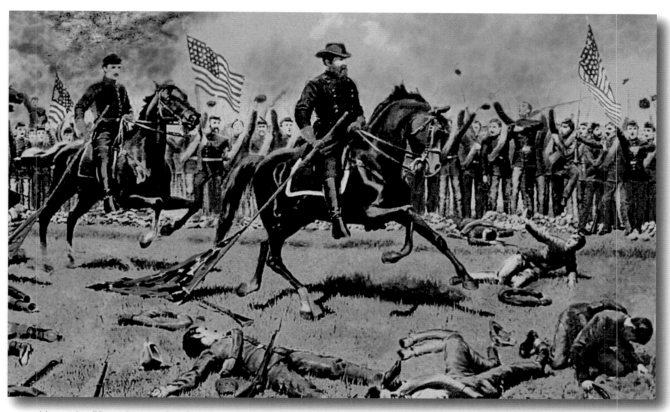

Alexander Hays drags a Confederate battle flag around the soldiers of his division, much to their pure exhilaration.
(General Alexander Hays and the Battle of Gettysburg)

Fellow mason Henry Bingham confers with a wounded Lewis Armistead and accepts some of the general's personal belongings. *(GNMP, Photo by John Kamerer)*

Strategically located northeast of Little Round Top and south of Powers Hill, the George Spangler farm had been seized by the XI Corps medical staff after the first day's fighting and converted into a field hospital. Doctors perform amputations along the barn's outside wall (right), and orderlies carry the victims into the barn either to recover or succumb. Armistead eventually dies in the smaller stone building that housed the summer kitchen (left center). Spangler, his wife Elizabeth, and their daughter pose here after the war. *(William Tipton, with thanks to Ron Kirkwood)*

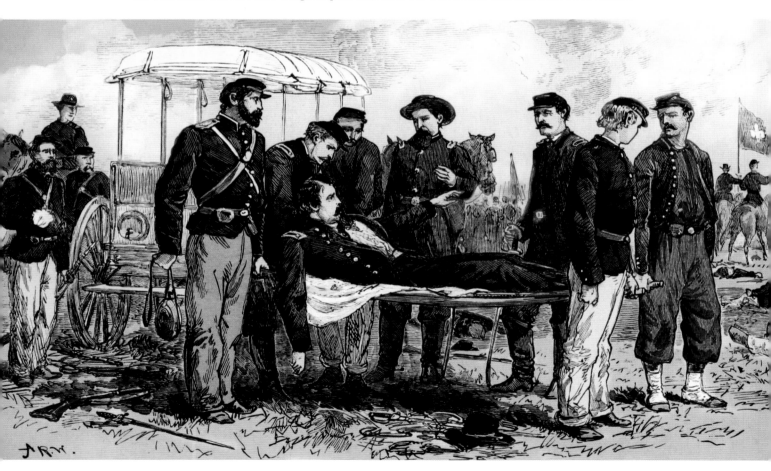

13. An ambulance crew prepares to remove a badly wounded Winfield Hancock from the battlefield. At his insistence, they wait until the fighting had ended. *(The Life of Winfield Scott Hancock: Personal, Military and Political)*

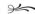

14. The field fronting the angle is covered with wounded, dying, and dead Confederates. *(B&L)*

In the tangle of pain and death that now covered the copse and the angle, Lewis Armistead caught the attention of a fellow Freemason by calling out for his widowed mother—the organization's universal distress sign. Three privates from the 72nd Pennsylvania carried Armistead up the ridge where the party met Hancock staff officer Henry Bingham. Armistead and Hancock had served together in the old army, and the Confederate asked Bingham to tell his old friend that he felt great remorse for his actions this day. He also gave Bingham some personal effects to deliver to Hancock.

The Pennsylvanians then bore the general to the George Spangler farm, already a crowded XI Corps field hospital. The attending doctors—perhaps missing the wounded groin—thought the officer's wounds slight and expected him to recover.

Lewis Armistead died two days later.

Winfield Scott Hancock meanwhile had remained on the field until the Rebel repulse was complete. Already he had sent one note to Meade. He then dictated another from his ambulance, describing the events and suggesting a counterattack with the V and VI Corps. Finally, he allowed the driver to cart him away.

⚘

In a perplexing afterthought, Judson Kilpatrick received word of the Confederate disaster and decided to launch his own mounted operation on the Rebels' southern flank. One of Brigadier General Wesley Merritt's detached regiments swung to the west toward South Mountain searching for the Confederate supply train. They came up empty handed while receiving rough treatment from William "Grumble" Jones's brigade near Fairfield. Meanwhile, the rest of

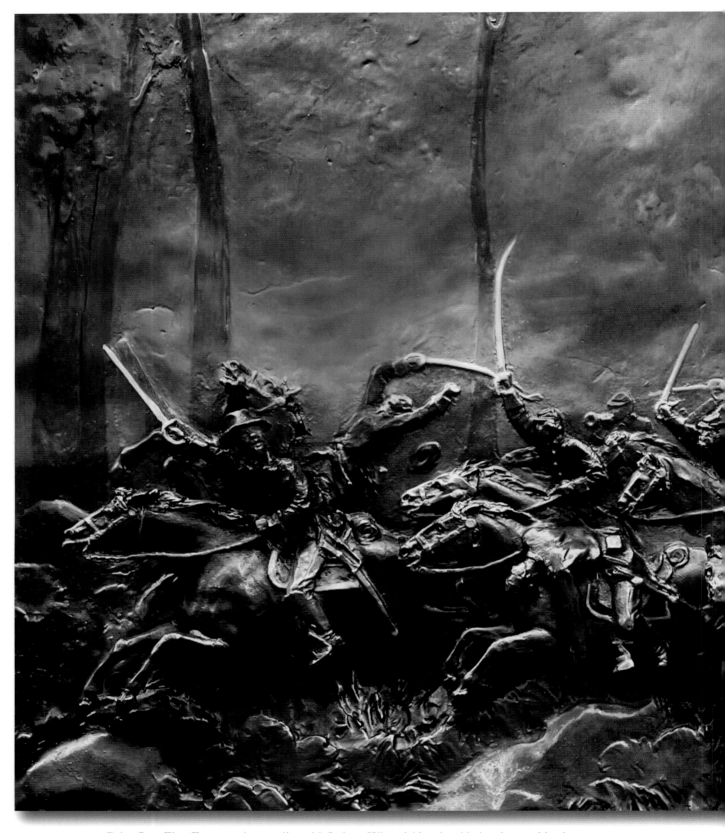

Brig. Gen. Elon Farnsworth complies with Judson Kilpatrick's misguided orders and leads
his brigade in a doomed charge.

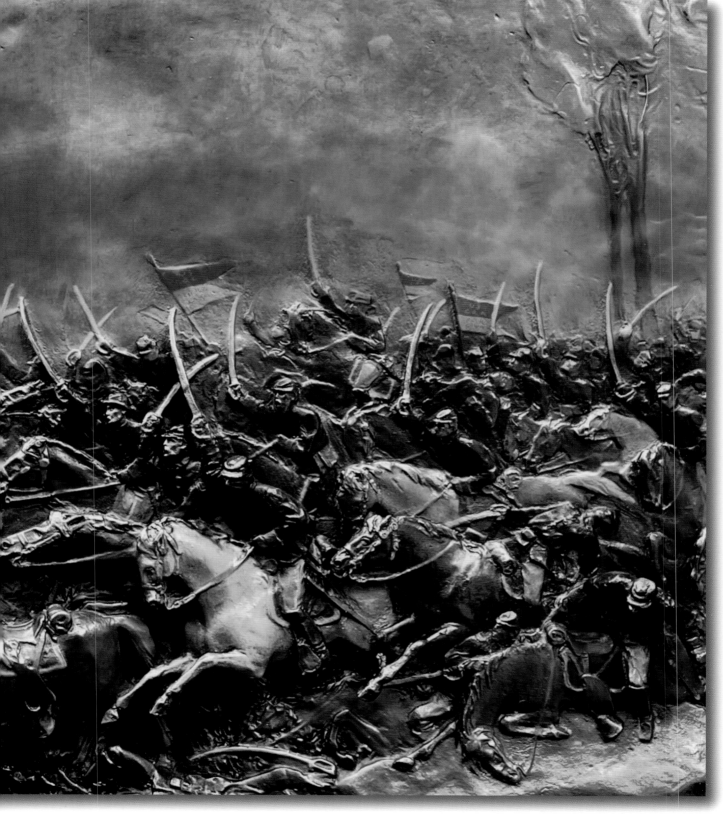

Here, the 1st Vermont Cavalry thunders across the broken landscape near Bushman Hill between Emmitsburg Road and Big Round Top. *(GNMP, Photo by John Kamerer)*

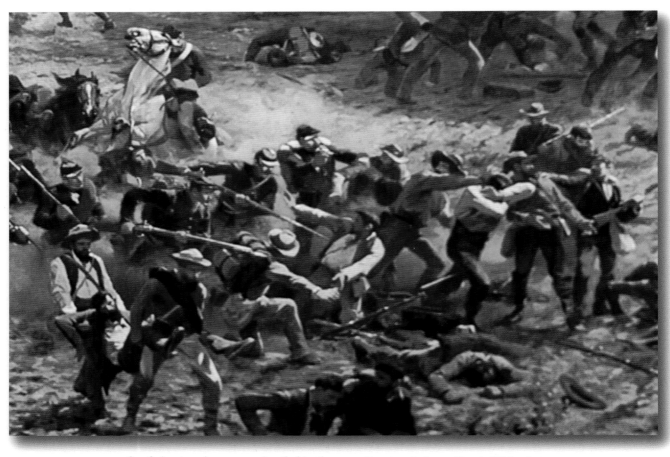

Confederate prisoners are hustled to the rear. *(Gettysburg Cyclorama, Photo by Bill Dowling)*

Kilpatrick's troopers attacked Hood's division down by the Round Tops. Cavalry rarely did well against infantry, and this misbegotten operation would be no exception. The remainder of Merritt's brigade arrived from Emmitsburg in time to barely dent the Georgians of Tige Anderson's former brigade west of Emmitsburg Road. Finally, in the most tragic of the three thrusts, Elon Farnsworth reluctantly led his brigade into a hornet's nest west of Big Round Top. The broken ground destroyed Federal cohesion, and the Texans and Alabamans who crushed the ill-considered attacks found the experience more of a frolic than a fight. With the shooting winding down, the Confederates cornered Farnsworth in a rocky cul-du-sac and killed him. When Kilpatrick ran out of troops to pump into the meat grinder, he called the operation off.

Kill-Cavalry, indeed.

Where the Rebel cannonade had elicited awe and wonder from the witnesses, the destruction covering Cemetery Ridge now drew emotions of a different nature. No one had seen anything like this. Bodies piled on top of bodies, rows of corpses almost neatly arranged, horrific dismemberments, rivulets and pools of blood, and already the permeating stench seemed everywhere. Some of the dead smoldered, their remains set afire by artillery sparks. Crestfallen Southern prisoners—over three thousand by one reckoning—trudged to the rear, accompanied by their cheering captors. Details began transporting the wounded both Blue and Gray to the various field hospitals. Others started to collect the dead for burial.

A stray Confederate shell exploded over Stannard's Vermonters, adding five names to the casualty lists.

Out along Emmitsburg Road, wounded and dead Confederates lay in piles against the shot-torn fences and strewn across the blood-soaked track. The

Collateral damage behind the Union lines. *(LOC)*

reactions of the witnessing Unionists were practically uniform: no one had ever seen anything like this.

At the Brian farm, one of Alexander Hays's subalterns counted twenty-one captured Rebel flags. When questioned how he came into possession of some of the flags supposedly captured by Webb's brigade, Hays querulously asked how that could have possibly happened. Then, with mock generosity, Hays sent six banners to Webb with his compliments.

Eventually the number of captured Rebel flags would reach twenty-eight.

George Meade rode to Cemetery Hill then all the way down to Little Round Top. There, he ordered George Sykes to advance a reconnaissance to the Wheatfield. That would be the extent of the Federal infantry counterattack to Lee's great charge.

Back on Cemetery Ridge, as the enormity of the Union landslide settled in, booming cheers rang up and down the heights. Two years of defeat and frustration had come to an end. Two years of McClellan's egotistical indecision, of Burnside's genial incompetence, of Hooker's licentious bravado, all swept away in a thrashing both stunning and complete. The men of the Army of the Potomac watched as their opponents stumbled across the fields toward the sheltering trees on Seminary Ridge, and they knew. Theirs was an epic triumph on home turf against an old and previously indomitable foe, a victory that gave meaning to all the losses, all the bloodshed, all the misery.

Everything had changed.

CHAPTER

7

FEDERAL GENERAL WILLIAM F. FRENCH had spent the campaign in Frederick, Maryland, impatiently monitoring developments. While he awaited orders, numerous sources reported a Rebel pontoon train near Williamsport. French decided to act. That morning, French dispatched 300 Federal troopers under Major Shadrack Foley to destroy it. As the battle raged at Gettysburg, Foley guided his troopers 25 miles to Falling Waters on the south bank of the Potomac. They arrived after nightfall, determined to attack the train guards at first light.

<center>∽o∾</center>

George Pickett's devastated division poured over Seminary Ridge in profound disarray. Tossing away their guns and accoutrement, the shell-shocked soldiers ignored calls for order and instead wailed bitterly of their fate. Pickett himself wept as he did little to abate the scattering. He rode on to be alone in his thoughts.

Baltimore native Maj. Gen. William French had compiled a solid resume by the time of Gettysburg. A West Point graduate and career army officer, French experienced typical frontier duty and staff work during the Mexican War, and he co-authored *Instruction for Field Artillery* with Henry Hunt. He led a brigade on the Peninsula and rose to division command at Antietam in which he continued through Chancellorsville. For the Gettysburg campaign, French headquartered in Frederick, Maryland, where he took charge of the Harpers Ferry district and Milroy's survivors from the Winchester debacle. *(LOC)*

As the sun fell behind South Mountain, clouds moved in promising rain. Slaves who had accompanied the army north took advantage of the darkness and post-battle chaos to steal away to freedom. Back on the battlefield's periphery, the field hospitals already taxed beyond measure could not keep up with the influx of

A Federal field hospital behind the lines of the Grand Charge. *(Gettysburg Cyclorama, Photo by Bill Dowling)*

the wounded. New arrivals, no matter their condition, lay in various states of agony, awaiting their turn with the surgeons.

Lee's grand charge had produced 6,700 casualties, including some 5,000 killed or wounded in action. All three of Pickett's brigade commanders were assumed mortally wounded. Only James Kemper would survive. Thirteen of Pickett's regiments lost their commanders, with a similar number of second and third-in-commands shot down. Pettigrew took a relatively minor wound to his hand, but Trimble's leg needed amputation, Marshall was dead, Fry was wounded and captured, Lane wounded but safe.

Lee rode through the wreck of his army and knew what he had to do. He called a council of his commanders and announced a retreat to Virginia. In a first act of consolidation, Lee ordered Ewell to abandon the town of Gettysburg and the base of Culp's Hill and withdraw to the ridges northwest of town where the battle had begun two days before. Ewell's Corps began the process sometime after midnight. Meanwhile, the army's vast reserves train carrying the plunder collected during the invasion—which included five thousand heads of cattle and thousands of sheep and hogs—would lead the retreat south. Under the command of the equally brilliant and inordinately

profane quartermaster Major John Harman, the 20-mile-long column stretched from Cashtown to Fairfield. Ewell's supply and ambulance trains would follow Harman, departing Gettysburg via the Fairfield Road, which Grumble Jones had managed to keep open with a skirmish near Fairfield earlier that day. 4,000 Yankee prisoners (1,500 Northerners had signed paroles) guarded by Pickett's Division would accompany the column. Jeb Stuart received instructions to divide his command to protect the two columns and both flanks of the army. Lee spent the rest of the early morning studying maps and devising the escape routes. To the south, Longstreet pulled his troops off Houck's Ridge and Stony Hill and repositioned them west on Seminary Ridge next to A.P. Hill. He refused his right flank to offset any Yankee attacks from the south. Porter Alexander's guns joined Longstreet on the ridge. With time of the essence, the Confederates were forced to leave many of their dead comrades splayed among the rocks of the Slaughter Pen and Devil's Den and across the fields of the Rose farm.

Abraham Lincoln had spent most of his free time in the telegraph office of the War Department poring over dispatches from Meade. Around 10:00 p.m., word came from Gettysburg that Lee's grand charge had been denied, so the jubilant president prepared a press release for the next day, the 4th of July. Of course, he bestowed all honor due to the defenders of the Union cause, but Lincoln saw a promise far greater in the Rebel defeat. With Ulysses Grant pounding the Mississippi River citadel of Vicksburg into submission, the moment had arrived for Meade to reach out and crush the rebellion by destroying its most important weapon—Lee and the Army of Northern Virginia. Meade rejoiced in the winning of a battle. Lincoln demanded the winning of the war—now.

⚔THE GLORIOUS 4th⚔

Cavalry officer Brigadier General John Imboden met the army commander around 1:00 a.m., the morning of July 4. Imboden and his brigade had spent the campaign doing little more than collecting forage and

guarding the Confederate supply train, so a weary Lee gave his relatively fresh subaltern the assignment to get the transportable wounded and the wagons of Stuart, Longstreet, and Hill's corps to Williamsport on the Potomac where they would cross the river and proceed to Winchester, Virginia. He also told the cavalryman that a packet to be delivered to Jefferson Davis would be in his hands by the morning. Fitz Lee's horsemen would protect the column's rear, and Imboden would have 23 artillery pieces for added security. He was to begin the 42-mile journey later that day.

Combined, the Army of Northern Virginia's wagon trains would stretch 100 miles.

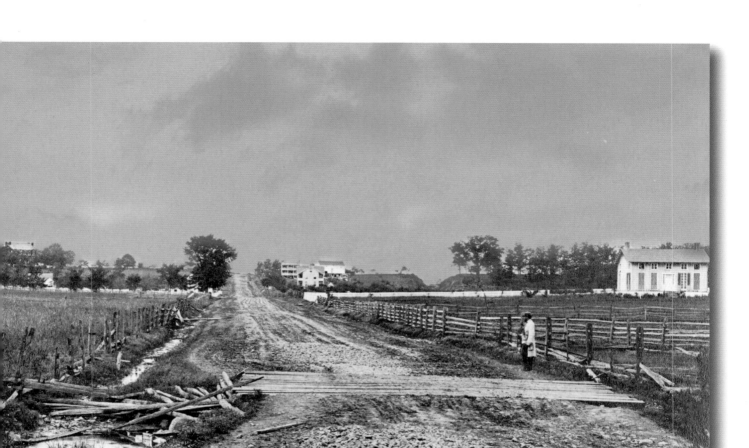

Looking west on the Chambersburg Pike, this scene greeted the Federals as they followed Ewell's withdrawal from Culp's Hill and Gettysburg proper. Ewell's troops had used fence rails and telegraph poles to construct a long line of obstructions along the military crest of Seminary Ridge that dominates the entire horizon. Visible from left to right: the Seminary, the Krauth house, the Chambersburg Pike crossing the ridge, the Dustman house and barn behind the Sheads house, the railroad cut, and the Tate house. *(GNMP)*

Before he departed, Imboden heard Lee say that Friday's assault had not been properly supported, otherwise victory would have been theirs. The fault for Friday's crushing defeat evidently was no longer the commander's.

Around 3:00 a.m., Harman got the Confederate reserve trains noisily moving through Fairfield and heading toward Monterey Pass. Back in Gettysburg, as dawn broke on this most extraordinary 4th of July, some civilians scurried through the southern stretch of their town and approached Union pickets to tell them the Rebels had abandoned the place. XI Corps units gingerly stepped off Cemetery Hill and entered the battered streets where they captured some 300 groggy Rebels who had missed the order to depart. Surprisingly, they were greeted by many of their

comrades who secreted themselves from the occupiers, including their own General Alexander Schimmelfennig who had spent the three previous days hiding behind a woodpile. The Bluecoats then worked their way west until they discovered Ewell's corps now realigned along Seminary Ridge. After a short skirmish, the Northerners settled into a standoff.

Sleepless, stressed, and foul of mood, Lee meanwhile requested a prisoner exchange that Meade rejected. The Northerner knew the captives would be a further burden on the Rebels if they tried to retreat. Meanwhile, sharpshooters made life miserable for both sides all along the front lines. Most of the Southerners expected the Yanks to attack and built extensive breastworks of fence rails in anticipation. Nothing would have pleased them more than to have the enemy attempt their own version of Friday's charge. Except for a few half-hearted Unionist forays, the Graybacks remained disappointed.

At 9:00 a.m., Union lookouts spied a rising dust cloud west near South Mountain, but Meade, unsure of Lee's intentions, delayed launching an infantry pursuit. Instead, he concentrated on getting the army's supplies at Westminster delivered to Gettysburg as his men were hungry and his animals starving. Sometime after noon, a pounding rain began to lash South Mountain and spread west toward Gettysburg. Soon, the storm blanketed the entire area. Some stricken soldiers still on the battlefield drowned as the local creeks spilled over their banks and inundated the unfortunates. Those wounded crowding the myriad field hospitals lay in the rain, their misery compounded.

Meade meanwhile congratulated his army for their great victory and encouraged them to even greater exertions to drive the Rebels from Northern soil. Later, on the 4th, when Lincoln read this, his joy turned to chagrin. The president feared that McClellanism still permeated the Army of the Potomac, a soft-war attitude that hinted at limited warfare, midnight conspiracies, and military coups. Had the president attended Meade's conference the evening of the 4th, his chagrin would have turned to anger. Sorely aware of the need to tend the wounded, bury the dead, and resupply the army, the Union corps commanders all agreed that they should await Lee's next move and that any pursuit would be east of South Mountain via Emmitsburg, Maryland, thus assuring Lee both a shorter route to the Potomac and a head start.

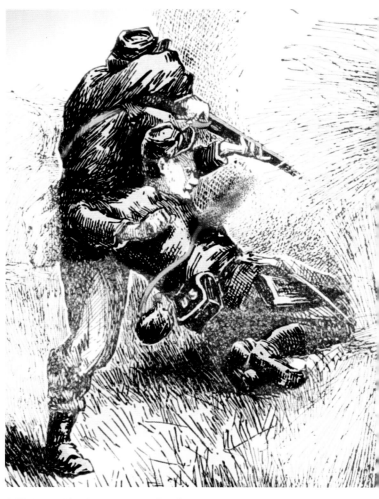

A Federal skirmisher takes a Confederate bullet to the chest as his partner returns fire. *(History of the 121st Regiment Pennsylvania Volunteers)*

Before dawn, Shadrack Foley and his Federal horsemen stealthily surrounded the small Rebel force protecting Lee's pontoon bridge at Falling Waters on the south bank of the Potomac. At first fire, most of the guards simply ran. The Federals spent the next few hours destroying the pontoons, the trestle work, and the trains, leaving burnt, hulking masses in their wake. They finished their work near noon, with torrential rainstorms plastering the area, and the river rising quickly. It was quite a coup. Foley and French had just denied the Rebels the means to escape their increasingly dangerous predicament.

Around 1:00 p.m., the head of Harman's column crossed South Mountain while the rear cleared Fairfield, prompting Ewell's trains to fall into line and begin their journey. Less than twenty-four hours after E.P. Alexander fired off the first shot of the Grand Charge, half of Lee's vast transportation system was somehow on the move. Three hours later, the other half lurched forward. All day, Imboden watched his trains gather on the Chambersburg Pike from Cashtown to Gettysburg. Around 4:00 p.m., as sheets of rain and howling wind swept the funereal landscape, the cavalry officer ordered his caravan of some 6,000 wounded soldiers west into the Cashtown Gap over South Mountain. Those walked who could manage, and those who couldn't rode.

One wagon housed the badly wounded John Hood and Wade Hampton. Another carried the remains of Isaac Avery, killed at the head of his brigade during Thursday's assault on Cemetery Hill. His slave, Elijah, was determined to bury his master at home in North Carolina.

Among thousands of others, Isaac Trimble (who would lose his leg) and James Kemper remained behind in Gettysburg. Neither could be moved and soon fell prisoner to the Yankees.

The Chambersburg Pike had been macadamized, so the early going was relatively smooth. Past South Mountain, the column turned south onto the Pine Stump and Walnut Bottom Roads, two rocky tracks that locals considered the worst in the area. The teamsters—mostly impressed slaves—fought through the pounding downpour as the rough roadways turned into fathomless quagmires that claimed broke down wagons and exhausted beasts alike. A vast moan rose up from the dolorous procession, begging for water, for mothers, for wives, for death. Their cries would haunt

In a relentless pouring rain, the Confederate wagon train transporting the wounded to safety creaks along a muddy track. *(B&L)*

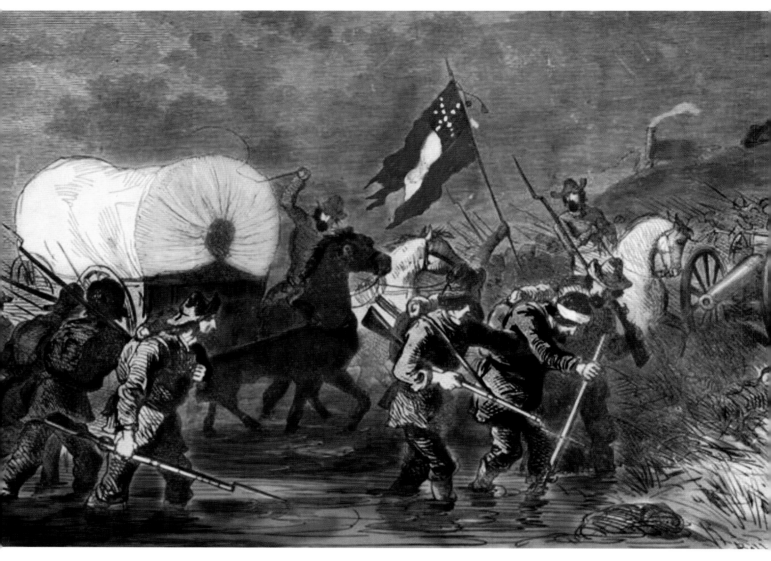

Confederate infantry and artillery brave a pounding rainstorm as they negotiate a flooded stream on their way south to safety.
(NYPL Digital Collections)

their guardsmen and civilian witnesses long after the operation's end.

By that afternoon, Meade learned of the vast Confederate wagon train moving west on the Chambersburg Pike. He reckoned Lee was withdrawing to South Mountain, perhaps to make a stand there, so he ordered his cavalry to move out and harass the retreating Rebels, cutting communications wherever he could. In response, Judson Kilpatrick removed his division south to Emmitsburg. Intelligence pinpointed the Rebel trains crossing South Mountain through the treacherously narrow Monterey Pass, and Kilpatrick—bolstered by Colonel Pennock Huey's

brigade—intended to strike them there. By mid-afternoon on the 4th, Kilpatrick's 4,500 troopers—with Custer's Michiganders in the lead—sallied west on the Waynesboro-Emmitsburg Turnpike and headed for the heights.

As darkness cradled Gettysburg's brutalized surroundings, Lee's infantry (Hill, then Longstreet, then Ewell) successively abandoned their positions and began to slowly march west on the Fairfield Road in the wake of Harman and Ewell's 40-mile-long train. The soldiers knew they had been whipped, but their spirits initially remained high. The miasma of hammering rain, utter darkness, and impassable roads soon

dampened whatever lofty spirits existed. Theirs became a march of misery.

By 9:00 p.m., Harman's trains had cleared Monterey Pass, and the leading edge approached Hagerstown. It was now Ewell's wagons's turn to inch their way through the narrow defile. Not two miles to the east, Kilpatrick arrived at the base of the heights where he received intelligence that the Rebel trains were crossing the mountain up ahead. He dispatched a squad of Michiganders north to cover his flank and attack the Rebel wagons near Fairfield Gap. In response to the foray, Rebel cavalry from Robertson and Jones's brigade deployed and fought them to a standstill. Meanwhile, Kilpatrick's main column trotted up the mountain on the turnpike and approached the eastern mouth of Monterey Pass. At first, in the inky gloaming and pounding deluge, a single Rebel cavalry company under Captain George Emack and a lone artillery piece with almost no ammo held the Yankee troopers at bay. The badly outnumbered Confederates launched a bold counterattack, and the stunned Michiganders withdrew. Unsure of the nature and number of the enemy, Kilpatrick took the advice of a local and dispatched a squad of dismounted

Pennsylvanians to the left to try to flank the Rebels. Emack, however, detected the movement. He withdrew his tiny force 200 yards into the pass and hunkered down to await developments.

As the torrential rain and searing lightning lent a surreal ambience to the scene, Kilpatrick and Custer took an hour to reorganize their advance. Custer's now dismounted Wolverines stumbled upon the new Rebel position and recoiled a second time from their volleys. This time, the Yankees quickly returned to the fight, and firepower finally held sway. The Yankee Spencer repeating rifles pushed the Southerners past the four-story Monterey House resort to within yards of Ewell's trains and the turnpike's tollgate. Grumble Jones just then arrived with a small cohort of cavalrymen. He assured Emack that help was on the way, but, for now, Jones's staff would be their only reinforcements.

Kilpatrick deployed artillery on a hill south of the road to harass the wagons whose rumble could be heard through the crashing thunder and the bellowing cattle herds. The Unionists managed to cross the deep gulley of a tributary of Red Run on a bridge and press the Rebels with a strong skirmish line. Meanwhile, 100 more Confederate cavalrymen arrived to bolster

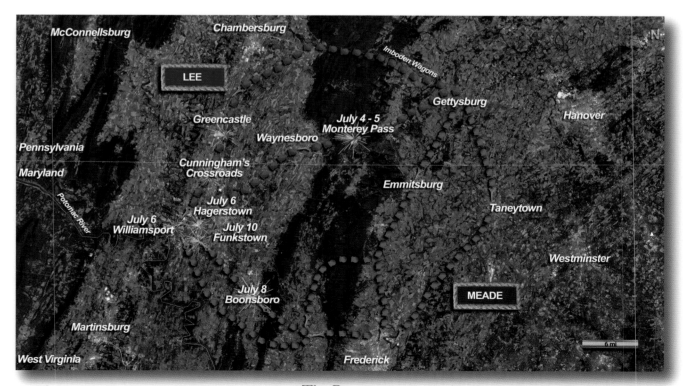

The Retreat
39° 37'14.82 N 77° 26'33.81 W. Google Earth Pro. 9/6/2013. 8/25/2022.

Emack's band, and again, the Yankee thrust slowed. As dismounted Yankees pressured the Rebels, Kilpatrick finally organized two mounted charges that broke through Emack's boys and crashed into the Rebel train. In the ensuing melee, Grumble Jones, George Custer, and the thrice-wounded George Emack barely escaped capture. The Unionists then hit Robert Rodes's divisional trains and began to collect prisoners. They worked their way west down the mountain, destroying or capturing around 250 wagons belonging to various artillery battalions. At Ringgold, Maryland, near the western base of South Mountain, Kilpatrick finally halted, the surreal battle of Monterey Pass ended. Kilpatrick held 1,300 Confederates captive and characteristically crowed that he had destroyed Ewell's entire train, all at a small cost of five killed and upward of 100 wounded or missing. In fact, he destroyed about nine miles of the wagons.

⤳JULY 5 ⤶

Ewell's caravan would not be the only Rebels to feel the lash. In the cloudy dawn, as the van of Imboden's procession passed through Greencastle, Pennsylvania, locals raided the unguarded wagons, stealing horses and cattle with no regrets. Others taunted the Southerners over their woebegone condition, and a gang of ax-wielding civilian partisans descended on the caravan near the town center and destroyed a number of vehicles. They were soon joined by 100 cavalrymen from the various

The son of Rear Admiral John Dahlgren, Captain Ulric Dahlgren had some pre-war experience as an engineer, land surveyor, and law clerk when he joined the Navy after Sumter. A meeting with Secretary of War Edwin Stanton in May of 1862 resulted in a captaincy and a move to various general staffs. He was serving on Meade's staff during the Gettysburg campaign. *(LOC)*

U.S. Regular regiments under the hyperaggressive Captain Ulric Dahlgren who had snaked their way across South Mountain searching for their prey. Dahlgren's lightning strike captured 176 wagons and 200 Rebels, but elements of Imboden's cavalry responded quickly and chased the Yankees away. Dahlgren and his cohorts abandoned their prizes and sped east toward Waynesboro, accomplishing little more than delaying the column a few hours.

∽◦∾

Grumble Jones picked his way through the sodden darkness across southern Pennsylvania and Maryland and arrived begrimed and soaked in Williamsport as the gloomy dawn of July 5 broke. Droves of cattle and vehicles of all shapes and sizes filled the streets of the small town, and panic gripped the air. The Potomac roared by at flood level, and Harman's boys discovered that the pontoon train—their one lifeline to safety—had been destroyed on the far side of the river. A privately owned, pole-driven cable ferry represented the only way across, but it could only transport two wagons at a time. Jones could grumble with the best, and he had difficulty with teamwork, but he immediately took gruff charge of the teetering situation. He assigned areas near the C&O Canal and the town's streets to corral the cattle and park the wagons. He began to mold a defense force out of the various cavalrymen and any convalescents who could hold a rifle. He ordered the three main arteries into town barricaded, and he distributed his few artillery pieces across the line. Williamsport would be defended to the last—building by building if necessary. Of this, Grumble Jones was sure.

∽◦∾

164

In Gettysburg early on the 5th, Confederate deserters and Federal signalmen confirmed Lee's withdrawal. From east of the Round Tops, Meade sent the VI Corps across the battlefield Golgotha and down the Fairfield Road in direct pursuit. By afternoon, Horatio Wright spread out his division in a half-mile long battle line and approached the town. Commanding the Rebel rear guard, Jubal Early learned of the Yankee movement and advanced his division into the fields east of Fairfield to counter it. An hour-long artillery exchange accompanied by some modest skirmishing at Granite Hill produced little result, but as Early withdrew slowly, John Sedgwick did learn that Robert E. Lee held South Mountain in force, practically inviting the Union to

attack. Sedgwick sent word back to Meade. His orders prevented him from triggering a major battle. Instead, he watched and waited.

Departing Emmitsburg about the same time Sedgwick began his operation was Wesley Merritt's cavalry brigade. Pleasonton ordered them and Buford's refitted division in Westminster to Frederick in the race to the Potomac. Much to the interest of the townsfolk, after Merritt departed around dawn, Confederate cavalry clattered into view, accompanied by Jeb Stuart himself. After a frustrating interrogation of some captured Yankee signalers and a member of a photographic team on his way to the battlefield, Jeb led his soggy troopers south. Rather than continuing

When Jeb Stuart showed up in Emmitsburg on the morning of July 5, he surprised and captured a group of Federal soldiers along with Alexander Gardner who was on his way to photograph the battlefield. Stuart detained Gardner for some time as the Confederates impressed all the horses they could find and drive them south. Bob Zeller and the staff at the Center for Civil War Photography reckon that this engraving shows a mounted Stuart watching the horse drive, sketch artist Alfred Waud directly below Stuart, and a dejected looking Alexander Gardner with his arms draped over the black horse in the left foreground. *("Confederate driving captured horses through Emmitsburg, Maryland, July 1863, artist's impression, detail," House Divided: The Civil War Research Engine at Dickinson College, https://hd.housedivided.dickinson.edu/node/40954)*

toward Frederick, Jeb instead crossed the Catoctin Mountains, traversed Harbaugh Valley, and trotted over South Mountain near Zion Church. He then divided his force into two wings to angle toward Smithsburg and Leitersburg in search of his prey, the Yankee horsemen.

While Merritt and Stuart spent the morning trotting south, Kilpatrick and his column mirrored their movements west of South Mountain. The cavalry commander needed to get his boys and his booty to Boonsboro then east to Frederick and the protection of William French's division. After dawn broke on July 5, Kilpatrick had stopped to burn most of his wagons. Slowed by his captives, he pushed forward, fully aware that Rebel cavalrymen lurked east of South Mountain and Lee's entire army marched somewhere to the north. At Smithsburg, Maryland, about mid-morning, Kilpatrick halted his command and deployed his boys to cover the eastern approaches to the town.

In late afternoon, Stuart's left wing descended the western slope of South Mountain near Cavetown. Stuart himself emerged from Raven Rock and spurred toward the hills east of the hamlet. Federal cannon opened on the Confederate van, but the Rebels quickly dismounted and forced the issue, triggering a vicious little firefight. Jeb rode with the right wing that circled north and came down hard on Kilpatrick's left flank. Artillery exchanges ensued for an hour, but with his left being pressured back, Kilpatrick decided to move south to Boonsboro, ceding the area north and east of Hagerstown to the Rebels. Jeb meanwhile trotted into Smithsburg and pushed his command west to Leitersburg where he reconnected with the rest of his cavalry.

∽o∾

Around the same time as the Early/Wright skirmish at Fairfield, Imboden finally reached Williamsport. His

Looking south, John Imboden designated the plain between the C&O Canal (left) and the Potomac River (right) as the holding area for the massive Confederate wagon trains. *(LOC)*

166

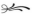

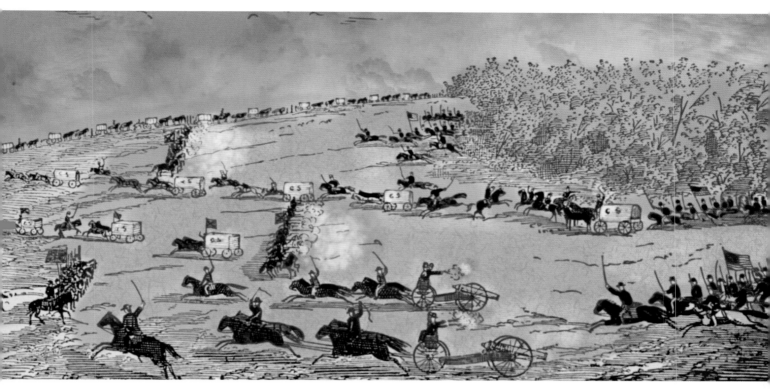

Late on July 5, Federals under Capt. Abram Jones (right) hit John Imboden's train at Cunningham Crossroads, Maryland.
(Boots and Saddles: A History of the First Volunteer Cavalry of the War)

column now stretched almost 25 miles, and the same troubling circumstances that greeted Grumble Jones had not dissipated. True, welcome reinforcements comprised of two regiments and an ordnance train were rumbling north from Martinsburg, but the relief force was still hours away. Imboden meanwhile converted the town into a vast hospital and put its citizens to work caring for the thousands of wounded soldiers exiting the wagons. He also designated the area south of town between the C&O Canal and the Potomac as the primary wagon park. As his trains slowly rumbled into the town, filling its streets with a horrible stench and swarms of flies, Imboden gamely dispersed his twenty-three cannon to cover the converging roadways and awaited the Yankees. One artery held particular interest for the general: the road running south of town to Downsville that intersected with the track to Falling Waters and Lee's intended crossing point. Beyond that lay a north-south ridge that could prove to be the Confederates's salvation.

By day's end, Grumble Jones departed Williamsport to rejoin his command near Hagerstown. At that point, the modest river town had become the Army of Northern Virginia's single most important piece of real estate. The responsibility for its defense lay solely and squarely on John Imboden's shoulders.

Meanwhile, back in Gettysburg, the photographic team that had been delayed by Stuart at Emmitsburg rolled into town. The three men—Alexander Gardner, Timothy O'Sullivan, and William Gibson—looked around at the blasted landscape and prepared to go to work.

∽∘∾

Near sunset, Imboden's column got hit again, this time at Cunningham's Crossroads just past the Maryland border. A 200-saddle Union cavalry unit under Captain Abram Jones that had escaped the June disaster at Winchester weeks before attacked Joe Davis's ambulances and made off with 134 wagons and 653 mostly wounded prisoners. The Federal rear guard held off Rebel pursuit while Jones, his boys, and their captives beat a retreat northwest to Mercersburg.

After a short delay, Imboden's bruised column pressed forward.

❧JULY 6—GETTYSBURG❧

With Sedgwick's report in mind, George Meade suspended the direct pursuit of the Rebels over South Mountain. Only a single VI Corps infantry brigade under Brigadier General Thomas Neill accompanied by cavalry and artillery would depart Fairfield to follow Lee's infantry into the mountains. At Iron Springs, two miles beyond Fairfield, they clashed sharply but briefly with some aggressive North Carolinians of Daniel's brigade. Meanwhile, Sedgwick redirected the rest of his VI Corps southeast to Emmitsburg.

Meade faced a perplexing question. If Lee planned to fight at South Mountain, Meade would have to move his supply base from Westminster to Gettysburg. But, if Lee were retreating, the Federal supply base would have to transfer to Frederick, Maryland. With no solid answers as to Lee's intentions, Meade would have to wait. Meanwhile, the balance of the Army of the Potomac did little more than rest, refit, and wait with him.

Out on the margins of the battlefield, as the burial crews interred the last of the dead, Gardner and his photographic team plied their trade.

❧JULY 6—HAGERSTOWN❧

Hagerstown and Gettysburg both shared common geographical traits that imparted a martial importance. They enjoyed a central location that attracted wide-ranging road networks, the control of which could dominate larger events. Kilpatrick's movement away from Hagerstown the evening before betrayed his surprising lack of awareness of this reality. Stuart suffered no such illusions. Put simply, Lee's infantry would need Hagerstown to get to Williamsport. On the morning of the 6th, Stuart dispatched two brigades of his troopers to Hagerstown with orders to hold it and followed with two more by a different route in support.

Through intelligence, both Kilpatrick and Buford learned that Rebel supply trains were rolling through Hagerstown and into Williamsport. With Elon Farnsworth's former brigade (now led by Colonel Nathaniel Richmond) in the van, Kilpatrick moved up the macadamized National Road and approached Hagerstown from the south. Ulric Dahlgren and his boys also rode with the column, having finished their independent harassing of the Rebel trains. Kilpatrick,

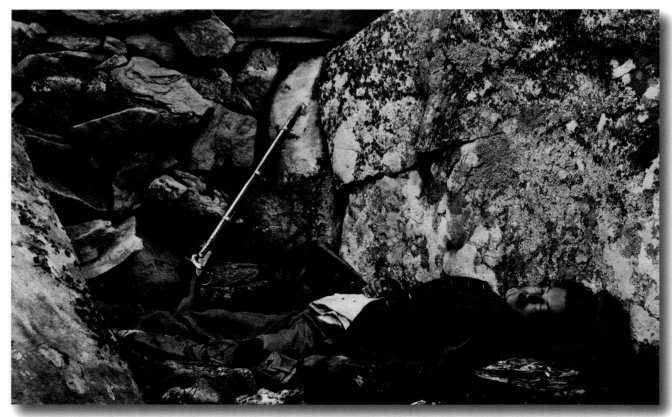

Gardner and his team famously moved this Confederate to this location near Devil's Den. *(LOC)*

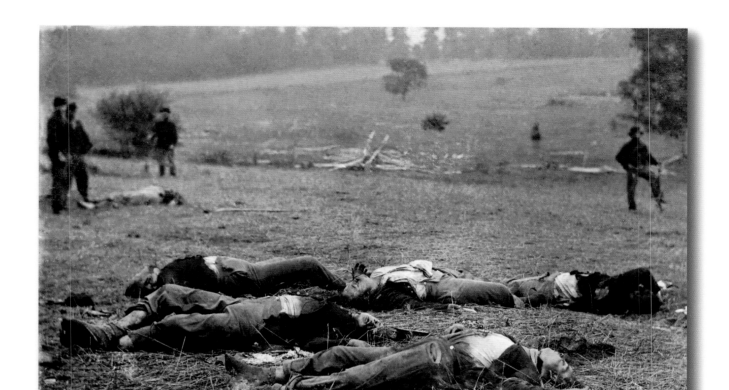

One of two Alexander Gardner images that shows both Union and Confederate dead on Seminary Ridge. The view is southwest toward McPherson Ridge which at the time of the battle featured three separate peaks between the Fairfield Road and the Chambersburg Pike—quite unlike the graded, flat surface we see today. Gardner's crew had already taken two images when the Federal burial crew arrived and began digging near the foreground corpse's head. They stopped and posed for the final photo. *(LOC)*

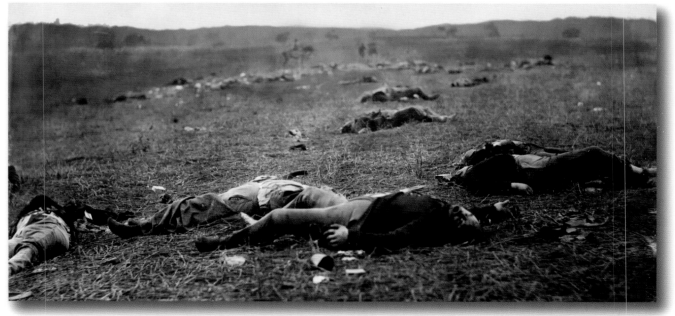

The same five Union dead photographed looking north by northwest. Fourteen of Scales's North Carolinians lie in the background. They will be buried in a trench near the horseman who is probably on the Chambersburg Pike. The Federals will be buried together where they lay. *(LOC)*

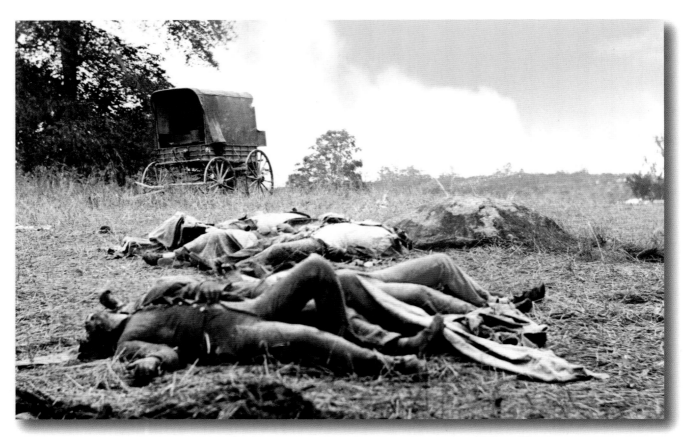

Another in the series that Gardner made on Rose farm near the margin with Rose Woods. *(LOC)*

however, stopped his command near Funkstown and returned to Boonsboro to confer with Buford. Around noon, they determined to attack both points—with Kilpatrick hitting Hagerstown and Buford assaulting Williamsport.

Those Confederates occupying Hagerstown hailed from Rooney Lee's brigade (commanded now by Colonel John Chambliss). They were engaged mostly in ordering lunch from establishments like the Washington House on Potomac Street. Instead, Kilpatrick had returned from his conference and ordered an immediate advance. With the enemy boiling up from the south, the Confederates abandoned their repast and threw up a barricade near St. John's Lutheran Church to combat the incursion.

Things escalated quickly. The Yankee troopers blasted through the barricade and routed two Virginia units, but a grim stand by Grayclad Marylanders doused the assault. Both Chambliss and Kilpatrick then fed more of their commands into the expanding brawl. The streets around the town center filled with rushing mounts, clattering sabers, rifle and pistol shots,

shouts, and cries. Even civilians joined in the carnage, including a doctor's daughter who supposedly plugged a Pennsylvania sergeant.

Soon after the action began, Jeb Stuart arrived from Smithsburg with Ferguson's brigade. Kilpatrick detected Stuart's appearance and so ordered his own artillery to mount a hill and take on the arriving Rebels. In response, Ferguson deployed his guns, and the long arm exchanges shook the eastern environs of Hagerstown with terrifying, concussive power. Kilpatrick also deployed a New York regiment to freeze Ferguson in place. As with the fight in the center of the town, the two sides battled to a standstill.

Richmond mounted yet another charge that hammered the dismounted Rebels defending Christ Reformed Church north of the town square. The fighting intensified to a pitch rarely seen in cavalry actions, prompting Beverly Robertson to add his small brigade to the fight. Fought to a draw, eventually the two sides disengaged to take up sharpshooting. North Carolinian infantrymen from Iverson's brigade then marched onto the scene. They were the first of Robert

The battle of Hagerstown raged right in front of the
Washington House, situated on the west side
of Potomac Street near the center of town.
(Western Maryland Regional Library)

⤳ JULY 6—WILLIAMSPORT ⤳

That morning, armed with intelligence from William French concerning the presence of the Rebel trains at Williamsport, Buford's cavalrymen pushed west from Frederick on the National Road. There they spotted a civilian spy hanging from a tree whom Buford had ordered executed the night before. Around noon, the troopers trotted through Boonsboro, passing Kilpatrick's captured booty. Buford's horsemen then turned left to advance on Williamsport. Imboden meanwhile presumed that the Yankee cavalry would be coming. He continued to organize a force of the walking wounded, abetted by dozens of dismounted troopers and sick soldiers (which took on the title, "Company Q"), to bolster his own ragged cavalry units. All told, he managed to field about 700 rifles. Luckily, Rebel batteries continually clattered into town. As they arrived, Imboden assigned them various positions on the heights east of town to cover the four converging roads. All the while, the cavalry officer anxiously looked to the ferry where a promised ordnance train from Martinsburg was due to arrive.

By late afternoon, with sheets of rain sweeping the area, a Rebel outpost four and a half miles from town near the College of St. James encountered William Gamble's lead brigade. The Federals dismounted and sprinted into line to return the fire. The fight for Williamsport had begun.

Confederate artillery initially dominated Buford's long arm and slowed the troopers of Wesley Merritt's brigade. The Confederates also employed aggressive mounted probes to hold the Yankees at bay. Merritt's boys gamely parried Imboden's thrusts and worked their way forward to within sight of the town. They wouldn't get much further. With Williamsport at their backs, Imboden's motley band of defenders dug in their heels and stopped Merritt's advance with repeated volleys and stinging artillery barrages. Holding an advantage over Buford in heavy metal, Imboden's previous experience as an artillerist served him well. He expertly rotated his artillery units to blaze away at the Yanks, slowly firming up the front. To his great relief, the ordnance train finally arrived. Crews ferried it across the Potomac and quickly distributed the ammo. Their chests replenished, Imboden's long arm continued its excellent work.

E. Lee's infantry to cross South Mountain (the tail of the column still rested back at Fairfield), and their weight proved crucial as they helped drive Kilpatrick's troopers south out of town. Stuart meanwhile reorganized his boys on the fly and sent them in pursuit of Kilpatrick down the Williamsport Road, gathering up exhausted Yankees in the sweep. Only a determined rear guard action by some Vermonters and some brilliant counter-battery artillery fire prevented a full-scale rout.

As he galloped toward Williamsport, Kilpatrick sensed danger. With Stuart's men pressing his rear, Kilpatrick could plainly hear the sound of battle up ahead. Earlier, Buford had requested him to assist in an attack on Williamsport, so on he rode, leaving Richmond with Farnsworth's former brigade to block the pursuit.

The College of St. James was a Protestant Episcopal school less than four miles east of Williamsport. On July 6, Confederates man an outpost on the campus where the first shots are fired in the battle for Williamsport. Once the opposing lines settle down, the campus stands in the no-man's-land between the two opponents. *(The Saint James School of Maryland: Celebrating 175 Years)*

Gamble's dismounted troopers meanwhile edged around Merritt's southern flank and hit some Confederate forage wagons on the Downsville Road, setting twenty-seven of them on fire. Led by the 8th Illinois Cavalry, this Federal advance had now cut off Rebel access to Falling Waters on the Potomac. A half mile south of town, some Virginians managed to blunt the Illini thrust near Rose Hill Manor. The determined Federals renewed their advance and dislodged the outnumbered Virginians, pressing them to the northwest and prompting Imboden to reinforce that wing with elements of his infirm brigade. Grumble Jones also recognized the danger and quickly mustered a few companies of armed wagon drivers to meet the threat. The fighting here was sharp, and somehow, the Rebel lines held.

Wesley Merritt's brigade kept up their probing of the Rebel lines north of Gamble, but he and his troops met continued Southern obstinacy, including the action of one Rebel artillery unit that advanced 400 yards unsupported to batter Merritt's northern flank. Then, near 7:00 p.m., three more organizations entered

the fray. Devin's Federal brigade arrived and took up a reserve position behind Gamble, As the Unionist pressure built, Fitz Lee's Confederate brigade pounded onto the scene. They had left their post defending the rear of Harman's caravan to thunder down the Greencastle Road and noisily bolster Imboden's northern perimeter. Fitz and his crew landed hard on Merritt's right flank, and the stunned Northerners began to break. Kilpatrick's troopers then galloped into the action on the Hagerstown Road just north of Merritt's reeling flank. Custer and some Michiganders advanced on foot but soon recoiled before the Rebel long arm and the combination of Imboden's Company Q and Fitz Lee's tough horsemen. Failing to link up with Buford, Kilpatrick's people finally fell back the way they came.

By sundown, with Merritt and Kilpatrick in full retreat, Buford had had enough. Convinced that he was outnumbered, the general put Devin in a blocking position and pulled the rest of his command back to Boonsboro. The retreat broke down as the two mounted Federal divisions intermingled in the

darkness on the muddy backroads, a confusing end to a rather bad day for the Yankees. Against a motley assortment of haggard cavalry units, untrained teamsters, and walking wounded, another Federal attempt to block Lee's retreat had ended in failure.

As the sounds of the battle for Williamsport died away, the van of the Army of Northern Virginia marched into town. With the stench of thousands of wounded soldiers mixing with the fly-packed masses of horse manure, cow dung, and cattle carcasses, the infantrymen of Iverson's brigade found the place disgusting beyond belief. However, one factor mitigated the awfulness of the scene.

The Confederates had won the race to the river.

Rose Hill sits less than a mile and a half south of Williamsport. Gamble's Brigade, including the 8th Illinois Cavalry, battle fiercely with the 54th North Carolina and 21st Virginia across Rose Hill's grounds.
(By Acroterion, https://commons.wikimedia.org/w/index.php?curid=40611344)

CHAPTER 8

ON JULY 7, NEWS TICKED into the telegraph office in the War Department: Vicksburg had surrendered! Suddenly, the great victory at Gettysburg paired with an equally epic triumph on the Mississippi to gift the North with a moment like no other. With two unprecedented victories within twenty-four hours of each other, perhaps the North could dream that this wicked war was truly nearing an end. Lincoln, however, felt little of the joy. He received the news of Vicksburg's fall early that morning, but at a cabinet meeting, he appeared depressed over Meade's supposed lax pursuit of Lee. Later that evening, however, he addressed a cheering crowd from a White House window praising the victory over those opposed to the concept that all men are equal while mocking the Rebels who had shown their feathers in flight. The crowd naturally went wild. Despite his worries, at a moment of great personal triumph, Abraham Lincoln felt the need to remind the gathered throng why he and they were fighting this war, and he singled out the Declaration of Independence as the touchstone of his beliefs. He then gave the stage back to a brass band that immediately struck up a spirited brace of patriotic music.

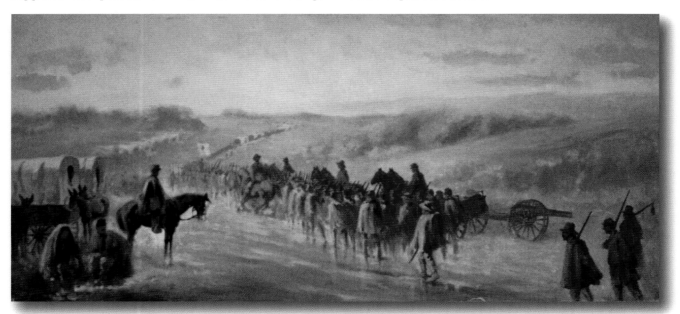

The Army of the Potomac marches south through a pounding rainstorm in pursuit of the Army of Northern Virginia. *(LOC)*

Three Confederate prisoners pose for Matthew Brady about two weeks after the battle. They stand on Seminary Ridge in front of the obstructions Ewell's boys built on July 4 after withdrawing from Culp's Hill and the town of Gettysburg. *(LOC)*

Still in Gettysburg and now fully convinced that Lee was heading for the Potomac, George Meade ordered his supply base moved to Frederick. He then divided his command into three wings to trigger his pursuit. The mud-encrusted Northerners spent the rainy day in a series of forced marches, slogging down the roads radiating south of Gettysburg.

By midnight, Sedgwick and most of his VI Corps had marched through Emmitsburg then crossed the Catoctin Mountains toward Hamburg, Maryland. Slocum's XII Corps tramped through Littlestown to the hamlet of Walkersville on the Monocacy River. Howard's XI Corps departed Emmitsburg and reached their intended concentration point of Middletown well

before Meade's expectations. The starving Bluecoats faced down the horrible marching conditions while suffering from a startling shortage of shoes, equipment, and uniforms. However, with the other corps making similar progress, the Army of the Potomac had accomplished everything Meade had hoped for in this first day of the chase.

At the same time, thousands of captured Rebel prisoners headed for Federal prison camps.

As Lee's infantry continued their slog into the Hagerstown-Williamsport corridor, Confederate cavalry started to cordon the sector's eastern approaches. That morning, a Southern infantry and artillery force drove Devin's outpost from the College

of St. James. Later, the 7th Virginia from Grumble Jones's brigade bloodied the 6th U.S. near Funkstown on the National Road—the same units that had tangled at Fairfield on the 3rd. The running fight continued almost all the way to Boonsboro and featured an embarrassing Federal breakdown at a stream crossing. Both actions served notice that the Rebels still had plenty of fight left after the bloodbath of Gettysburg. Jeb Stuart had now established a tight web, pinning his counterparts to the area around Boonsboro south to the Antietam battlefield. By the time the first of Meade's foot soldiers reached Middletown late that night, Lee's infantry was well established in Hagerstown.

To relieve the overcrowding in Williamsport, Confederate teamsters tried to drive a herd of sheep and cattle across the Potomac, but something went wrong. One thousand sheep and a few hundred cattle drowned in the deadly current. Their distended carcasses littered the river all the way down to Harpers Ferry.

As usual, hard rain continued through dawn on the 8th when, shockingly, the sun burst through the gloom. Jeb Stuart awoke early, fully aware of his duty this day. Lee's infantry continued to occupy Hagerstown, and Lee himself wanted to reconnoiter the area from there to Williamsport to establish a defensive line to protect the wagon trains and the army. Jeb determined nothing was going to interrupt that operation. He gathered five of his brigades and five batteries at Funkstown, two and a half miles southeast of Hagerstown on the National Road, and headed for Boonsboro, seven and a half miles away. A Federal signal station near the ruins of the Washington Monument on South Mountain spotted the advance and warned Buford who deployed Gamble north of the National Road and Merritt south to meet it. About mid-morning, Jeb's van, led by Grumble Jones, engaged Buford's pickets and drove them onto the main Federal battle line some two miles from Boonsboro, igniting a fight that would last the rest of the day.

As the opposing artillery deployed in the seemingly bottomless mud, both sides dismounted to fight as mobile infantry. Jones hit Gamble's troopers north of the National Road, while to the south, Ferguson's Confederates met Devin's boys on the Williamsport Road. The fighting oscillated across the sodden fields

Confederate prisoners under armed guards are marched into captivity. *(LOC)*

and tree stands, even as Rebel foragers fanned out across the area and plied their trade. Stuart gained the upper hand with his superior numbers and pressed Buford who called in Kilpatrick for support. Custer and his Michiganders charged forward to relieve Gamble and blunt the Rebel pressure, but the Southerners rebounded and held their ground. Although neither side could gain a decisive advantage, the Rebels slowly pushed the Yankees back toward Boonsboro. The Federals feared Stuart might gain Turner's Gap on South Mountain, but Stuart was simply content to hold Buford in place. Fearing the worst, Pleasonton begged Meade for infantry support,

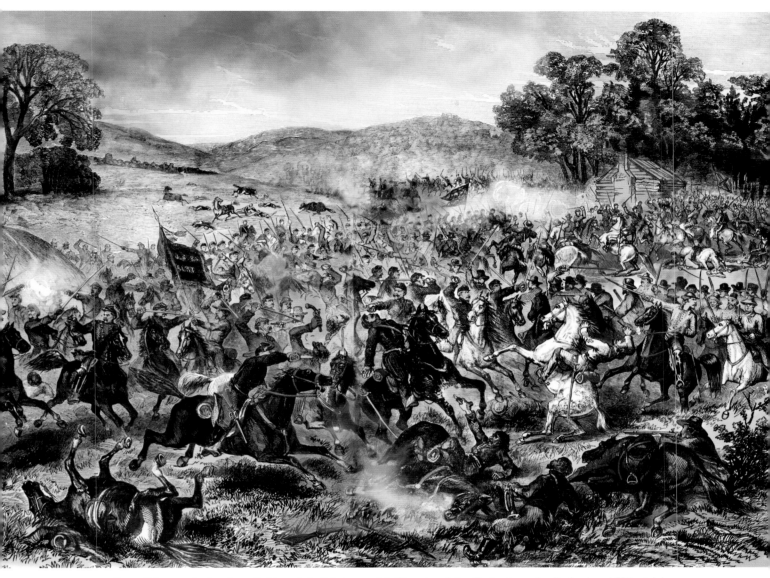

Part of the nearly day-long fight on July 8 between Jeb Stuart and the Federals under Buford and Kilpatrick northwest of Boonsboro. *(The Soldier in Our Civil War: A Pictorial History of the Conflict, 1861–1865)*

so the army commander ordered the XI Corps to cross South Mountain. He also dispatched the VI Corps (which had already crossed the mountain) to descend on Boonsboro from Hamburg. By sundown, Union infantry flooded the area, and Stuart broke off the action. Buford followed, but darkness ended the work.

Stuart had performed his duty well. Unhindered by roving enemy patrols, Lee and his lieutenants spent the day inspecting a north-south stretch of broken hills that ran six and a half miles from west of Hagerstown to the Potomac southeast of Williamsport. Called Salisbury Ridge, the heights offered similar protection to that enjoyed by the Yankees at Gettysburg. Confederate

engineers then went to work laying out the lines and assigning artillery positions. If Lee was going to have to fight for his life, his boys were going to enjoy the benefit of good ground.

Back in Gettysburg, as Gardner and his crew finished their work, the authorities reached a necessary determination. Thousands of wounded soldiers were still being cared for in churches, private homes, barns, stables, and even gardens. This slapdash approach needed more organization and structure, so the government gained

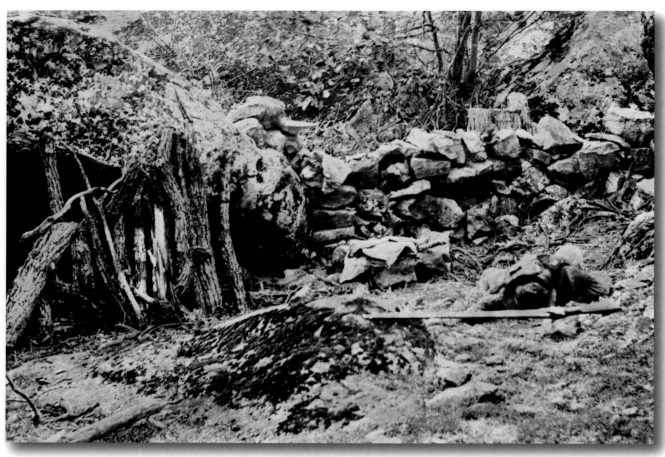

Gardner's team captured this dead Confederate along the western base of the Triangular Field west of Devil's Den. *(LOC)*

access to 80 acres on the Wolf farm a mile east of town and began construction of a large medical camp. Named after Jonathan Letterman, the visionary "Father of Battlefield Medicine," Camp Letterman would care for over 14,000 Union soldiers and 6,800 Confederates during its six months in existence.

∽○∾

Slowly but surely, the sick and wounded Confederates in Williamsport rode the cable ferry across the swollen Potomac and headed to hospitals as far south as Staunton, Virginia.

To the east, all along South Mountain, the news of Vicksburg's surrender coursed through the soggy Union camps. Cheers fired the mountainsides. The end of the war seemed closer than ever before. Just one more push.

Most of the exhausted Union infantry rested along South Mountain on the 9th. Meade had decided to give his boys a break, although he moved his headquarters from Frederick to Turner's Gap. He would wait twenty-four hours to continue the movement west. Only a sharp skirmish along the National Road between elements of Stuart's and Buford's commands marked the day.

Meanwhile, the long crest of Salisbury Ridge yielded to Confederate shovels.

∽○∾

On July 10th, morning broke with a light rain. From his headquarters in Turner's Gap, George Meade ordered his entire force to advance. Across a wide front, the Army of the Potomac rolled forward to confront its nemesis, with but a bare knowledge of exactly where the Rebels were. John Buford advanced his three brigades out the National Road toward Hagerstown, followed by Colonel Lewis Grant's infantry brigade and the rest of the VI Corps. Stuart's scouts discovered

the movement, and Jeb acted quickly. He gathered up elements of his five brigades near Hagerstown and advanced them southeast on the National Road across the Antietam Creek and through the hamlet of Funkstown. With an accompanying four-gun battery, Stuart's dismounted troopers deployed in an arc covering the roadway on rugged ground almost three miles east of the town and waited.

When the Rebel artillery opened on their column, Buford's three brigades and two artillery units shook out a two-mile-long battle line and moved forward at a walk. The Bluecoats enjoyed the advantage of numbers and pressed Jeb back across the sodden fields and ridges toward the outskirts of the town. As his boys fought with an Indian-style delaying action, Stuart recognized his relative weakness and called for support. James Longstreet's corps happened to be nearby. He responded to Stuart's entreaty by rushing infantry and artillery to the front.

With Stuart and Fitz Lee overseeing their deployment, Georgians from Anderson's brigade (now commanded by Colonel William White) and Semmes's brigades (now commanded by Colonel Goode Bryan) joined their cavalry comrades and collided with the troopers of Gamble, Merritt, and Devin. Lee performed poorly as an infantry officer when the Yankee artillery creased his poorly conceived dispositions. Buford, meanwhile, determined to move north—as per Pleasonton's original orders—to seal off the upper approaches to Hagerstown. He rode back to Lewis Grant, and together they devised a switch that allowed Grant's five regiments to take Buford's place at the front. When Buford's division abandoned the line to trot north, Grant's Vermonters pitched into in Bryan's and White's people in a surprisingly fierce struggle—the first time the opposing infantry met in battle since Gettysburg.

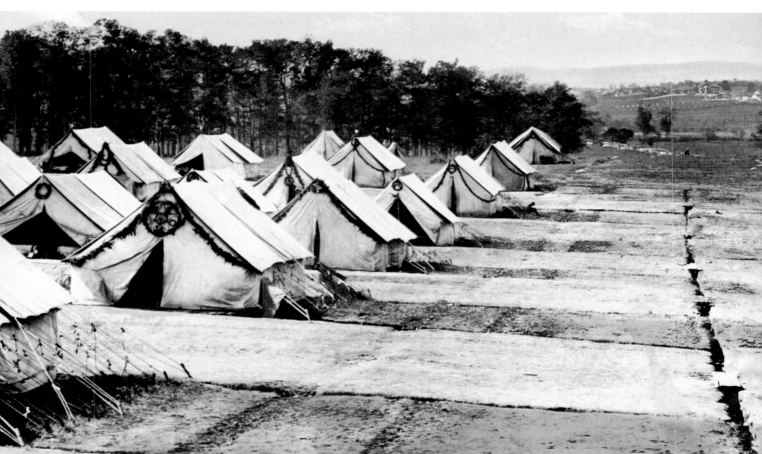

Looking southwest toward Gettysburg (right distance), the tidy tent rows of Camp Letterman reflect the organizational skill of its namesake. *(LOC)*

1. Marching west, the men of the VI Corps cross the bridge over Antietam Creek after their victory at Funkstown. The mill is gone, but the bridge is still in use today. *(LOC)*

To counter Buford's move, Stuart pulled his boys back through Funkstown and redeployed them north along the National Road on the west bank of the Antietam. Meanwhile, as the afternoon wore on, Kilpatrick's command joined Grant's infantry in front of Funkstown, and the Federal weight drove the Rebels back. By sundown, the hard-pressed Confederates withdrew.

With Funkstown in hand, Meade now controlled all the roads from South Mountain to the Hagerstown-Williamsport corridor east of Antietam Creek. The commander assured Washington that he would advance the next day—with all due caution—to develop the Rebel line.

∽o∾

With Lee's decision to defend Salisbury Ridge a fait accompli, the general turned to the knotty problem of building a new pontoon bridge. Word went out that morning for the army's engineering battalion to come to Williamsport and begin construction. Confederate pioneers already ranged across the area confiscating lumber and planks, and Williamsport's few industrial assets found new clients in the Confederate army. The engineers spent the day designing the structure. They benefited greatly when they found they could repair a number of the original pontoons.

The next day, July 11, construction began. At the same time, Robert E. Lee's soldiers climbed up then hunkered down on the entrenched heights of Salisbury Ridge. Longstreet held the right, anchored on the Potomac and protecting the road to Falling Waters near Downsville. A.P. Hill occupied the center, west of the College of St. James, and Ewell manned the left near Hagerstown. The rainy weather suddenly blessed the Confederate cause. To the east, a flooded Marsh Creek paralleled the ridge, and the adjoining fields now looked more like ponds than solid ground. Anyone attacking the ridge would flounder in an ocean of muck before reaching it. Seeing the strength of their new position, the soldiers themselves shook off whatever blues they may have felt over the Gettysburg loss and gladly welcomed an attack.

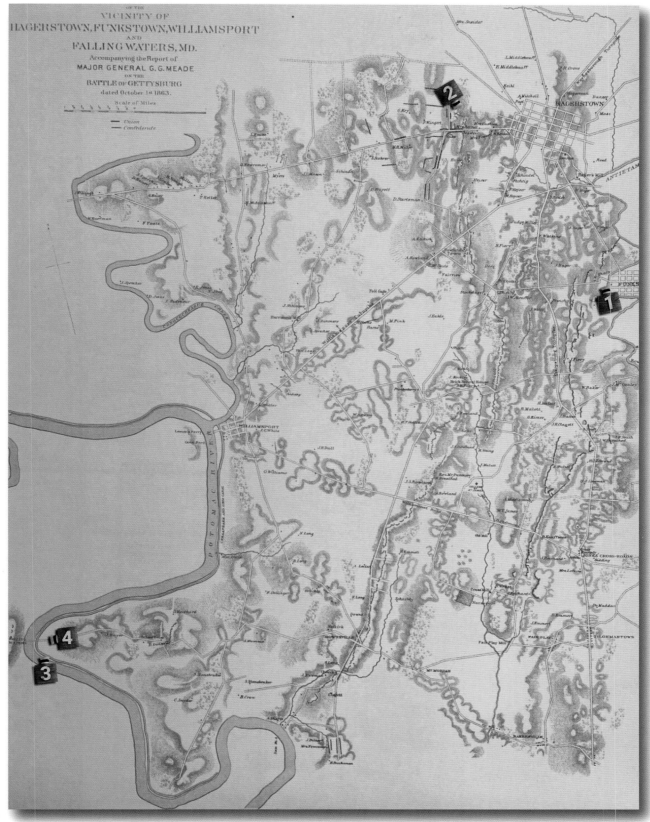

George Meade's engineers drew up a detailed map of the opposing lines along Salisbury Ridge to accompany his official report on the Gettysburg campaign. *(War of the Rebellion: Atlas to Accompany the Official Records)*

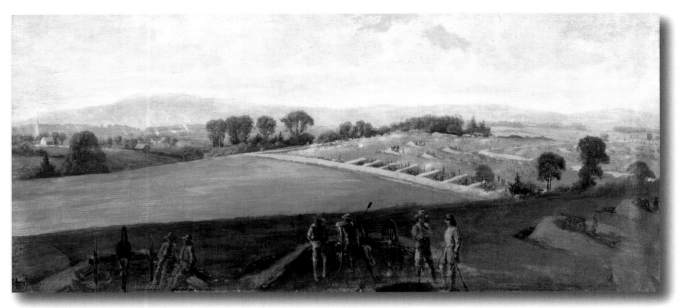

2. The northern flank of the Confederate defenses on Salisbury Ridge. At the upper left are the outskirts of Hagerstown with the steeple of St. Mary's Catholic Church clearly visible. Just to the right, two buildings lie along the National Pike with the smoke from the campfires of the XI Corps rising in the distance (probably near Funkstown). South Mountain dominates the horizon. *(LOC)*

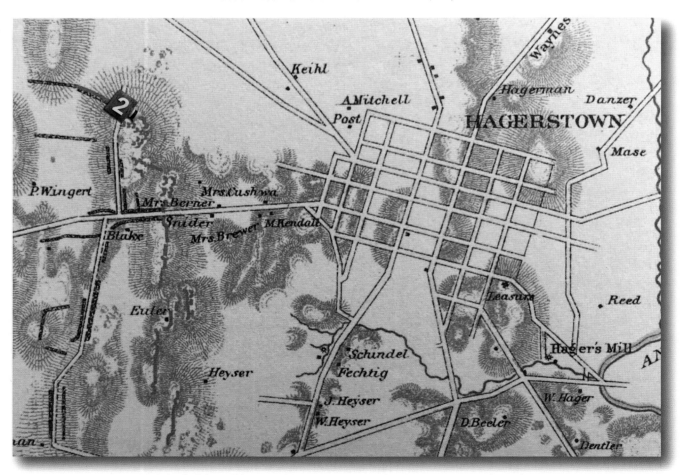

Detail of the Salisbury Ridge positions showing the Confederate works pictured above.

(War of the Rebellion: Atlas to Accompany the Official Records)

As the day progressed, the van of Meade's army began to appear to the east. Federal artillery units deployed, and the Northerners struck shovels to the saturated fields. Foragers from both armies spread out to impress everything they could find. Pickets advanced and struck up their old rhythms. After a week of maneuver, the two foes faced each other again, and Lee felt zero hour had arrived. He issued a statement read to his entire army exhorting his men to prepare to meet the enemy. Their honor and the very life of their country depended on them.

Rain again lashed the area a few hours after midnight, but the weather failed to stop operations. That morning, Kilpatrick cleared Hagerstown, allowing the XI Corps to occupy it. The advance, however, accomplished little. West of town rose the ridge crowned by the frowning Rebel entrenchments with Stuart's cavalry guarding the flank. Oliver Howard mounted the steeple of a church to analyze the Rebel bastion. His Germans went to work developing their new positions just west of Funkstown.

Continuing Meade's dispositions to the south stood John Newton's I Corps, Sedgwick's VI Corps, Sykes's V Corps, and Alexander Hays's II Corps. Slocum's XII Corps completed the front line to a point south of the Boonsboro Road, behind which Meade established his headquarters on Antietam Creek near a ridgeline named Devil's Backbone. Along the entire front,

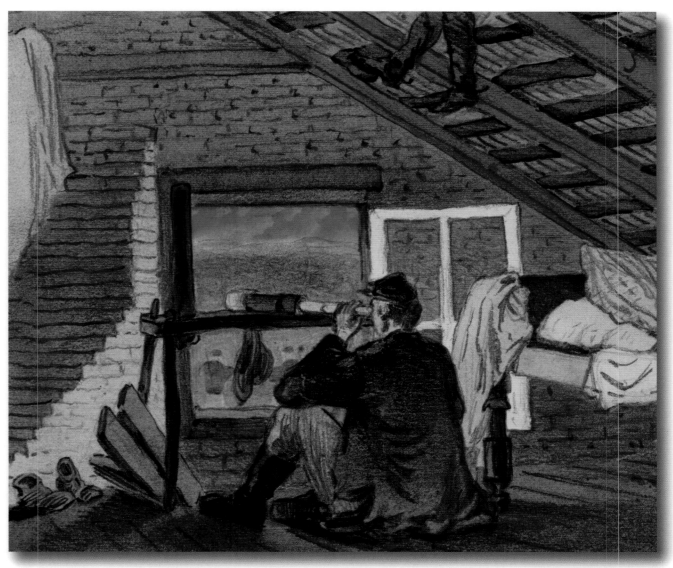

A Union observer attempts to monitor the Confederates along the Salisbury Ridge defenses. The boots of his signal partner dangle from a hole in the roof that they cut to aid in direct communications with other posts. *(LOC)*

occasional Yankee cavalry and infantry forays tested the Rebel works, but Meade still had little idea how to attack what appeared to be a powerful defensive array. Fog and smoke wreathed the area, making visual observations difficult. Meade did learn one fact that gave pause: the Potomac was falling quickly. He called for another council with his corps commanders to learn their thoughts. At the meeting on the night of the 12th, Meade announced his intention to launch a reconnaissance in force the next day with the hope of discovering a weak point in the Rebel defenses. Only Warren, Pleasonton, and new chief of staff Andrew Humphreys supported the movement. The rest, fearing a setback that would spoil the fruits of the Gettysburg victory, vigorously objected. For the time being, Meade relented.

While Meade cautiously weighed his options, the Confederate engineers completed their construction project. The hospital staffs had been using the small cable ferry to transport the wounded to Virginia. With the causeways on both sides of the river finished and the pontoon bridge in place, the groaning ambulances now rerouted to the new bridgehead and rumbled into Virginia. A vast unspooling then occurred, as the endless rows of Harman's booty-filled wagons rolled into line on the C&O towpath and creakily headed south to the crossing. The engineers also chose a ridge about a mile and a half from the bridgehead on the Donnelly farm to construct a bastion to cover the retreat.

No doubt the army's commander felt some relief when his trains started moving into Virginia. Lee, however, knew he would need the Williamsport ford to extract his troops over the course of one night—the one bridge simply wouldn't be enough. The weather again proved decisive. Although rain continued to fall fitfully, the monsoon-like storms that had soaked the area for a week finally let up. The river level fell, and Lee's staff calculated the soldiers could negotiate the four-foot-deep ford at Williamsport on the evening of the 13th. Lee agreed. Orders quickly circulated for the Confederates to abandon Salisbury Ridge that night. The Rebels were finally going home.

When Washington learned of Meade's latest council, the reaction was swift. Henry Halleck implored Meade to act on his own and encouraged him to ignore the opinions of his subalterns. Accordingly, Meade

reversed his position and called for a reconnaissance in force for the morning of the 14th. As Meade's orders circulated through the Northern camps, the Southerners fashioned fake flags and Quaker guns—logs cut to look like artillery—and built roaring campfires, an elaborate charade to fool Yankee observers into believing the army remained in place.

Ewell's corps began the operation. They abandoned their positions on the northern section of the ridge near Hagerstown and, with bonfires illuminating the route, slogged six miles through the rainy gloom to the Potomac. At Williamsport, they waded the putrid standing water of the C&O Canal's aqueduct to access the shallowest section of the ford north of Conococheague Creek. Smoky torches dimly beckoned the crossers to the Virginia shore, and the taller soldiers formed a human chain to prevent anyone from being washed away. A layer of dumped tar on the

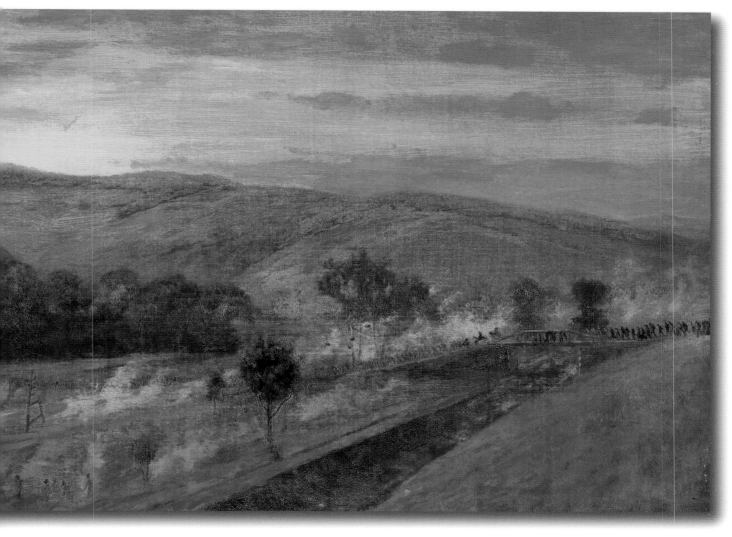

3. With the sun setting on July 13, the army ambulances and John Harman's wagon trains cross the Potomac River at Falling Waters. The bridge over the C&O Canal is on the right. *(LOC)*

far shore provided traction for the soaked soldiers and stabilized the landing zone. It was said no one drowned during the dangerous operation.

To relieve some of the pressure, Ewell's divisional trains moved a mile upriver to employ the next four Potomac fords. Stuart's cavalry followed across the Williamsport ford, while Ewell's artillery rumbled south to cross the new bridge at Falling Waters.

While Ewell's artillery rolled into Virginia, Longstreet's boys peeled off the ridge and followed the cannoneers across the pontoons. Fitzhugh Lee's cavalrymen noisily took their place in the fieldworks to act out their own charade. Longstreet's evacuation proceeded through the storming night, through knee-deep mud, lightning strikes, and innumerable soul-

sapping delays. A.P. Hill's Corps then followed Longstreet into the gloaming. For some of the soldiers struggling through the quagmire, the seven-mile trip took 12 hours. Finally, in the dense fog of the morning, Hill's boys began to cross. Harry Heth's division took up their blocking position along the earthworks at the Donnelly farm, with Pettigrew's people north of the road, Brockenbrough's and Davis's troops to the south. Oddly, although he manned a series of newly constructed artillery lunettes, Heth received no artillery support. Hill felt his rear guard simply wouldn't need the long arm.

It was an ironic posting indeed. Heth's advance nearly two weeks before had triggered the conflagration that was now ending, and Heth would

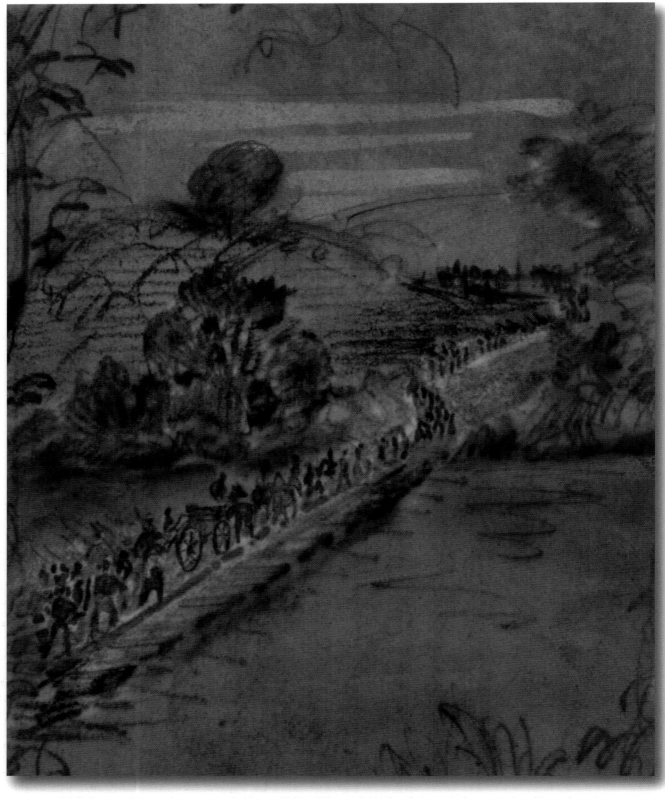

4. Night crossing on the pontoon bridge at Falling Waters, with Confederate infantry and artillery gingerly making their way through the darkness. *(LOC)*

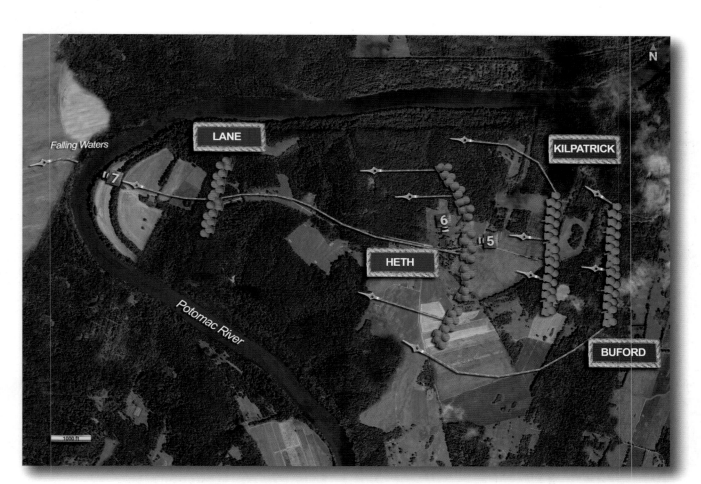

The Battle of Falling Waters—July 14, 1863
39° 33'16.16 N 77° 51'58.86 W. Google Earth Pro. 9/6/2013. 8/25/2022.

now command the last Confederate infantry north of the Potomac.

In a further irony, command confusion had left Heth's front totally devoid of cavalry protection.

The rain had stopped.

∽◦⌐

Judson Kilpatrick awoke that morning near Hagerstown and found the Rebels gone. Stuart's troopers had pulled out well before dawn to follow Ewell across the ford, completely fooling their Bluecoated foes. Kilpatrick was aghast and led his division south—Custer in front, naturally. With the roads churned into a muddy morass, Kilpatrick's straining column lost cohesion. They slogged through fog-enshrouded streets of Williamsport, the detritus of the Rebel army scattered everywhere. Visible across the Potomac were Stuart's horsemen, and it became

painfully clear that Robert E. Lee had stolen a march on George Meade. Then word came that the enemy still were crossing at Falling Waters, so Kilpatrick and the Yankees pounded south.

Noon had yet to arrive when the Blue van reined up a mile in front of Heth's lounging boys. The Southerners assumed Jeb Stuart would prevent any surprises, so when Heth and Pettigrew eyed the distant figures emerging from some woods, they took them for Confederates. Of course, no sane commander would attack an infantry line with two cavalry squadrons. However, when about 100 of those dim figures came charging out of the gloom to within a few hundred yards of the Confederate lines, Heth realized his miscalculation.

By the time the now alert Rebs loaded their rifles, the Union troopers from the 6th Michigan Cavalry crashed over the works near the Donnelly farm buildings and plowed into the butternuts. With swinging sabers and smoking pistols, Custer's boys

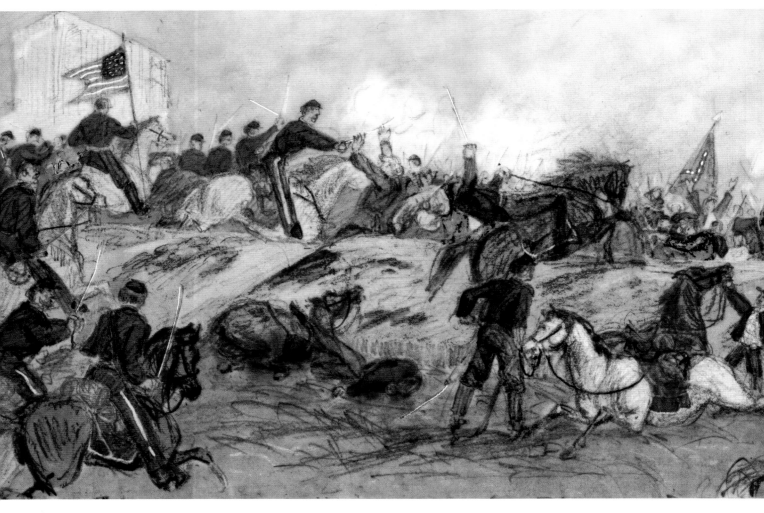

5. Looking west, Union troopers from the 6th Michigan cross the earthworks on the Donnelly farm and slam into Pettigrew's surprised defenders, triggering a battle to protect the crossing. *(LOC)*

broke through the line and raised holy hell. The Michiganders then curled to the north and reversed their direction to try to fight their way out. In a confusing swirl of close combat, the Confederates responded using their rifles as clubs and delivering blows with everything from axes to fence rails. The Rebels struck down most of the badly outnumbered Yankees and dispersed the rest, but, after becoming unhorsed while rallying his men, James Johnston Pettigrew took a slug to the stomach. Not wanting to either endure captivity or death in the North, he insisted on being muscled onto a stretcher and carried across the Potomac. Pettigrew, who survived the July 3 holocaust on Cemetery Ridge, passed on three days later.

One witness estimated the entire action only took three minutes.

As Kilpatrick fed more of his now-dismounted horsemen into the battle, John Buford rode up to add his weight to the operation. The Federal cavalry counted some 7,000 saddles and artillerists, a force that more than doubled Heth's infantry. While the Federal pressure swelled across his front, Heth requested artillery from A.P. Hill. Hill again demurred, but he did order elements of James Lane's brigade to bolster Heth's boys. For now, however, Heth was on his own.

Brockenbrough's brigade of Virginians still held Heth's flank south of the road. Brockenbrough himself decided to abandon the field, but he ordered his Virginians forward under the command of one of his

staffers to counter Buford's build-up. They engaged the surging 8th Illinois in a hand-to-hand struggle, but as more of Gamble's brigade thundered up, the outnumbered Virginians made a run for the bridgehead. The Yankee troopers rode in and surrounded the Confederates, taking hundreds of captives and three battle flags.

Once Lane arrived, Heth pulled his survivors back. Then the two commands played leapfrog as they fell back to the bridgehead. The Yankees, however, kept up the pressure. Mounted companies would rush in and do damage, then the Rebs would counter and drive them off. Kilpatrick also dispatched a Michigan unit to loop around the enemy's left and attack from the north. There the Michiganders overran a Rebel Parrott gun and laced the Graybacks with their own canister. Dazed and confused Confederates surrendered by the dozens.

6. Identified as the charge of the 6th Michigan, this image more accurately represents the later actions when some Confederates broke before the Union pressure. *(LOC)*

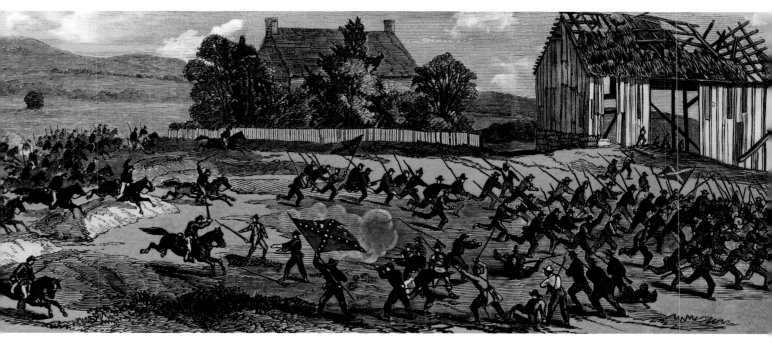

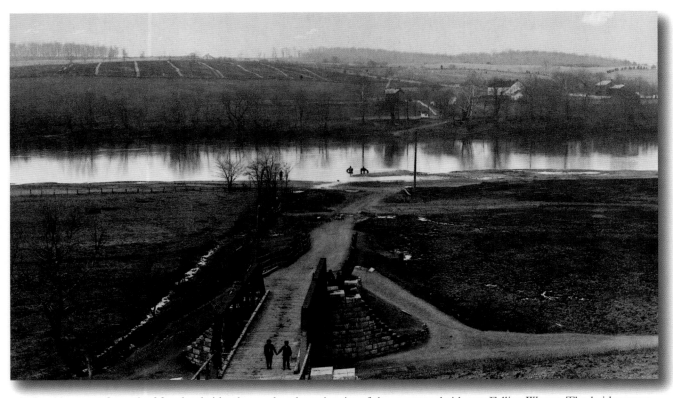

7. Looking west from the Maryland side, the road ends at the site of the pontoon bridge at Falling Waters. The bridge over the C&O Canal (visible at the right in Image 3.) is in the center foreground. *(Kent Masterson Brown Collection)*

All told, the Union cavalry action increased Lee's losses by some 500 effectives. Still, Kilpatrick's rash opening attack probably prevented the capture of Heth's entire command, a wasted opportunity that angered Buford and his lieutenants. Recriminations, however, would have to wait as the battle continued to rage. With Yankee cavalry pressing them from every direction, some of Lane's men got tangled up in the vine-choked bluffs collaring the C&O Canal north of the bridgehead and marched away prisoners of the Yankees. Most, however, retained commendable discipline in the mile-and-a-half retreat. Both Lane's and Heth's beleaguered commands fought through the encirclement to Falling Waters and managed to join the procession to safety. Determined New Yorkers from Buford's command followed closely, but Confederate artillery dropping trail across the Potomac battered their pursuit and momentarily held them at bay.

As he sat astride Traveler on the Virginia riverside sipping coffee with Jeb Stuart, a deeply relieved Robert E. Lee watched Heth's troops pour across the bridge. The two generals then observed the final act. The Tarheels

from the 26th North Carolina cast wary glances to the east as they approached the bridgehead. Except for assorted stragglers, they were the last Rebels in Maryland, and they knew thousands of Yankees lurked in their wake. Confederate shot and shell continued to spin over their heads and crash into the woods beyond, holding off the unseen enemy. Escape was only moments away.

The 26th North Carolina. They had helped push the Iron Brigade off McPherson Ridge on July 1, and they had spilled their blood in front of the blazing enemy line north of the Angle on the 3rd. Now, with the men of the Army of Northern Virginia back on the soil of their namesake, the Carolinians clambered onto the bridge and axed the ropes anchoring the structure to the Maryland waterside. Slowed by the Rebel artillery barrage, Buford's Blueclad troopers arrived just a few minutes too late to inflict any more damage. The Northern cavalrymen watched the pontoon bridge drift into the current, and as a Confederate regimental band struck up "Dixie" off in the distance, the Southern boys rode the flow across the Potomac to safety, finally to rest under the shade of the trees.

EPILOGUE

W HEN THE BATTLE ENDED, the leading citizens of the town began to meet to determine how to recover from the unprecedented trauma the entire area had just endured. Chief among their concerns were the thousands of buried dead and how and where to reinter them. Led by attorney David Wills, the citizens successfully petitioned to have a national cemetery established next to the local cemetery. Wills oversaw the reinterment of the bodies and kept detailed notes and maps of the locations of the graves. Later, a civil engineer working in California named S.G. Elliott visited Gettysburg after a business trip to Washington D.C. Using Wills's detailed notes, Elliott created a map designating where the 8,352 bodies and 345 horses were originally buried.

Photographed two weeks after the battle began, the Evergreen Cemetery gatehouse shows the effects of the fighting. The town's cemetery covers the area beyond the structure to the south (left), while the land that would house the new Soldiers' Cemetery stretches to the north (right). Matthew Brady's peripatetic assistant strikes a jaunty pose while a single soldier seems to stand guard beyond the archway. *(LOC)*

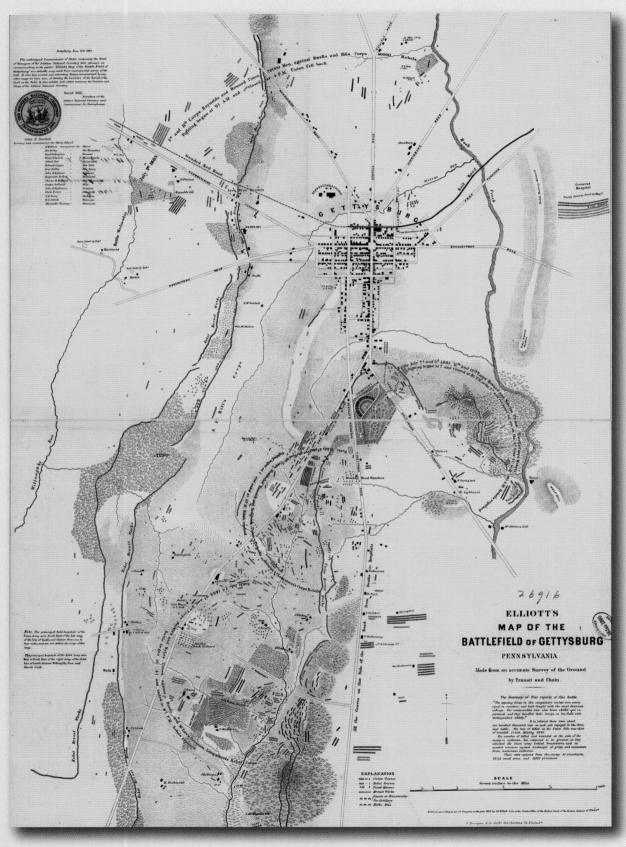

The Elliott Burial Map. *(LOC)*

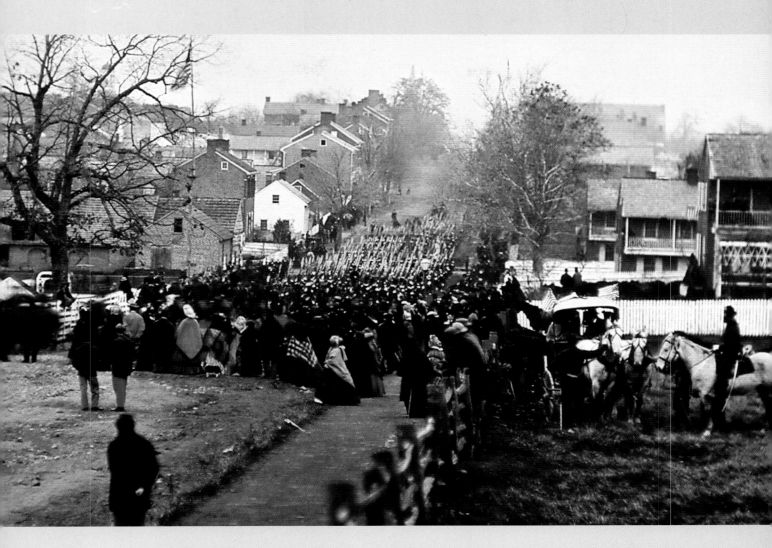

The dedication ceremony for Soldiers' National Cemetery was scheduled for November 19, 1863, and President Abraham Lincoln accepted an invitation to share his thoughts. In the days leading up to the event, Lincoln worked to get his words just right. He continued to hone his speech on the train ride to Gettysburg and in his room in David Wills's house where he stayed the night before the ceremony.

The ceremony began in the morning with a procession down Baltimore Street. Dignitaries included Edward Everett, an expert in giving long, classically oriented speeches and who was scheduled to deliver one today. Also marching in the parade was an honor guard complete with white gloves and buffed uniforms. At the intersection of Baltimore Street and the Emmitsburg Road, the procession slowed long enough for the camera to capture this image. *(NA)*

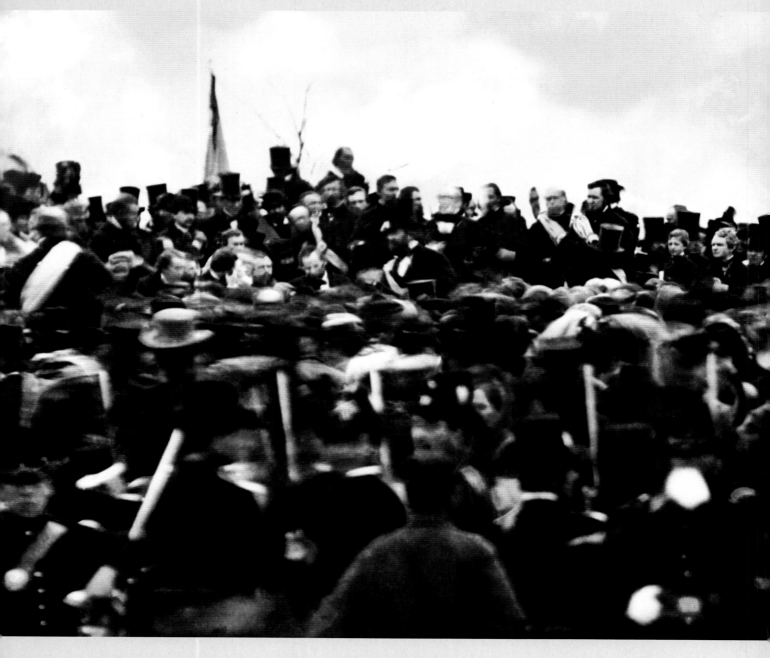

Planners constructed a stage near the southern border of the cemetery. A crowd of 20,000 gathered to hear Everett speak for two hours. About the time that Lincoln rose to deliver his remarks, a photographer took this shot. Some of the honor guards appear far more interested in the photographer than with the president. It is believed Lincoln is below and slightly to the right of the bare tree. *(LOC)*

Abraham Lincoln took two minutes to speak 271 words in ten sentences. Crowd response was muted but deeply respectful. The next day, Edward Everett wrote to the president. He admitted Lincoln did in two minutes what Everett couldn't manage in two hours: getting to the heart of the matter. *(LOC)*

Soldiers' National Cemetery eventually became The Gettysburg National Cemetery, the final resting place of 3,512 Civil War soldiers. Built in 1869, Soldiers' National Monument stands at the center of two semi-circles of graves, and a statue of John Reynolds constructed in 1872 rises above the main gate on the Baltimore Pike. A number of unit markers also dot the area as the cemetery occupies part of the Union defense lines from the second and third day of the battle. Evidently, this photo was taken during a re-sodding effort. (*Sue Boardman Collection*)

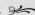

In the years after he delivered it, Lincoln's Gettysburg Address came to be regarded as one of the greatest orations in American history. In that same period, Congressman Dan Sickles led the movement to establish the Gettysburg National Military Park to honor the Unionists and their units who fought there. Sickles had a self-serving streak and no doubt basked in his own glory, but he also insisted that they build a monument solely to Lincoln's speech. Finally, in 1912, the Park dedicated the memorial. *(Sue Boardman Collection)*

Slowly, the Gettysburg area began to recover, but the bruises ran deep. Long after the war ended, the trees on Culp's Hill show severe damage from the sustained fighting there. *(LOC)*

Some enterprising residents made game efforts to interpret the battle. Showing the effects of the heated sharpshooter exchanges on Day 2 and 3, this riddled fence stood near the Winebrenner House east of Baltimore Street and north of Cemetery Hill. *(Sue Boardman Collection)*

Right after the battle, Gettysburg began to draw the curious who wanted to see where the great Union victory had happened. Many picked up pieces of the detritus that littered the field as souvenirs of their visit. Self-appointed guides who may or may not have had knowledge of the battle charged the tourists for tours. Commercial establishments sprang up on the battlefield proper, including photography shops, eateries, and even a trolley line.

For the Union veterans of the battle, Gettysburg became a mecca for honoring themselves, their comrades, and those they lost. The states and the veteran organizations raised money to build monuments to their sons' and daughters' service and place them on the field where they endured and sacrificed and persevered. In 1886, the Bucktails of the 149th Pennsylvania gathered to dedicate their monument on the McPherson farm where they fought on the first day. Two years later, they built a bigger monument on this spot and moved the original to their Cemetery Ridge position on day three. *(William Tipton Sample Photograph Album, William L. Clements Library, The University of Michigan)*

On a sunny day in 1884, the veterans and the families of the 124th New York met on Houck's Ridge above Devil's Den. Their colonel, Augustus van Horne Ellis, was killed in the fighting there on July 2, and they decided to honor him by placing his statue—folded arms and all—on top of the granite memorial shaft. A local Gettysburg brass band provided music for the occasion. *(William Tipton Sample Photograph Album, William L. Clements Library, The University of Michigan)*

The site of Hazlett's Battery on Little Round Top became a particular favorite for veterans and visitors alike, providing a dramatic bird's-eye view of the battlefield and an up-close view of two artillery pieces. *(Sue Boardman Collection)*

These veterans of the 14th Connecticut anchored Hays's line south of the Brian farm and helped repel Pettigrew's and Trimble's wing of the Grand Charge. Twenty-one years to the day after the battle, they gathered to dedicate their monument. *(William Tipton Sample Photograph Album, William L. Clements Library, The University of Michigan)*

Gettysburg also became a place for the officers to return to, sharing with the fighting men the deep desire for connection. The twenty-five-year reunion in 1888 could not be matched for sheer star power as a veritable cavalcade of military luminaries showed up. From the left, here we see Joshua Chamberlain in a gray top hat, a bow-tied New York Senator Warren Miller who had served as a cavalry trooper, Dan Butterfield who had spent his post-Gettysburg career trying to make George Meade look bad, a monumentally bewhiskered James Longstreet, John Hartranft wearing his Medal of Honor, Dan Sickles, and III Corps brigadier Joseph Carr. Many Confederate veterans joined the festivities, but there was much grousing among the Unionists concerning the Southerners wearing Stars and Bars lapels. The official policy of the Park prevented the Rebel battle flag from being unfurled—even as a small metal clasp on a coat's lapel. *(William Tipton Sample Photograph Album, William L. Clements Library, The University of Michigan)*

On another visit, Sickles and Carr joined another III Corps brigadier Charles Graham next to the Trostle barn at the very spot where a Confederate projectile crushed Sickles's leg and ended his battle.

(William Tipton Sample Photograph Album, William L. Clements Library, The University of Michigan)

The man who left perhaps the deepest mark on the battle also returned. A former presidential candidate and a revered public figure, Winfield Scott Hancock (center) posed at a place on the field that had taken on a life of its own, the Copse of Trees. They would call it "The High Water Mark of the Confederacy," and on Hancock's 1885 visit, he was accompanied by a group that included John Batchelder (second from left). Batchelder had already begun collecting first-person material on the battle, a treasure trove that has become the primary source for students of the battle.

It was Hancock's last trip to Gettysburg. He would die three months later. *(William Tipton Sample Photograph Album, William L. Clements Library, The University of Michigan)*

As the years passed, the number of veterans returning to the field grew fewer and fewer. *(LOC)*

Finally, the old soldiers moved on, leaving the battlefield and her monuments to future generations to help them discover their own truths. *(William Tipton Sample Photograph Album, William L. Clements Library, The University of Michigan)*

"But, in a larger sense, we cannot dedicate, we cannot consecrate—we cannot hallow—this ground. The brave men, living and dead, who struggled here, have consecrated it far above our poor power to add or detract."

"The world will little note, nor long remember what we say here,
but it can never forget what they did here."
(William Tipton Sample Photograph Album, William L. Clements Library,
The University of Michigan)

WHEN THE CIVIL WAR ERUPTED, twenty-one-year old New Yorker Jonas Evans followed the footsteps of many of his Irish compatriots and enlisted to fight for the Union. He joined the 44th New York Infantry and served until May of 1862 when a wound suffered at Hanover Court House, Virginia, earned him a trip home. Once healed, Evans decided to forego the infantry life and instead joined the 6th New York Cavalry. Serving as a private, Jonas rode to Gettysburg either as part of Col. Thomas Devin's brigade (which helped delay the Confederate advance on July 1) or as Maj. Gen. Daniel Sickles's headquarter guard (which arrived late on July 1). Either way, he saw action skirmishing near the Millerstown Road on July 2 until his brigade, along with the rest of Gen. John Buford's division, departed the field to rest and refit.

Evans was riding with the 6th near Berryville, Virginia, in early September of 1864 when a vicious encounter with Col. John Mosby's men left him lying on a roadside with a severe head wound. His mates thought him dead on the field, but the Confederates found him alive enough to travel as a prisoner to Richmond, Virginia, and the infamous Libby Prison. He somehow recovered, left Libby, and surprised his fellow cavalrymen when he returned to the unit late in the war. He mustered out with the war's end, became a Brooklyn policeman, and in 1865, married twenty-year-old Annie Rabbitt.

In 1886, Jonas and Annie welcomed George Vincent Evans to their growing family. Evidently a man of patience, George waited until he was in his mid-30s to marry Mary Cecelia Cantwell. Their union, which was now based on Chicago's north side, produced four children: George, William Tilden, Mary Virginia, and Robert. They all would marry and raise families of their own.

In August of 2021, I happened to be in Lake Geneva, Wisconsin, at a reunion of the Evans clan. You see, I married Mary Virginia Evans's youngest daughter, Sheila (Virginia married Jack Burns and had five children), and I always looked forward to these family roundups. I was a year into the production of the book you now hold, and the family knew of my Gettysburg project. I had semi-heard from Sheila's Uncle Bob that they had an ancestor in the Civil War who had been wounded and captured. Of course, it seemed everyone had a tenuous connection to the war, so when the subject came up at this last reunion, I nodded politely. Then one of the Evans women upped the ante. Would I like to see his medals? Well, sure. She soon produced a shadow box with two medals under glass: a prisoner of war citation from the state of New York, and a Gettysburg Veteran medal! I suddenly realized I was in a room filled with the descendants of Gettysburg veteran Private Jonas Evans of the 6th New York Cavalry, including my and Sheila's two children!

∽∘∾

In the mid-1880s, the 6th New York's veteran organization financed and constructed a magnificent monument on the first day's field. Some veterans went to Gettysburg for the dedication and posed for a photo on a rainy, muddy day. Was Jonas one of them? We may never know as there is no known photo of him despite a long career as a Brooklyn cop, so we have no image to compare with the stern faces in the photo. However, of one thing I am sure. The descendants of Jonas Evans helped make these books what they are. My wife Sheila

brilliantly critiqued every image in these books and made those images markedly better. Our son Kevin helped create the maps with his digital skills. Our daughter Dylan designed and produced the maps and created new ways to colorize the photos you see here. My daughter Maggie and I may feel a bit left out as we have no ancestors of such particular renown, but we gladly accept our fate.

Meanwhile, the spirit of Jonas Evans will dwell here forever.

On July 11, 1889, veterans of the 6th New York Cavalry gather for the dedication of their monument on the First Day's field. *(William Tipton Sample Photograph Album, William L. Clements Library, The University of Michigan)*

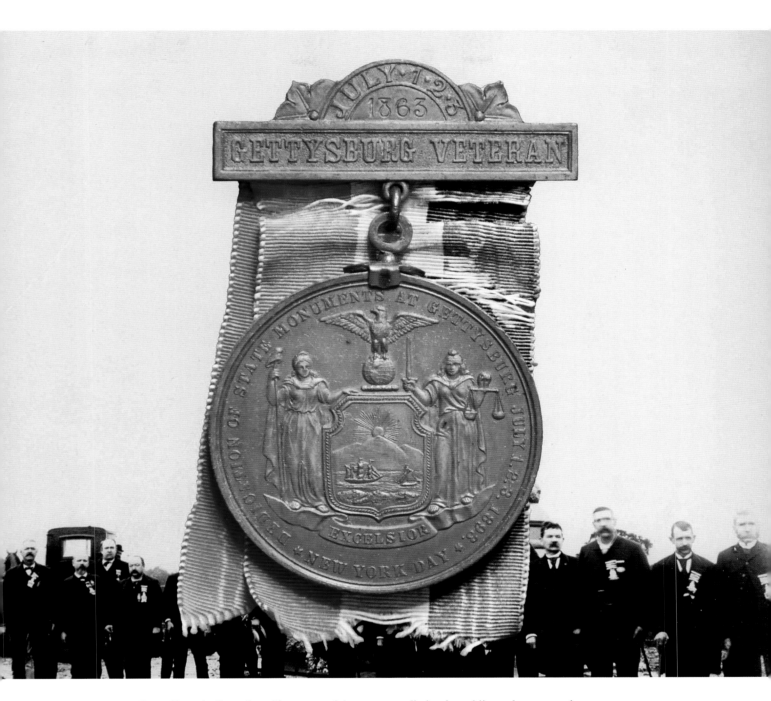

Jonas Evans's Gettysburg Veteran medal, worn proudly by the soldiers who returned to the battlefield July 1, 2, and 4, 1893, to help dedicate the New York Monument in the National Cemetery. *(Photo and design by Dylan Brennan, with thanks to the entire Evans clan who have kept Jonas's memory alive)*

ACKNOWLEDGMENTS

We extend our deepest appreciation to the following.

The staff at the Guthrie Memorial Library in Hanover, PA. The staff at the United States Army History and Education Center. Amy Frey, Robert Hill, and the staff at the State Museum of Pennsylvania. Tim Smith and Maria Lynn at the Adams County Historical Society. The staff at the North Carolina Museum of History. Marlana Cook and the staff at the West Point Museum, United States Military Academy. Catherine Perry at the Musselman Library, Gettysburg College. Mazie Bowen, Mary Palmer Linnemann, and the staff at the Hargrett Rare Book and Manuscript Library, University of Georgia Libraries. The staff at the Virginia Military Institute Archives. The staff at the Snite Museum of Art, University of Notre Dame. The staff at the New York State Archives. Terese Austin and the staff at the William L. Clements Library, University of Michigan. Sofia Yalouris and the staff at the Maine Historical Society. The archives staff at the State of Minnesota. William H. Brown and the staff at the North Carolina Department of Natural and Cultural Resources. The staff at the Jennie Wade House. Bob Zeller and the Center for Civil War Photography. Sarah Carrier and the staff at the North Carolina Collection Photographic Archives, Wilson Special Collections Library, University of North Carolina at Chapel Hill. The staff at the New York Public Library. The staff at the House Divided Project at Dickinson College. Jill Craig and the staff at the Western Maryland Regional Library. Gay Miner and the wonderful staff at St. James School. Kent Masterson Brown. Cassidy Lent and John Horne at the Baseball Hall of Fame. Robert Hancock at the American Civil War Museum, Richmond, VA. Kelly Kerney and the staff at The Valentine, Richmond ,VA. Sherri Jackson and everyone at Bridgeman Images. Sandra Izer at WCHT. Jo Davies and everyone at Bloomsbury Academic and Osprey Publishing.

Our thanks also extend to these fine individuals.

Craig Symonds. Wayne Motts (WWWD?). Ron Kirkwood. Codie Eash. Jennifer Loredo. George Wilkinson. Marty Bertera. Ron Coddington. Ron O'Neill. Gary Casteel. Garry Adelman. Rick Allen. Ellen DiBiase. Stephen Bockmiller. Craig Heberton. Tom Paine. Jim Nolan. Mitch Yockelson. Zach Lindermann. John Miller. Philip Laino. Scott Mingus Sr. The entire Evans family. Sarah Bierle. David Powell. Tom Ledoux. Richard Marsh. Ed Italo.

Our great thanks to Ralph Peters and Dr. Allen Guelzo. It's an honor to have two such esteemed writers contribute such beautiful forwards to our two volumes.

As you could imagine, Chris Gwinn and Greg Goodell at the Gettysburg National Military Park were incredibly helpful in answering questions and locating resources. We truly do owe them a lot.

Besides producing a wonderful book on the Gettysburg Cyclorama, Chris Brenneman and Sue Boardman read and critiqued an early version of the manuscript. Chris cleaned up the second draft, and Sue gave us her extensive collection of Gettysburg photos, many of which appear in the book. Of course, any manuscript mistakes or factual miscues are ours and ours alone.

Greg Ainsworth, another Gettysburg photo maven, proved terribly generous in providing access to his collection and his expertise. Rich Kohr did the same with his work on the Marine reenactment in 1922. Jenny Johnston reminded us many times what good writing looks like.

Artist and author Mark Dunkelman generously granted us use of his magnificent painting of the Brickyard Fight. Dennis Morris allowed us use of his great Gettysburg Diographics (https://diographics.com/), which were crucial in bringing to life the fight along the Emmitsburg Road on July 2. Artist James Shockley's excellent paintings of the 150th New York (https://www.facebook.com/theArtistJamesAShockley/)

helped illuminate that unit's actions. David H. Jones's stellar work on Bigelow's Battery, which includes his fine book *Hold At All Hazards*, proved extremely useful.

Dale and Anne Gallon very generously helped us place many of Dale's excellent paintings in these two volumes. We are indebted to them and their grandkids, Ben, Elsie, Chapin, and Jake.

We are also indebted to artist Dan Nance and his fantastic work.

We are truly thankful for modern artists Steve Noon, Mark Maritato, Michael Haynes, Don Troiani, and Gil Cohen

We especially thank the field artists of the Civil War. Without them, this book would have been impossible to produce.

From Dylan Brennan

Thanks to Mike, Alex, and Courtney for always being right by my side. And to Chloe, Lauren, Claudia, and Billie for always being there virtually. You were the reasons my shouts weren't aimed at the void.

From Pat Brennan

Doing a project like this with my kids is quite the blessing. Many thanks and much love to Maggie, Dylan, and Kevin.

My eternal thanks to documentarian extraordinaire Jonathan Towers. His dictum of "See it, say it" has been a guiding principle throughout this entire process.

The owner and editor of *The Civil War Monitor*, Terry Johnston Jr., has been a long-time compatriot. His clear vision and pursuit of excellence have made me terribly proud to be associated with his magazine, easily the best in the world on the subject of the Civil War.

John Kamerer makes up half of my Gettysburg ground crew. His brilliant camera work enlivens many of these pages, and for that and the bonhomie, I am eternally grateful.

I wish two folks were alive today to see this work: Rich Rollins and Bill Dowling.

Ian Hughes did a remarkable job designing and laying out both volumes.

Many thanks to the staff at Savas Beatie Publishing. Sarah Closson and Sarah Keeney have been unflaggingly wonderful in navigating the craziness of birthing a book like this. Veronica Kane has displayed incredible skill hammering the narrative into form, and her interest in Rebel Yell continues to fascinate. I owe the three of them so much.

Twenty-seven years ago, Ted Savas thought my manuscript *Secessionville: Assault on Charleston* deserved to be published, so he made it happen. It took us that long to do it again. He's a pillar of the publishing community and a fine author in his own right, and I am extremely grateful and fortunate to have my good friend at the helm of this project.

And to my wife and my love, Sheila.

INDEX